# FIGURE DRAWING
## for Comics and Graphic Novels

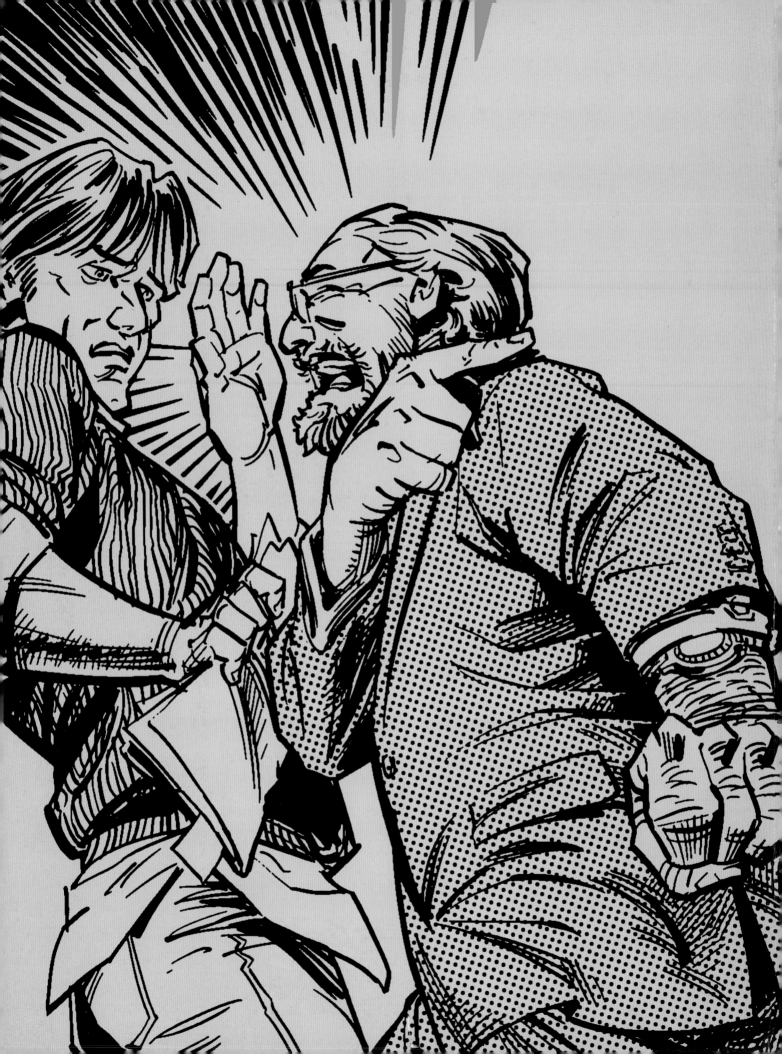

# FIGURE DRAWING
## for Comics and Graphic Novels

DANIEL
COONEY

B L O O M S B U R Y
LONDON · NEW DELHI · NEW YORK · SYDNEY

# CONTENTS

A QUARTO BOOK

Published in 2012 by Bloomsbury Publishing plc
50 Bedford Square
London WC1B 3DP

Copyright © 2012 Quarto plc

ISBN: 978-1-4081-7090-8

A CIP record for this book is available from the British Library.

QUAR.DCCF

Conceived, designed and produced by
Quarto Publishing plc
The Old Brewery
6 Blundell Street
London N7 9BH

Project editor: CHLOE TODD FORDHAM
Designer: JOHN GRAIN
Art director: CAROLINE GUEST
Picture researcher: SARAH BELL

Creative director: MOIRA CLINCH
Publisher: PAUL CARSLAKE

Colour separation by Modern Age Repro House Ltd, Hong Kong
Printed in China by Hung Hing Off-Set Printing Co. Ltd

10 9 8 7 6 5 4 3 2 1

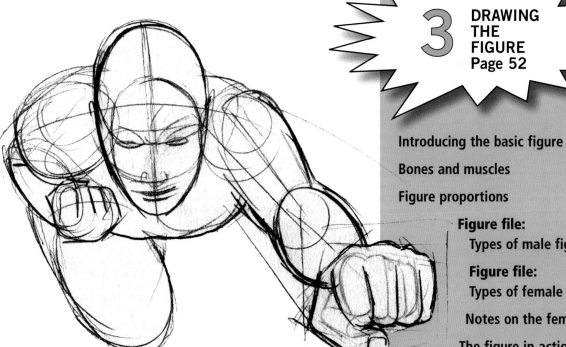

## 4 DRAWING THE CLOTHING
### Page 94

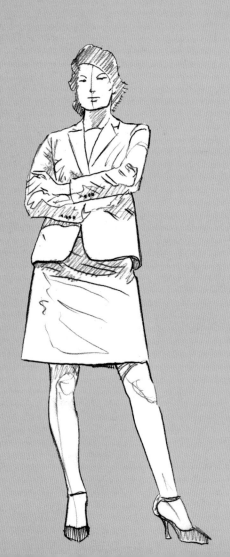

## 5 BACKGROUNDS
### Page 118

6 **FIGURES AND THE PANEL**
Page 146

7 **GRAPHIC NOVEL PREVIEW: THE FINISHED PAGES**
Page 168

# FOREWORD

I blame my love for drawing comics on my weekly jaunt to the comic book shop on Wednesdays after school when I was a kid.

Going to the comic shop was like seeing a movie for the first time; there I would discover a new comic to read that would inspire me to draw people, aliens, robots, just about anything I could think of to draw. If I was lucky, there would be a new *Uncanny X-Men* book with art by John Byrne and Terry Austin, or *Thor* by Walt Simonson, or *Batman* featuring Gene Colan art, or *Daredevil* by Frank Miller and Klaus Janson, or the latest *Star Wars* comic drawn by Carmine Infantino, who later became one of my art teachers at The School of Visual Arts. These artists inspired me to become an artist, and it was going to take a lot of work on my part to make that a reality.

As my appetite for drawing my own stories increased, so did my desire to improve my figure drawing. I started to draw everything and anything I could, observing everyday life and listening, for the most part, to my art teachers, who helped me to improve my drawing skills and storytelling. Alongside the drawing lessons, I bought instructional books, went to museums, photographed images to draw from and attended figure drawing workshops. It wasn't just comics that inspired me to create characters, but books and movies, particularly the latter in the late 1970s and early 1980s. It was a fantastic time for movies. As a kid, I witnessed *Superman, Star Wars, Raiders of the Lost Ark, E.T., Tron, The Terminator, Blade Runner, Ghostbusters* and *Back to the Future* on the big screen. These films helped to shape my vision of the stories I wanted to write and draw. I'm not satisfied with just writing a good story: the artwork in a graphic novel needs to deliver on that promise of entertainment to the reader. To engage the reader into the world you're illustrating, you need to understand how to draw it on a piece of paper.

The aim of this book is to inspire artists to produce dynamic and convincing figures for comic books and graphic novels. Treat this book as one of the many tools in your resources for improving your figure drawing. What you will learn in these pages is what I learned from my instructors and peers, various instructional books and my own experiences. What worked for me may or may not work for you. I'm still learning; I have been drawing comics professionally for 17 years and I'm only just starting to figure some things out. However, what I do know is that there are no shortcuts, no secrets, no easy way of drawing the figure well. What I can offer is to be your guide, of sorts, and help you find your way to becoming a good artist.

This book is only a small part of the many ways to tackle the problems you may face as you develop your drawings. Practise as much as you can and you'll be on your way to drawing better than you did yesterday. Just as the heroic figure trying to save the day would be in your story, be fearless, and don't be afraid to make mistakes: it is one of the keys to improving your work. Learn from your mistakes and set the bar higher next time, so that the next figure leaping into action will be better than the last.

Last but not least, observe and learn from the artists who inspire you. Look to the past for inspiration – from artists like Andrew Loomis, Burne Hogarth, Neal Adams, Alex Raymond, Jack Kirby, Will Eisner, Leonard Starr, Hal Foster, Roy Crane, Milton Caniff, Joe Kubert, Wally Wood, Alex Toth, Al Williamson and José Luis García López – and keep your eye and imagination on the present to create tomorrow's great dynamic figure for graphic novels and comics.

Daniel Cooney

# 1

## GETTING STARTED

The following pages are full of suggestions for what materials to use for figure drawing. The chapter will explain how computers and software can help you with drawing figures and will offer advice and tips on choosing a model, drawing from life and building your own reference library.

# ESSENTIAL TOOLS AND EQUIPMENT

The requirements for figure drawing are pretty basic, but there are a few essentials you will need in order to do it properly.

Prices can be misleading on art supplies, so rather than assuming the most expensive is the best, you will need to experiment with materials to find what produces the best results for you. Here is the lowdown on what you'll need for sketching out your action poses, pencilling and inking your finished figure work.

### DRAWING TOOLS

Pencils, sharpeners, erasers and a light box are all you need to create successful line drawings.

In pencil speak, 'H' denotes hard, which means the line will be very fine and light. 'B' means soft, which means the line will be darker and thicker.

### PENCILS

The chart below gives an idea of the varieties of pencil lead available to you. Softer, darker leads such as B and 2B are generally considered best for sketching. For finishing figure work on art boards, use harder and lighter leads, such as 2H, H and F, to avoid smearing and smudging of the lead on the paper. Generally, you should work out the pose, proportions and facial expression with a medium-soft lead, then refine the figure with a tighter contour line, using an even softer lead to emphasise line weight, folds in the clothes, light and shadow. A clutch pencil (or lead holder) tends to use thicker leads of 2–4 mm (¹⁄₁₆–⅛ in). Most hold only one piece of lead at a time. Mechanical pencils come in three widths: 0.7 mm (thick line), 0.5 mm (the most commonly used) and 0.3 mm (fine line).

| 9H–7H | Extremely hard |
| --- | --- |
| 6H–5H | Very hard |
| 4H–3H | Hard |
| 2H–H | Medium-hard |
| F–HB | Medium |
| B–2B | Medium-soft |
| 3B–4B | Soft |
| 5B–6B | Very soft |
| 7B–9B | Extremely soft |

9H    5H    2H    F    B    2B    4B    7B

## SHARPENERS

Use an ordinary electric sharpener for sketching and drawing pencils, and a regular lead pointer for a clutch pencil.

## ERASERS

A kneaded eraser that you can shape into form is good for cleaning up pencil smudges and unwanted construction lines. For smaller areas, use a Pentel Clic or Sanford Tuff Stuff eraser. To remove pencil lines from larger areas, use a white plastic eraser.

## LIGHT BOX

A light box is a useful drawing tool that should be an essential part of your art equipment. A light box provides a brilliant under-lighting illumination on your piece of paper, making it easier to see a drawing on top of your art board. This allows you to trace loose pencil work from sketch paper onto a tighter contour line on your art board.

**DO** maintain good posture by keeping your back straight.

**DON'T** sketch flat for long periods of time, since your neck, shoulders and lower back will become strained by looking down at your work, thus creating bad posture over time from not sitting at your drawing table properly.

**DO** position your knees lower to simulate a higher seat and work surface. This is the most suitable position for long periods of sitting, with the muscles relaxed and the body in perfect posture.

**DON'T** sit it out if you are in pain. The recommended chair height is one-third of the artist's height, and the desk height one-half. Most people with back pain will find this uncomfortable, and for the first weeks you will only be able to sit like this for five to ten minutes, because your back muscles need training.

**DO** reduce back pain by moving to the front of the seat of a traditional chair, or by using a forward-sloping cushion. Most desks are far too low, and this may be improved by placing wooden blocks under the legs.

**DO** take breaks for five to ten minutes to stretch, and even go for a short walk while working long hours at the drawing table.

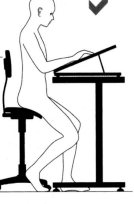

**DON'T**
Drawing in this position, with your paper flat on the desk, strains your neck and back, as well as giving a distorted view of your drawing.

**DO**
Sit upright at your desk and draw on a raised surface, tilted at a 45-degree angle.

## INKING TOOLS

As an inker, you'll need the right equipment for inking comics professionally. The following is a breakdown of useful tools and supplies.

### INKS

Pelikan Higgins, Speedball, FW Acrylic and Holbein inks are all suitable and available at most craft or art supply shops.

### TECHNICAL PENS

Rotring pens are very similar to Rapidograph pens. Rotring pens are best because they come with replaceable cartridges and don't clog as easily. You will find that you have to take the maintenance-heavy Rapidograph pens apart completely to clean them thoroughly. Both pen types come in several pen tip sizes.

### CORRECTION FLUID

There are several types of correction fluid, in both pen and bottle. Pelikan Graphic White, Pro White and FW acrylic all work for covering up ink while being opaque enough to ink over when dry. The Pentel Presto! correction pen is great for special effects after you've inked over your pencils. However, it doesn't work so well for actual corrections, it's difficult to ink over, and gives a rougher surface than standard correction ink. White gouache, although most commonly used for painting, is a reliable corrective.

## MAINTAINING YOUR TECHNICAL PEN

It is very important that you use your pen continuously, even if you are using it repeatedly, until your project is completed. Do not leave ink in your pen for an extended period of time. Here is a foolproof way to maintain your pen and always have it in a good working condition.

**1** Disassemble the pen parts.

**2** Use the nib wrench that came with your pen and remove the pen point from the body.

**3** Rinse the pen parts under a tap until no ink is evident.

**4** Store the pen tip and the pen body in a small container (a film canister works wonderfully) filled with household ammonia – any brand or type will suffice. Store until the next time you have a project to work on.

**5** When ready to start a new project, take the tip and body out of the ammonia. Wipe the parts and tap them gently onto a paper towel to remove the ammonia. No need to rinse; just add ink to the cylinder, assemble and begin writing. In just a few seconds the ink will cancel out any ammonia still left in the stainless steel tip, and you will have ink flow.

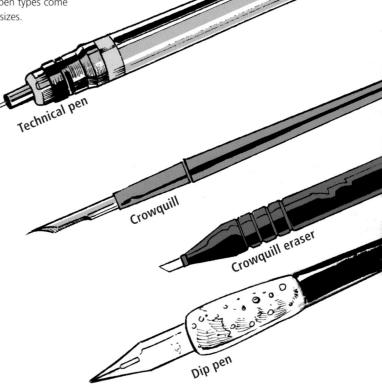

Technical pen

Crowquill

Crowquill eraser

Dip pen

### PENS

Hunt Crowquill, Gillot and Speedball pens with holders work best for inking comic book artwork. There are a variety of pen nibs ranging from fine point to coarse. Some pen nibs are more flexible than others. You may want to try a few different types to see what results work best for you.

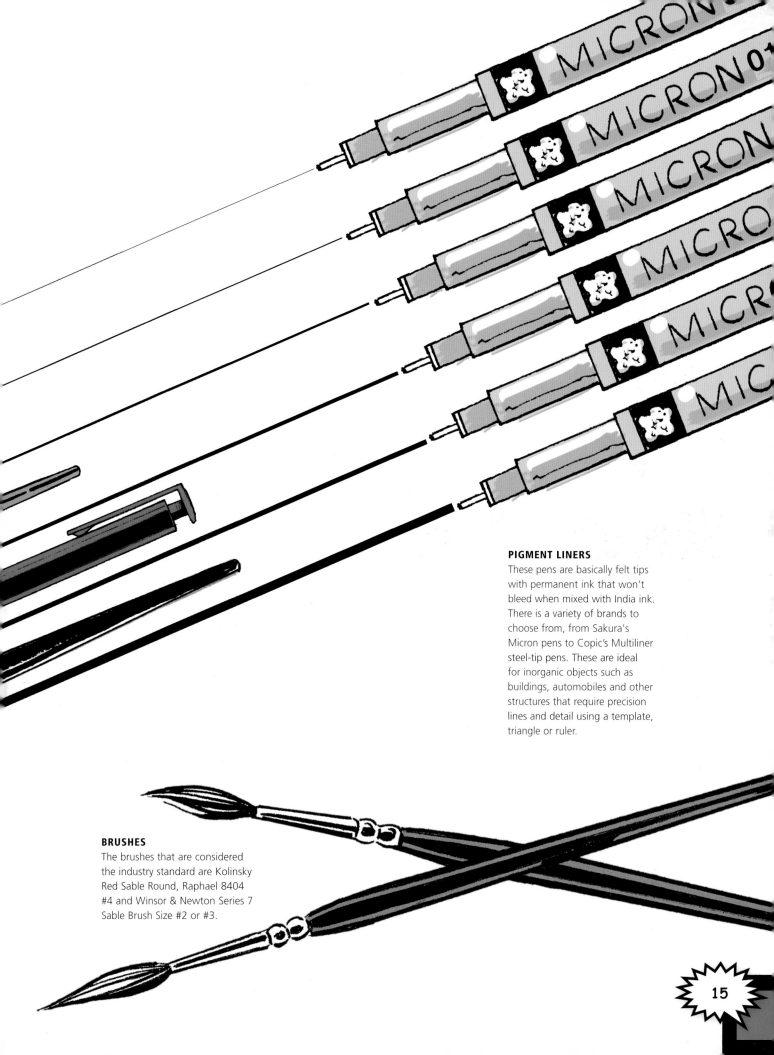

**PIGMENT LINERS**

These pens are basically felt tips with permanent ink that won't bleed when mixed with India ink. There is a variety of brands to choose from, from Sakura's Micron pens to Copic's Multiliner steel-tip pens. These are ideal for inorganic objects such as buildings, automobiles and other structures that require precision lines and detail using a template, triangle or ruler.

**BRUSHES**

The brushes that are considered the industry standard are Kolinsky Red Sable Round, Raphael 8404 #4 and Winsor & Newton Series 7 Sable Brush Size #2 or #3.

## TECHNICAL TOOLS

Whether you want to draw curves, ellipses and circles consistently and accurately, or want to take a photograph of a chosen model, these technical tools are your essential kit.

### FRENCH CURVES

A set of French curves is handy for drawing clean, curved lines in pencil or pen. They are useful for figure work, architecture, special effects and more.

### TEMPLATES

Circle and elliptical templates are great for word balloons, vehicle tyres and more. Get into a good habit of drawing clean, precise shapes throughout your comic book when they're called for.

### DRAWING COMPASS

A compass with a pencil and ink attachment is great for large circles of all sizes.

### PROJECTOR

Projectors primarily do one task for you; they project an image onto a work surface or wall for tracing, scaling and viewing. This allows you to size, view or lay out a particular composition with incredible speed and accuracy, while still maintaining creative integrity and control. Projectors are available in all types, shapes, costs and makes.

### USING A PROJECTOR

A three-step approach for enlarging or reducing a figure drawing.

**1** Place the original in the copy area of the projector.

**2** Enlarge the image by changing the projection distance.

**3** Adjust the lens to sharpen focus, then trace around the outline, drawing in as much detail as you need.

### STRAIGHTEDGE TOOLS

A 30- or 40-cm (12- or 15-inch) ruler, 45- or 60-cm (18- or 24-inch) T-square and a set of triangles (45/90-degree and 30/60-degree) can be used for pencilling and inking straight lines, as well as panel borders and special effects.

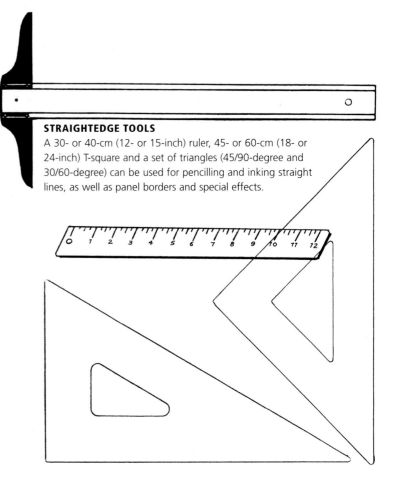

| Smart phone | Compact camera | Digital SLR |

## LIGHTS
The sun, indoor lighting, stage lighting, clamp lights and even flashlights are all equipment used to light your model.

## HOMEMADE REFLECTORS
Build your own reflector for lighting a model.

**1** ALUMINIUM FOIL
This highly reflective material can be found right in your own kitchen, and is great for when you need a strong bounce light. Simply wrap the foil around a big piece of cardboard, and glue it securely.

**2** CAR SUN SHADE
Car shades usually have two sides, a dark one and a lighter side. The lighter side is made of reflective material to bounce off the sun's harsh rays. This is a great option as a homemade reflector if you need ample bounced light. You can get one at any car accessories shop and, since it is often foldable, it is easy to carry around with you. Clip it to a light stand and angle accordingly.

**3** POLYSTYRENE BOARD
A big polystyrene board can be purchased at any craft shop and, though it's not made of a reflective material, the even, white surface is great when you need to softly bounce light. It gives off a very subtle reflection, and is good for lightly illuminating your subject.

## CAMERAS
Taking photos for reference doesn't mean you have to be a professional, or even take good pictures. These pictures are not going to be displayed in a gallery, they are going to be used for reference to help you improve your figure work. Any camera will work, from a portable mobile device to a decent point-and-shoot digital camera, to a DSLR (digital single-lens reflex camera, more commonly known as a 35 mm format camera). DSLRs are often preferred by professional photographers because they allow an accurate preview of framing close to the moment of exposure, and because they allow the user to choose from a variety of interchangeable lenses.

## PAPER AND TRACING PAPER
There are several types of paper made specifically for drawing the figure. Canson produces a series of comic book papers suitable for pencilling and inking, as well as Strathmore 500 series paper. Common paper types used are 2-ply semi-smooth or vellum surface. The semi-smooth surface is slightly textured, making it well suited for pen and ink tools, pencil, speciality pens and markers, while the vellum surface is slightly rougher, ideal for pencil rendering and dry-brush effects. A suggestion would be to try different types of paper to see which you like best.

It's always good to have some tracing paper on hand for sketching and refining drawings that can take a beating from erasing and redrawing. Tracing paper is ideal for transferring your loose sketches onto a light box and will create clean, revised line art.

**Canson tracing paper**

Essential tools and equipment

# COMPUTERS AND SOFTWARE

You will need image-editing tools to scan, edit, draw, ink, colour and letter your comics and graphic novels. The combination of traditional methods fused with technology has taken the production of comics to a new level.

### COMPUTER

In today's comic book industry, a computer is important a tool as any pencil, pen or brush. You'll also need a good internet connection for uploading files to clients and downloading images and other source material necessary for producing your comic book or graphic novel.

### SCANNER

A scanner is useful for scanning in your original art pages for editing on the computer. These days you'll need to scan your work to send to your editor or artist for inking, colouring or lettering your pages. Ideally, a large-format scanner (11 x 17-inch or A3 size) scanner is preferable to a standard (8.5 x 11-inch or A4 size) scanner.

**Scanner**

### PRINTER

There are benefits to having a colour printer: the last thing you want to see are mistakes in your book after you received it from the printer. Reviewing your artwork at print size helps you to see whether or not your art is reproduced properly. Another benefit of having a good colour printer is printing out your scanned pencils as blue line to ink over before scanning the inked page for editing. This method is insurance against making mistakes on the original pencil art when inking over it. This way, the artist has a digital file of the pencilled page to print out on good 2-ply paper suitable for inking. Many artists will scan their artwork after it's inked and then hand-colour work on the page. There are a variety of production options now at your disposal.

**Colour printer**

### DIGITAL TABLETS

Have you ever tried to draw detailed work with a mouse? It's extremely frustrating. Many artists these days use a digital tablet. They're available in many sizes, types and quality, depending on your expertise and your pocket. The industry standard is the pressure-sensitive 'pen' with interchangeable nibs that simulate the work of a pencil, pen, brush and marker. A high-end alternative is the Cintiq interactive-pen display tablet.

**Wacom tablet**

Most likely your computer didn't come with software that's created for making comics. The following software programs are considered the industry standard.

### Adobe Photoshop
An excellent program for scanning, editing, art cleanup, colouring and more. Pencillers, inkers and colourists use this quality software for producing their comics.

### Adobe Illustrator
Import your art page into this program and create word balloons, caption boxes, sound effects, logos, title fonts and dialogue for your comic book or graphic novel.

### Adobe InDesign/QuarkXpress
Either one of these page layout programs is excellent for assembling your completed comic pages for prepress.

### Manga Studio
This quality software was created specifically for the comic book artist for creating Manga and comics. The comics creation software offers cutting-edge drawing and colouring tools, making it essential for professional comic and Manga artists.

This free software offered by Google (http://sketchup.google.com), available for Windows and Mac, is a valuable resource for creating backgrounds. You can search, download and either build 3D models of backgrounds or download ones already made and ready to use. Models are ready to use and it is easy to navigate point of view.

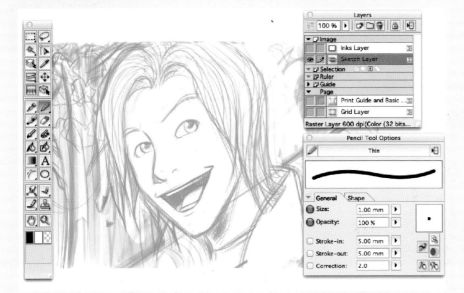

Manga Studio provides the artist with myriad drawing facilities. The underdrawing in blue line has been inked over in Manga Studio. The advantage of the digital method is the use of layers, which separates the sketched drawing from the ink work.

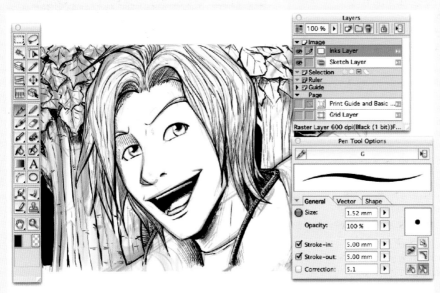

When the image is completed, the artist can hide or delete the sketch layer and save the image as the inked version ready for colouring and lettering.

Computers and software

19

# CHOOSING A MODEL

More often than not, the character and the story
you create will dictate the type of models you need
to photograph for reference material.

**DIVERSITY**
Show diversity with
your figure drawing by
working with models
from different cultural
and ethnic backgrounds.

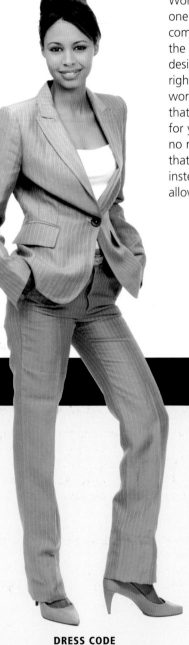

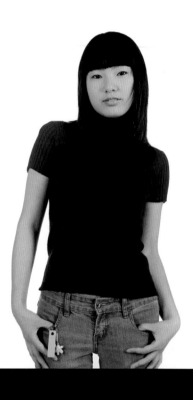

Working with models for photo reference can be
one of the most rewarding things about making a
comic book or graphic novel. It can also be one of
the most frustrating experiences. This section is
designed to give you some tips for choosing the
right model for your project, as well as how to
work with them. The goal is to produce photos
that work well based on the conceptual sketches
for your story, not to take great pictures. There's
no reason not to rule out a model, just remember
that photos should be used as a reference only,
instead of tracing the photograph directly. This
allows for consistency and creativity in your work.

**DRESS CODE**
It's good practice to
draw figures in different
clothing. This model
poses in business attire.

## 10 TIPS FOR WORKING WITH MODELS

**1 Build a rapport.** One of the quickest and
easiest ways to shoot with a model is to talk with
them like they are a real person, because they
are! Whether it's ten minutes before the shoot
or a week prior at a coffee shop, establishing a
verbal relationship will allow communication to
flow easily before and during the shoot. Show
them your sketches and talk with (not to) them
about what the character is experiencing in that
particular scene.

**2 Establish expectations.** There are two main
reasons you shoot: for photo reference and for
the model (to build their portfolio, for their fun,
for their client, etc.). Have your outline of the
scenes you need ready, as well as props and
costume, before the shoot. It will go much faster
and more smoothly, particularly if your models
are being paid by the hour.

**3 Co-create.** Your model is co-creating with you
for your characters in your story. Don't forget
that! They are not a prop. They should be
interacting with the camera based on the desired
outcome of the photo. Allow them some freedom
for input if you're unsure how the character
should be acting in your scene.

**4 Be clear.** Clearly explain what you need them
to do without being condescending. While a
model co-creates with you, they still rely on
direction and most photographers double as art/
set directors without even realising it. Explain
prior to shooting what the pose or situation
is, and elaborate by letting them know what
specifically to do, such as twist, turn and tilt their
head, shoulders or body, or rotate clockwise or
anti-clockwise. Communication is key.

## ATTITUDE

A model's attitude and pose can give your figure drawings personality that will reflect the type of character you're developing.

## BUILD

A model with a muscular physique is useful for heroic figures.

## HAIRSTYLE

Hairstyles can play a part in distinguishing characters from one another. A model with striking hair can help you to make stylistic decisions for your graphic novel.

## FACIAL EXPRESSIONS

A smiling model like this one will lead to the creation of a happy character. Don't shy away from directing your model to alter their facial expression if you need, in order to capture a different emotion.

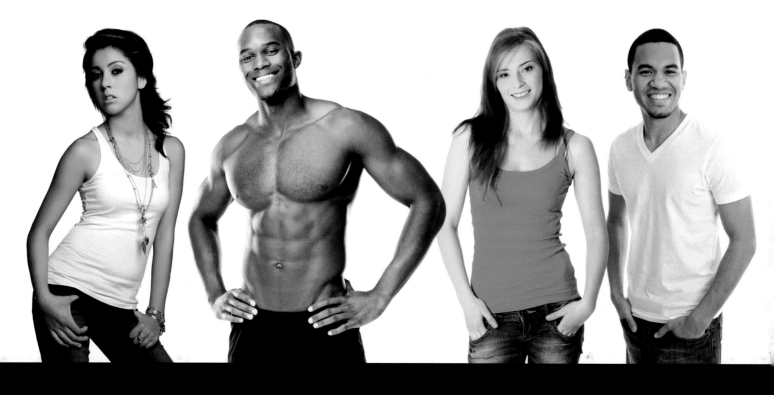

**5 Compliment and give reassurance.** It boosts morale for the model and anyone else on set when everyone is in a good mood.

**6 Pay attention to details.** If your character wears boots, see if the model can wear a pair of boots instead of trainers. Looking at these small details while you draw helps keep the focus on the character and not the model.

**7 Take a break.** Shooting isn't a five-minute job. There is a lot of time put into the execution of quality work. Taking a few five-minute breaks so that everyone can drink water, relax for a minute and unwind will not only help your model to perform better, but will give your arms a break from holding the camera up for hours on end. Keep water on set or location too!

**8 Never touch the model!** It's that simple. If clothing malfunctions – such as the end of a shirt sleeve rolls up or a dress strap becomes twisted – don't fix it; bring it to the model's attention and ask them to. Same thing goes with hair falling out of place or random eyelashes and lint on clothing. It's one thing if your friends are helping you out, but another if you hired models.

**9 Business and pleasure do not mix.** A photo set is never supposed to be doubled as speed-dating. Not only will you gain a bad reputation as a slime ball, you could lose business and lots of potential income. Stay professional.

**10 Stay positive and have fun.** You're shooting reference photos for your story, and the more prepared you are with your sketches of page layouts, the better the experience will be for you and everyone involved.

ARTIST IN RESIDENCE: LUKE ARNOTT:
## Drawing from life

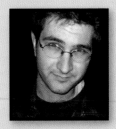

### ABOUT THE ARTIST

Luke Arnott wrote and illustrated independent comics before becoming a writer and academic. He has spent a decade writing online about entertainment, travel and technology. He has contributed to a wide variety of websites and publications, including AskMen.com, ConsumerSearch.com and *The Economist*. Luke's scholarly writing on comics has been published in the *International Journal of Comic Art*, and his current research looks at the relationship between virtual objects and narrative in video games.

Comic book artists need a solid grounding in figure drawing, no matter what genre they are writing and drawing in. Life drawing classes – and other anatomy references – are essential. Life drawing classes are an indispensable part of an artist's education. The stress on anatomy in many superhero comics makes experience with live models even more important, though alternative artists benefit just as much from such training.

Even if an artist's model isn't always available, comics illustrators should practise figure drawing from secondary resources, such as anatomy books or reference photographs.

### ADVANTAGES OF LIFE DRAWING CLASSES

The vast majority of English-language comics sold are superhero comics, filled with men and women with idealised figures. So it's understandable that aspiring comics artists would want to draw

**IN PRACTICE**
Attending a life drawing class or workshop will hone your drawing skills to render the figure, clothed or nude, for a better understanding of the human body.

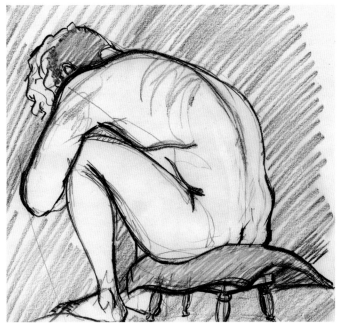

**WORK QUICKLY**
Sketching quickly and confidently will give you a feel for the shapes and contours of the human body.

characters with the proportional precision of an ancient Greek sculpture.

Though it's easy for aspiring artists to copy the muscle-bound heroes drawn by others, without a grounding in life drawing, artists can't get an understanding of how a human frame and musculature moves and hangs in real life. (Breasts, which unpractised artists draw like gravity-defying spheres, are the most obvious example.)

Creators of alternative comics, which often place a greater emphasis on realistic depictions of characters, can also benefit from practising their skills with live models. Even caricaturists and cartoonists need to master human figures in real life in order to distort and exaggerate them convincingly.

### ALTERNATIVES TO DRAWING LIVE MODELS

Even when aspiring artists are keen to draw live models, this is not always feasible. Life drawing classes can be expensive, or may simply not be available where you live.

Artists' reference books can be a good substitute, and can be especially helpful for teaching theoretical and anatomical points not covered in a regular life-drawing class. There are many books now available on drawing specifically for comic books, starting with the classic *How to Draw Comics the Marvel Way*. However, even the best of these manuals can be limiting, since they focus on figures with superheroic (i.e. unrealistic) proportions.

Another option is to find a reference manual of photographed figures, or an online figure photo service. While learning to draw from photographs isn't always ideal – artists can't see other angles, making it harder to depict depth – photos have advantages.

Artists can work with photos just about anywhere, and take as much time as they like. Also, photos allow artists to study hard-to-hold poses or motion shots that are impossible in a studio setting, but often perfect for using in a comic book panel.

In fact, combining life drawing with studying photos and reference books is the best way to gain the understanding needed to depict convincing, dynamic characters in comic books.

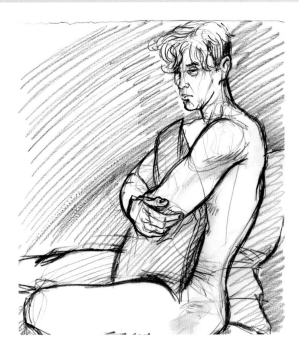

### ATTENTION TO DETAIL

You might find a particular aspect of the model interesting. Here, the artist has spent considerable time on the hand and the foreshortened arm; all good practice for figure drawing.

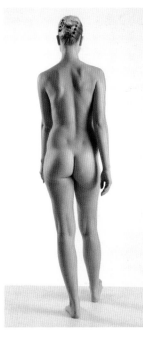

### APPLICATION

Sometimes you will find you can apply your life drawing sketches straight into your comics, as with this nude.

23

# BUILDING A REFERENCE LIBRARY

While there are plenty of sites that offer royalty-free images or let you pay for the usage or limited copyright, it is important that you get into the habit of collecting your own reference materials.

## WHY BUILD A REFERENCE PHOTO LIBRARY?

In case you're asking yourself why should you go to all this trouble, especially when there are so many sites where you can purchase the rights for photo usage, well, here are three good reasons why you should start today.

1 Connects you with your work
2 Avoids legal issues
3 Professionalism

Collecting your own reference photos will definitely aid in your ability to connect with your art. And if you connect with it, the chances are collectors will also. You'll rest easy knowing that if someone tries to make a claim against you, you have your own reference material to back it up.

If you have not already done so, start to build your own reference library by taking your own photos. Photos found online or in old *National Geographics* (or any other magazine, no matter how obscure) don't count, except as illegal. Do not trace them directly from the source; instead sketch freehand and alter what you need for your composition. There's no need to take all the details from the photograph; keep it simple and use only what's relevant to your story.

**DESIGN WALL**
A reference library enables you to organise and catalogue photos. A design wall helps you keep track of your progress as you sketch, draw and ink your figure work until it is ready for publication.

## WHAT'S THE DIFFERENCE BETWEEN ROYALTY-FREE, COPYRIGHT-FREE AND PUBLIC DOMAIN?

The defining characteristic of copyright infringement is if the average viewer, when looking at the two works, sees a similarity. The copying need not be exact. So, if you feel you must use someone else's photos, you need to be careful. And you need to know the difference between royalty-free and copyright-free, according to Wikipedia:

• **Royalty-free** is a term employed in negotiating the right to use creative content, such as photographs, video or music. The term royalty-free means that once the content is licensed under a set of guidelines, the licensee is normally free to use it in perpetuity without paying additional royalty charges.

• **Copyright** is the set of exclusive rights granted to the author or creator of an original work, including the right to copy, distribute and adapt the work. These rights can be licensed, transferred and/or assigned. So **copyright-free** is a conventional expression extensively used in Japan by authors whose works can be used freely regardless of copyright. It is distinguished from public domain.

• Works are in the **public domain** if they are not covered by intellectual property rights at all, if the intellectual property rights have expired, and/or if the intellectual property rights are forfeited or unclaimed.

**FLAT FILE**
A flat file is an invaluable piece of furniture for your studio and is ideal for storing photo references.

**1 Think ahead.** Organise your photo references into categories before you start to draw.

**2 Keep an image bank.** Never throw out a magazine without cutting out good photos you might use for reference in the future – and not just pictures of fighter planes and mountains, but photos of interesting or difficult poses, like holding a phone or shaking hands. Organise your clippings by subject and keep them in a file cabinet or scrapbook.

**3 Point and shoot.** Take as many pictures as you can of the subjects you intend to draw, from as many angles as possible.

**4 Look online and offline.** Visit your local library for books, newspaper archives and photographs you can use for your story. Look on the internet. It is a vast resource of photographs that's just a click away.

**5 Build models** of cars, planes, ships and small dioramas you may use frequently throughout your story. The advantage of these models is that you have three-dimensional examples of your subject from every angle to work from.

**6 Watch movies.** Movies are a great resource for capturing angles of people in various light and shadow. If you have a desktop computer or laptop that plays DVDs, or the ability to download a film, television show or documentary, find a scene that works well as reference and take a screen capture of it. Print it out and now you have another resource to work from.

**7 Visit local museums** and bring a sketchbook. Be prepared to draw anything you see that might interest you. You never know when you'll be using those sketches as subjects in a comic book or graphic novel.

**8 Don't limit yourself** to only one photo reference of the subject. You need views from all angles, and you shouldn't feel limited to a specific pose. Keep in mind that no one becomes a comic book artist or cartoonist as a result of one drawing. It takes time, patience, motivation and work. Make mistakes and learn from those mistakes. And drawing and drawing, and then drawing some more, leads to improvement.

**9 Don't be a slave to the reference.** Having only photo reference means drawing the same thing with no variations, because you don't know what the subject looks like from different angles. When that happens, the reference is using you, instead of you using the reference.

**10 Go to a workshop.** Figure-drawing workshops are a great place to take photos and sketch figures in various poses and costumes. Check with your local universities, art galleries and even comic book shops on where a figure-drawing workshop might be taking place.

**SKETCHBOOKS**
Sketchbooks are great for jotting down your ideas and concepts. Never throw away your sketchbooks. Store them in your studio for when it is time to start developing those ideas into stories.

**WORKSHOPS**
Build a reference library from drawings created at a life-drawing workshop.

Building a reference library

# 2 THE HEAD AND FACIAL FEATURES

One of the most important drawing skills a comic book artist can develop is the ability to draw facial expressions and heads. The step-by-step instructions throughout this chapter are intended to serve only as a springboard to help you to continue your development of drawing figures in general.

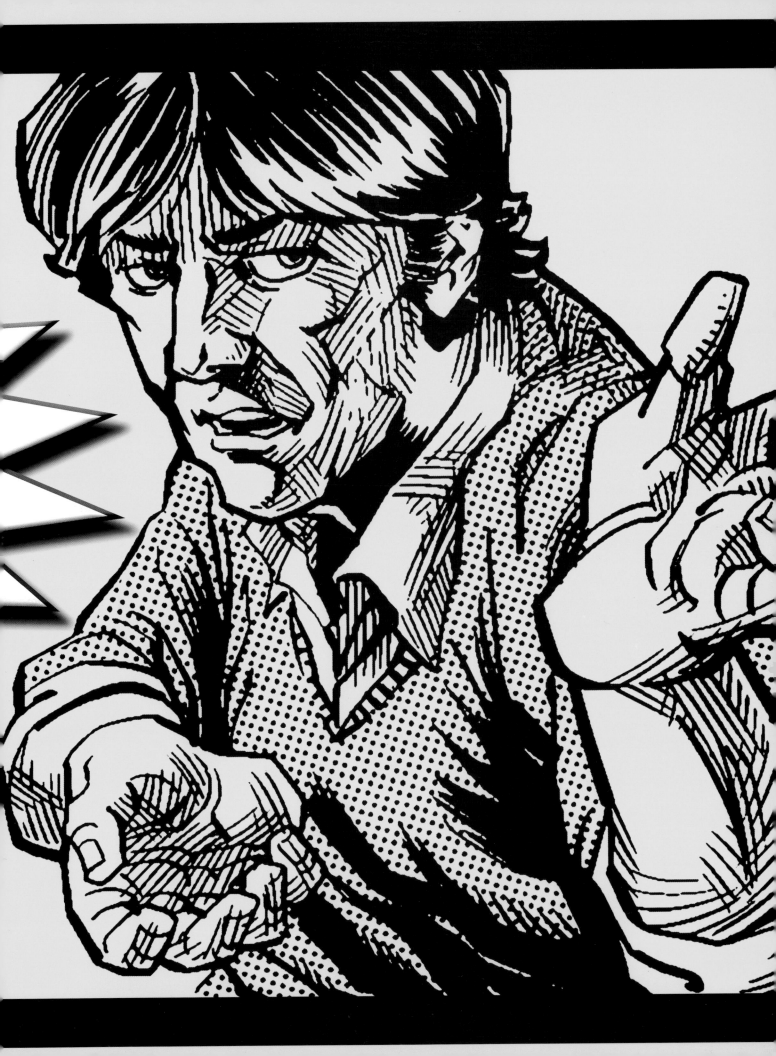

# CONSTRUCTING THE HEAD

Regardless of whether you are drawing a male or a female head, the underlying head construction is the same. These pages show you how to construct the head in profile, head-on, from the back, from above and below and at a three-quarter angle.

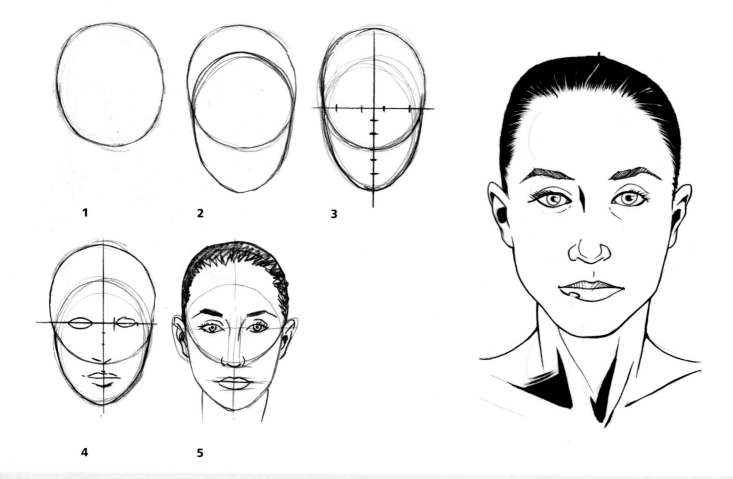

1

2

3

4

5

## FRONT VIEW

The proportions of a head will vary from person to person and change slightly with age, but there are some basic principles you can follow to improve your drawing.

**1** Draw a circle.

**2** Add an oval within the circle until your shape looks like an egg with the small part pointing down. This will be the chin of your character.

**3** Draw a horizontal and vertical line to divide the head into quarters. Divide the horizontal line into quarters and divide the bottom half of the vertical line into fifths.

**4** Place the eyeballs between the two marks on the horizontal line. Sketch the nose line on the second mark down and the mouth line between the fourth and fifth marks on the vertical line.

**5** Add eyebrows and lashes (for a female). Line up the bottom of the ears with the tip of the nose. Draw some loose lines to indicate a hairline or hairstyle.

The approach to drawing the basic shape of the male or female head is the same, structurally speaking. However, personality, age and facial features play a part in composing the head shape of a character to distinguish one from the other.

### Look around you

Faces can be any shape: rectangle, pear, triangle, balloon. Take a look around you and observe the various shapes of male and female heads. Keep in mind that the more you exaggerate the shapes, the more stylised or cartoony your characters will become.

### Think about volume

When creating heads, think about the volume, meaning that they're three-dimensional, and learn how to draw them from just about every angle imaginable. Volume is created by establishing two planes of the basic shape. Imagine a face that you draw straight on – looks flat, doesn't it? Now imagine the same face with a three-quarter view, essentially in two-point perspective (see page 75), or as two sides of a cube. You've gone from a shape that has one plane, like a square, to multiple planes, like a cube. See, it all comes back to the basic shapes.

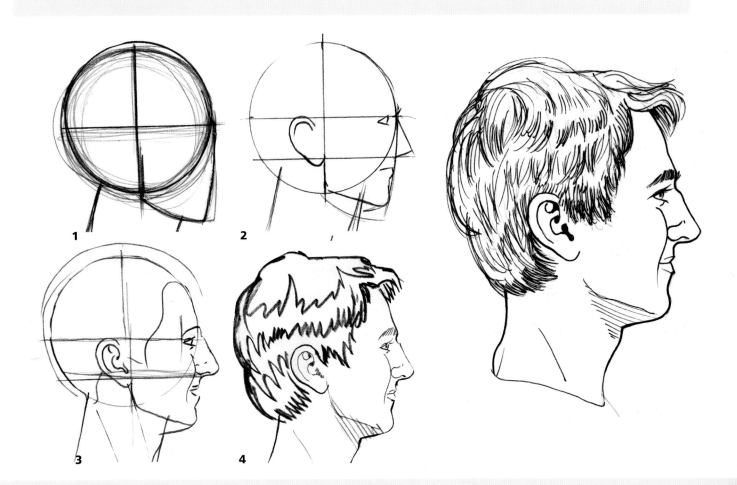

### PROFILE

When drawing a person in profile, notice where the features line up. It is key to getting the proportions of the head drawn correctly.

**1** Draw a circle and divide it into quarters. Carry the vertical line through the bottom of the circle. Draw a diagonal and bring the line up to meet with the horizontal line, creating the jaw line.

**2** Establish the eye line on the horizontal line. Draw another horizontal line starting at the point where the bottom of the circle and jaw line intersect to the vertical line for what will be the bottom of the nose. Add the ear from the back of the jaw line and draw it up over the eye line.

**3** Lightly draw in the eye on the horizontal line and add a nose between the two horizontal lines. Note how the back of the nostril lines up with the front of the eye. Divide the vertical line that sits between the bottom of the nose and the chin in half. Establish the upper and bottom lip. Let the upper lip protrude out slightly more than the bottom lip and draw it at an angle.

**4** Add the features and the head details. Notice how the line just below the bottom lip goes in at a diagonal and comes out again before curving into the jaw line.

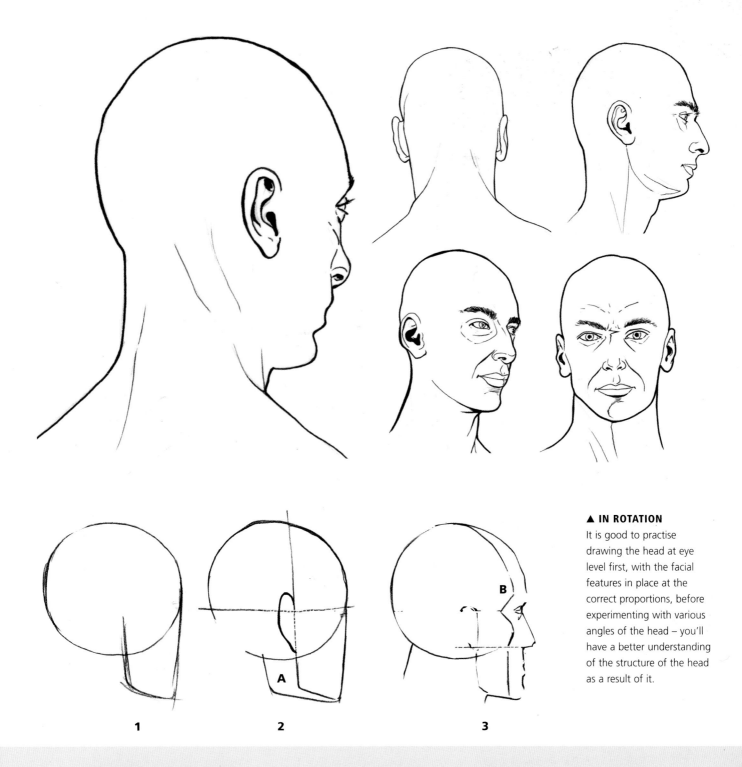

**▲ IN ROTATION**
It is good to practise drawing the head at eye level first, with the facial features in place at the correct proportions, before experimenting with various angles of the head – you'll have a better understanding of the structure of the head as a result of it.

**1**    **2**    **3**

**THREE-QUARTER REAR VIEW**
The foreshortened male face from this point of view is not difficult to draw once you understand how to apply the steps shown here. The key to understanding what is happening is the ear, since it determines what parts of the facial features are exposed to your point of view.

**1** Draw a circle and then a 'jaw' similar in shape to the profile, but narrower.

**2** Bisect the shape horizontally. Add a plane (A) representing the far side of the jaw to guide you for the view you've chosen to draw.

**3** Lightly block in a plane line (B) that will show you where the side of the head meets the front. Location of the features is identical to the profile, but you will not be able to see the full eye, nose or lips. This is key to proper three-quarter rear view illustrations of the head.

## FEMALE CHARACTERISTICS

❯ Keep the nostrils small.

❯ The eyes and mouth must be in perfect placement.

❯ Brows: thick or thin? Follow the trends of fashion.

❯ Voluptuous lips; do not draw flat lips.

❯ Bone and muscle less apparent in women's heads than men's.

❯ Woman's eyebrows are usually higher than men's are.

❯ Mouth is smaller than a man's.

❯ Eyes are slightly larger than a man's.

❯ Less emphasis on jaw and cheek muscles than with a man's head.

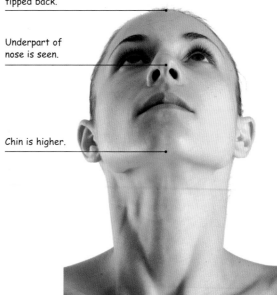

Hairline disappears when head is tipped back.

Underpart of nose is seen.

Chin is higher.

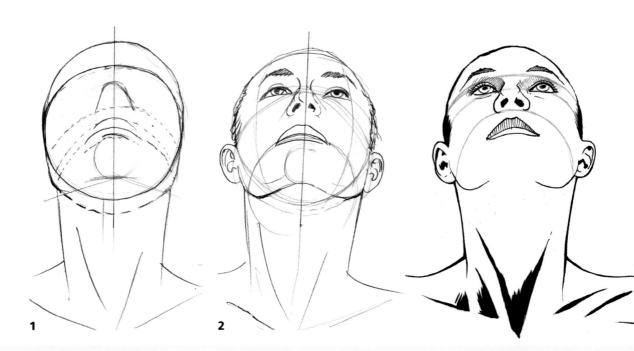

**1**                    **2**

### WORM'S-EYE VIEW (UPSHOT)

Your characters won't always be at the reader's eye level. For this reason, it is important to learn how to draw foreshortened views of the head. This angle is known as a worm's-eye view (or upshot) because the camera is looking up at the character.

**1** This type of head angle is drawn foreshortened. Begin by drawing a circle, jaw (curved line) and a vertical line down the centre that divides the head in half. The curved lines help determine where the features will go. When first learning to draw foreshortened heads at an angle like this, practise working from a photo, such as the one depicted above.

**2** Add in the features. The difficulty of this front view at an angle is learning to draw the underside of the jaw and chin correctly. The key is to follow the proportions of the head. Use photo reference if it helps you draw in the features correctly.

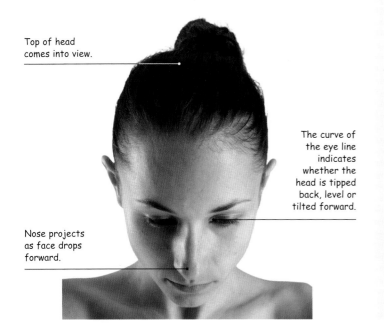

Top of head comes into view.

The curve of the eye line indicates whether the head is tipped back, level or tilted forward.

Nose projects as face drops forward.

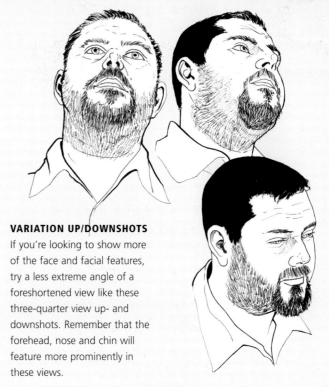

## VARIATION UP/DOWNSHOTS

If you're looking to show more of the face and facial features, try a less extreme angle of a foreshortened view like these three-quarter view up- and downshots. Remember that the forehead, nose and chin will feature more prominently in these views.

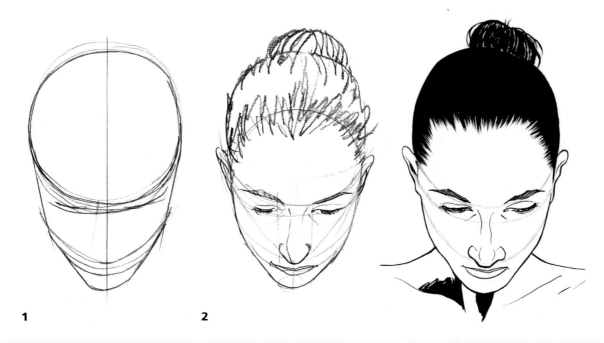

**1**       **2**

## BIRD'S-EYE VIEW (DOWNSHOT)

When the camera is looking down at a character, it is known as a 'bird's-eye view' (or downshot).

**1** Start by drawing an upside-down egg shape. Add a jaw line on the smaller end of the egg, making sure your lines follow the form of the shape. Add several curved lines to indicate where the features will be drawn in. Again, a photo reference is provided to work from for this demonstration.

**2** Add in the features. Make sure you apply the features proportionally. Emphasise the form of the head with contour lines of various thicknesses – this will give weight and depth to the head structure.

Constructing the head

33

# EYES AND BROWS IN DETAIL

The eye is basically a ball, set in a socket of the skull and covered by lids of definite thickness. The placement of the eyebrow in relation to the eye is important in getting the right expression.

In comic books, the eye can be simplified to a dot within a circle. The placement of the dot within the circle determines the direction of the gaze. Study the steps and examples on these pages and do some real-life observations by making faces in a mirror until you are thoroughly familiar with the action of the eyes and brows in expressing different attitudes and emotions.

**EXPRESSIVE EYES**
Eyes can express so much on their own. This wide-eyed man expresses surprise. Notice how the muscles around the eyes and cheeks stretch as his mouth and eyes open.

**DRAWING A CONVINCING EYE**
Eyes are fairly easy to render in five basic steps as shown.

**1** The basic shape of the human eye is the football ellipse. Draw a horizontal line from corner to corner.

**2** Slightly flatten the top left and bottom right corners.

**3** The outer or right corner may be lifted a little above the original centre line (optional).

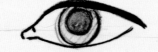

**4** Lightly sketch in the iris and the pupil within this shape by determining the direction of the gaze. Make a slight wedge-like line on the inside corner. Make the top curve of the eye slightly heavier in line weight to the contour line.

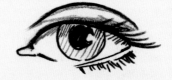

**5** Add the light and dark values to the iris and pupil (optional). Add the eyelid and lashes as needed. The upper lid casts shadows over the iris. Add your highlight to the iris by using opaque white or an eraser.

## REALISTIC RENDERINGS

Rendering realistic eyes begins with understanding how the eyeball and the eyelid work together. The eyeball, iris and pupil don't change, but the way the eyelid behaves over the eyeball creates a variety of expressions.

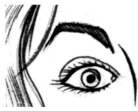
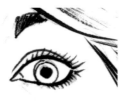
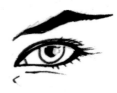

The wide-eyed expression of the eyes and brows suggest a surprised or startled look.

The brows draw in on slightly closed eyes to demonstrate a determined expression.

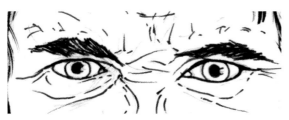
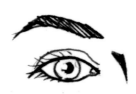
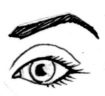

Furrowed brows move in close on top of the squinted eyes. Wrinkles around the eyes express anger.

The raised brows and eyelids suggests this person is in a pleasant mood.

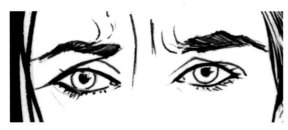
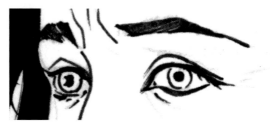

The slightly furrowed brows and compressed eyelids indicate a worried look.

In a three-quarter view, the worried expression to the left is further emphasised by prominent lines between the character's brows.

## DIRECTING A CHARACTER'S GAZE

In its most basic form, the eye is a ball with lids enveloping it. The lids open to reveal more of the iris and pupil, or close to expose less.

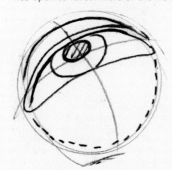
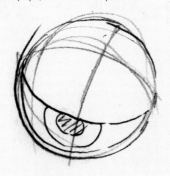
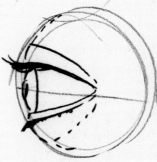
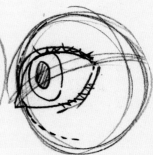

The angle of the eye reveals more of the lid underneath (looking up)...

...or above (looking down).

Drawn in profile, the eye reveals the cornea as a curved disc on the eyeball.

The eye can move up, down or sideways. At this angle, the eye is drawn in perspective as an oval.

### EXPRESSIVE EYEBROWS

Characters are only effective if they demonstrate personality. Eyebrows are the most useful way of expressing your character's desires and vulnerabilities.

**1** Dubious
**2** Sinister
**3** Terrified
**4** Agony
**5** Surprised
**6** Sarcasm
**7** Determined
**8** Smug

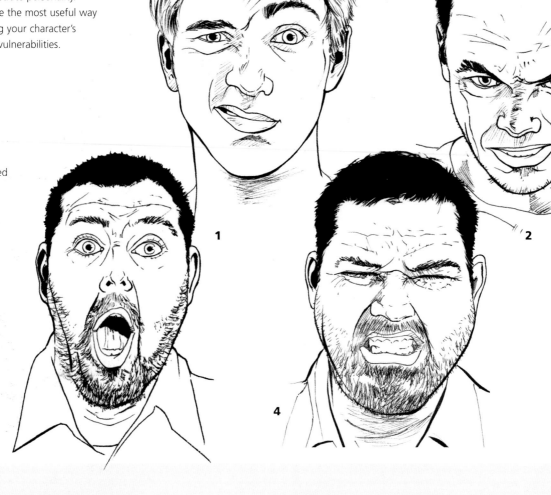

# EARS IN DETAIL

The ear listens to gossip, brushes against revolving doors when it sticks out too far and serves as a mooring for strange-looking earrings. It can contribute to the character of the head (the cauliflower ear of the prizefighter is a good example) but not to the facial expression. In its natural state, the ear is complicated – full of confusing ridges and convolutions – but, since simplicity is the essence of comic book drawing, we can streamline it down to its overall shape and very little else.

### IN ROTATION

The images depicted below show the same ear from different angles. Notice how the 'Y' shape changes shape as the ear changes shape and, in some cases, disappears completely.

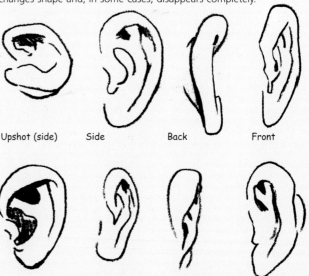

Upshot (side)   Side   Back   Front

Three-quarter view (front)   Three-quarter view (front)   Downshot (back)   Downshot (front)

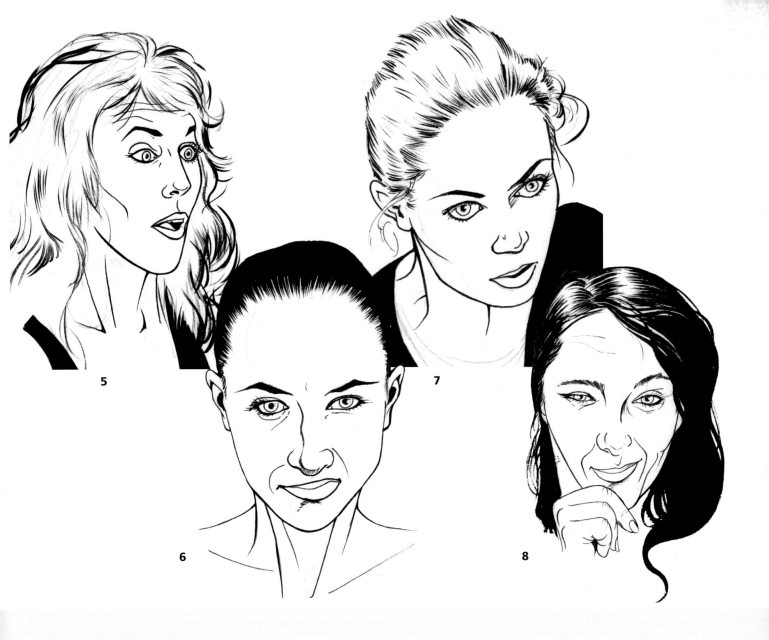

5

6

7

8

## DRAWING A CONVINCING EAR

A simple ear is made up of a 'C' shape, a 'Y' shape and a 'U' shape, as shown below.

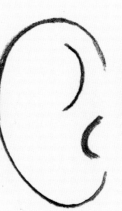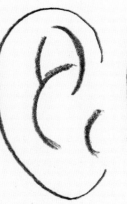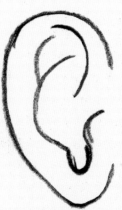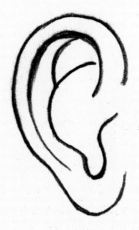

**1** Lightly sketch the 'C' shape.

**2** Draw a curve as shown on the inside and one pointing outside.

**3** Add the 'Y' shape.

**4** Add the 'U' shape.

**5** Add the back line or 'rim' line.

# NOSE IN DETAIL

The nose is an interesting and funny-looking feature. It gets involved in other people's affairs, it smells various scents from perfume, smoke and delicious food, and it sounds like a tuba at times.

There are four simple nose shapes. By combining certain traits from each, you can create countless variations of the nose. Experiment with these combinations, sketch many and have fun creating some of your own unique noses that reflect the personality of your figure.

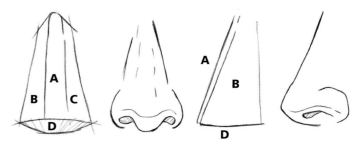

**NOSE CONSTRUCTION**

All noses have one frontal plane (A), two side planes (B, C) and a bottom plane (D). In order to draw these noses from any angle, apply the steps demonstrated below and use basic shapes to establish the planes of the nose in perspective before adding the details. Some noses will not show all the planes from every angle.

**DRAWING A CONVINCING NOSE**

Create a convincing nose in four easy steps as shown.

**1** Begin by drawing a right angle. Draw a vertical line down, then left or right horizontally, before connecting the two. Make sure you give your nose tip a corner.

**2** Give the diagonal line a bit of personality by varying the line thickness. Start from the top, curving it out a bit. Follow with a slight indentation before curving back out to the tip.

**3** Draw in the nostril. Give consideration to whether you're drawing a female nose (less pronounced) or a male nose (more defined, more lines, more pronounced).

**4** Finally, render the nose to give it a personality that reflects the type of character it may be featured on. Note the emphasis of line weights from thick to thin due to the light source from above.

**FOUR BASIC NOSE SHAPES**

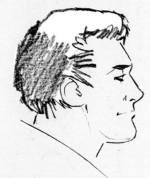
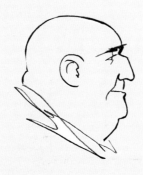
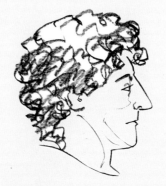

**REGULAR** (normal bridge): This has no special trait but can be enlarged or reduced in size in relation to the size of the head for comic effect.

**ROMAN** (high bridge): Indicative of its cultural ancestor, the base for the bridge of the nose is reflective of a native American or a pretentious person.

**GRECIAN** (no bridge): The nose and forehead are structured into one another for a tyrannical look. This type of nose is stylised for draconian characters.

**PUG** (low bridge): Neither sharp, nor hook-like, nor wide, but extremely short in length, this nose is known as a pug (or snub) nose.

## PLACING THE NOSE ON THE FACE

If lines are drawn from eye corners to lip corners, the crossing point will be the nose tip. This applies to a frontal view only. The height of the nose is approximately half of the distance between the eye line and the chin.

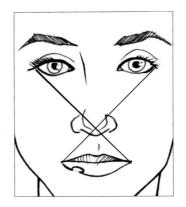

## EXAGGERATED NOSES

Exaggerating noses in shape and size can lead to some wonderfully peculiar characters and expressions.

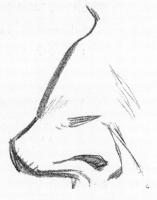

This profile nose is typical of an older man: large nostrils, prominent tip and angular bridge.

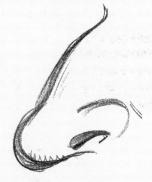

The tip of this nose points downwards.

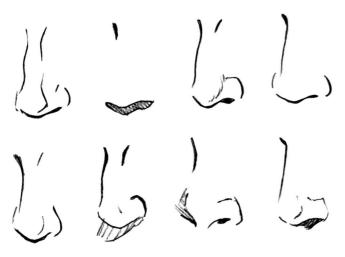

## THE MALE NOSE

The male nose is wider and more angular than the female nose, as these rough sketches indicate.

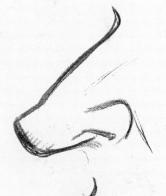

Here, the tip of the nose is extra-angular for comic effect.

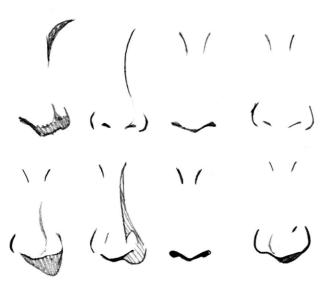

## THE FEMALE NOSE

The female nose tends to be a bit thinner. Draw the spacing of one eye width between the eyes and reduce it slightly to give you a good proportion to use for the width of the female nose. Generally, the female nose will not push out from the face as much as the male nose.

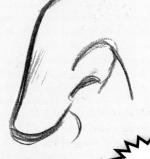

An extremely exaggerated downward-pointing nose.

39

# THE MOUTH AND CHIN IN DETAIL

As you draw the mouth and chin, you will probably find your own moving as you draw one on a character. It means that you are getting a little personality into your drawing.

The mouth smiles, grins, snarls and bellows with laughter. The chin is an important part of the face. With it you can indicate weakness, strength or weight. The chin also gives you an opportunity to add personality to your character – it can be exaggerated in size or left out altogether. Just keep in mind that the chin, mouth and nose should more or less fit together.

**DRAWING A CONVINCING MOUTH**
Draw a convincing mouth in three easy steps.

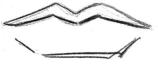  

**1** Less is more when drawing mouths. Try to use as few lines as possible when drawing the basic shape of the mouth.

**2** Add in some shading to the upper lip and a little more emphasis to the contour lines to thicken them up a bit.

**3** Accentuate the mouth by shading underneath the bottom lip. Add texture to the bottom lip with light pencil lines.

**TYPES OF MOUTH**
You can achieve a variety of different expressions by altering the way the lips move. The top lip has its characteristic bow shape, which varies considerably from person to person. The bottom lip is usually larger than the top and is more creased with vertical stretch lines.

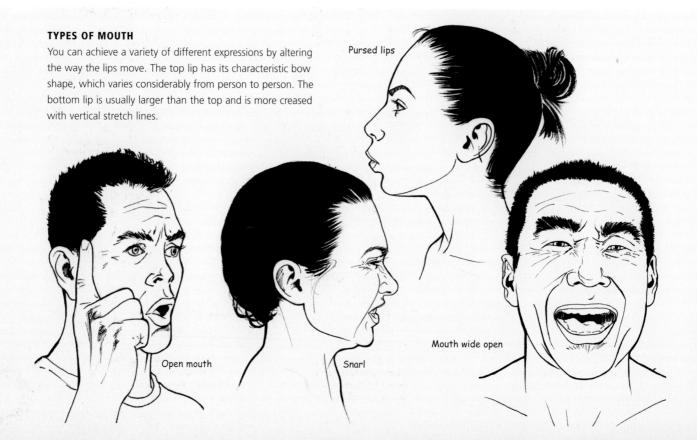

Pursed lips

Open mouth

Snarl

Mouth wide open

## FIVE TYPES OF CHIN IN PROFILE

The chin is a vital part of the face. With a little practice, and by experimenting with various types and sizes, you can render a character to appear timid, overbearing, powerful, overweight or funny.

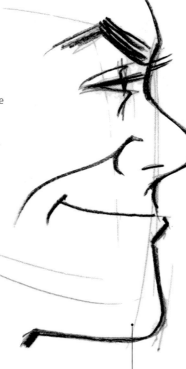

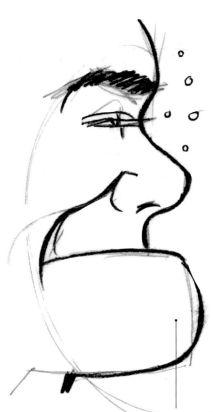

Qualities of the heroic chin are a strong, square jaw line. This is indicative of a bold personality or a good Samaritan.

An aggressive figure may have a chin that juts out at an unfavourable angle to reflect their unfavourable personality.

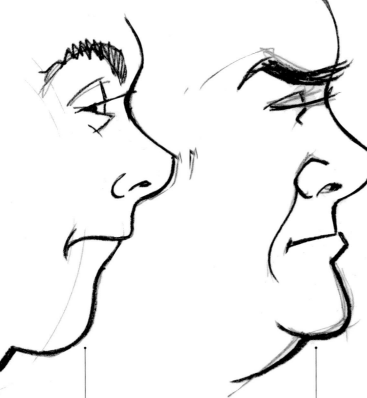

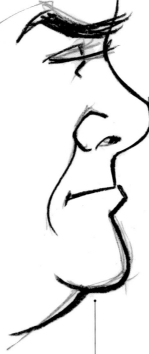

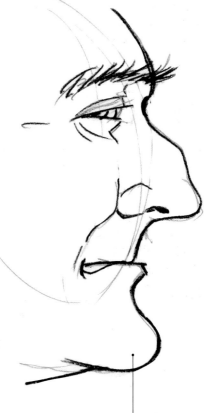

A receding chin with practically no jaw line suggests a feeble or weak character.

A double chin implies that the character is overweight and may have a wily personality.

Old age may cause a loss of teeth, which means that the chin recedes.

# FACIAL EXPRESSIONS

As discussed previously, the eyes, mouth and chin are keys to changing moods. Raised eyebrows, the frown (a line between the eyebrows), droopy lids, lowered eyebrows, closed eyes, pursed lips, a scowl or growl – all help you get across the expression you want.

Sketch light, sketch fast, get the simple lines down to establish the facial expressions you're creating for your character. Follow the old stage actor's creed: always play to the back row. Make sure your reader knows what your characters are saying, thinking and feeling by their expressions and body language. Whether subtle or exaggerated, your character's emotions should always be apparent. The mouth in particular – accented by cheek and lip lines – is a vital part of any expression.

## BUILDING A FACIAL EXPRESSION

The steps illustrated here show how the shorthand example of anger (below left) is developed into a realistic angry face.

**1** Lightly sketch the basic shape and contour lines that make up the features of the facial expression. To draw an angry facial expression, be sure to accentuate the key features, such as the lines in the forehead, furrowed eyebrows, squinted eyes, protruding cheekbones, scrunched-up nose, gritted teeth and protruding chin.

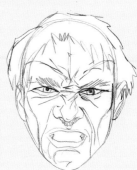

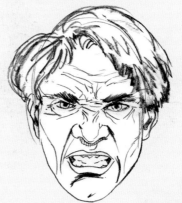

**2** Emphasise the contour lines. Establish a light source (here, frontal) and add line weight under the dishevelled hair, eyebrows, eye sockets, cheekbones and under the nose and lips.

## SHORTHAND FACIAL EXPRESSIONS

Refer to these shorthand facial expressions as you create your figures; although puerile, they are the foundation of all well-rendered facial expression.

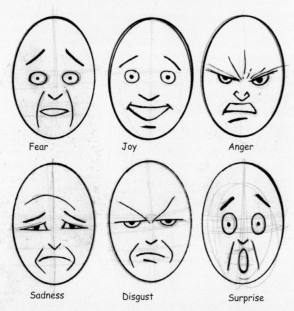

Fear   Joy   Anger

Sadness   Disgust   Surprise

**3** Add contrast by inking in solid black areas, such as the shirt, eyebrows, pupils and the thick brushstrokes in the hair. Draw in some muscles around the neck area – this communicates strain and tenseness, which are characteristics of anger.

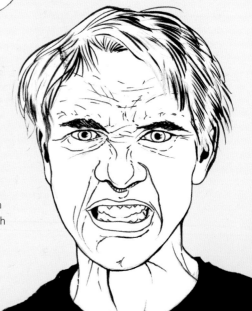

## FROM SHOCK TO ANGER

The wide eyes and open mouth, coupled with the emphasis on the cheekbones, displays a convincing look of shock (1). The brows slowly come down in the following drawings, expressing disbelief (2), disapproval (3) and, finally, anger (4).

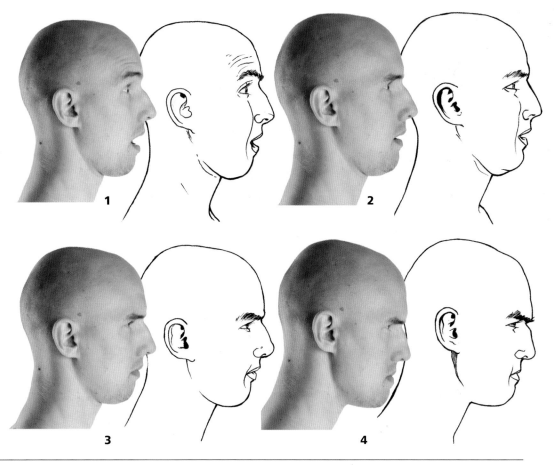

**1**

**2**

**3**

**4**

## FROM JOY TO DISBELIEF

This opening three-quarter view displays a convincing look of surprised joy (1). It is as if this girl has seen a long lost friend. Drawing 2 depicts the same expression, except the straight-on view reveals muscle definition in the neck, and the eyes reveal a self-consciousness, as if the girl wishes she hadn't spotted the friend after all. A sudden change of expression in drawing 3 reveals a confused disapproval. Perhaps the friend isn't a friend after all? The dishevelled hair compounds the woman's disbelief in drawing 4.

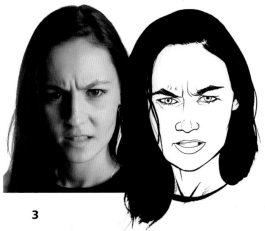

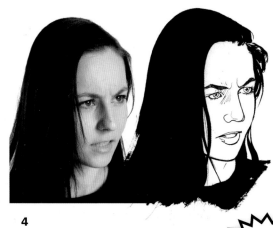

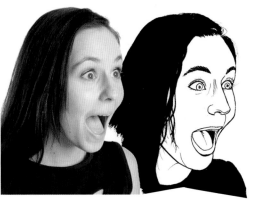

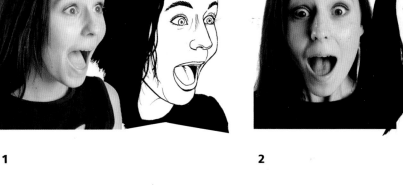

**1**

**2**

**3**

**4**

### DISGUSTED
Notice the lines in the forehead, and around the mouth and neck. The eyes are squinting and the brows curl. This man feels disgust.

### JOYOUS
The laughter is compounded by his eyebrows and big smile that raise his cheek muscles, creating small wrinkles around his eyes.

### STRICT
The man is shouting 'No!' The brows, furrowed forehead, the protruding lip and the raised hand reinforce the expression.

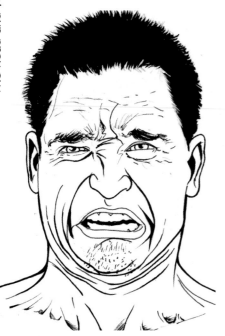

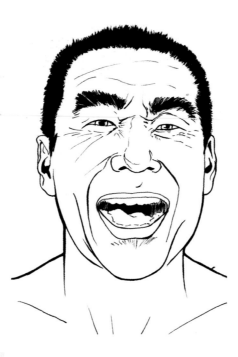

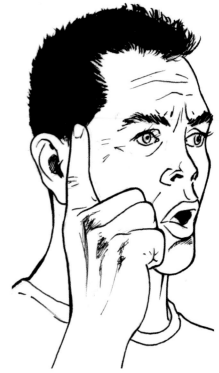

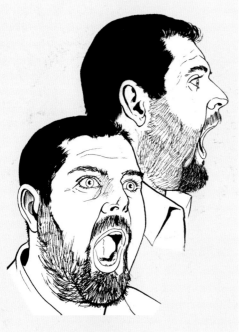

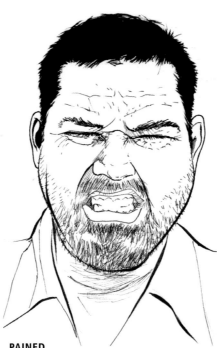

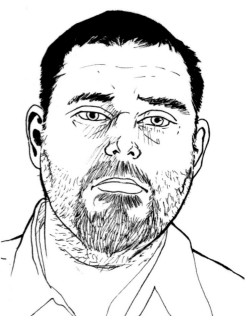

### DUMBFOUNDED
The look of surprise in this man's profile view works well due to the wide opening of his mouth, which raises his nose. The raised eyebrows add to his surprise. A three-quarter view gives the reader more of the surprised man's face. Notice the wide eyes, raised eyebrows and lines in his forehead.

### PAINED
Note how the eyes are closed tightly, and the teeth gritted, emphasising the strain on the forehead and teeth.

### INDIFFERENT
This neutral expression displays a relaxed face.

## COY

Wide eyes, raised eyebrows and puckered lips illustrate coyness. Her neck muscles are defined as she puckers up for a kiss.

## STOIC

The stoic manner of the woman's face is emphasised by an elegant jaw line and soft features. The pulled-back hair may suggest a more serious tone.

## REPULSED

The profile view of the woman's disgust is compounded by the lines representing wrinkles around her squinted eyes, nose and mouth. The eyebrows curve down towards her eyes.

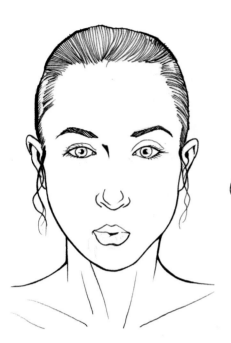

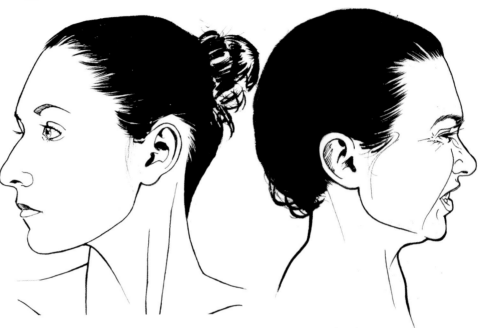

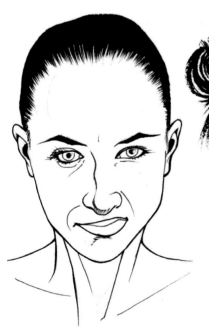

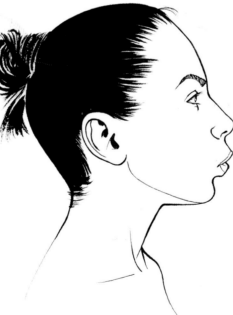

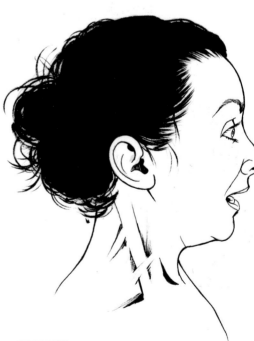

## DISDAINFUL

The curl of the lip, the raised cheek muscle and the defined cheek lines all support her attitude.

## AFFECTIONATE

This profile view suggests a woman puckering her lips in a kiss. Her eyebrows are raised and eyes are wide open, but they could equally be closed.

## SURPRISED

The woman's surprise is emphasised by the muscles in her neck, and by her lower jaw, which is open as her chin recedes into her neck. Notice the line running from her nose to the corner of her mouth, formed by her wide-eyed stare.

# DRAWING HAIR AND FACIAL HAIR

When you draw hair, remember this important point: be sure to draw the outline of the top of the head in pencil before you put hair on it. Many beginners draw the face and then pile a stack of hay on top for hair. They forget that there is a solid head under the hair, and create a head that is out of proportion.

### HEAD HAIR

Hair, or the lack of it, can indicate the type of character you wish to draw. Sophisticate or yokel, glamour type or the plain coiffure – by their hair you shall know them.

When drawing hair, it sometimes helps to change from pen to brush, or use the side of your pencil. Hair is flexible and demands a flexible line. Don't use a thousand lines where three would do the trick. Try to make it appear to grow from the scalp by 'combing' it with the pen or brush.

### BIRD'S-NEST BUN

By drawing with the side of your pencil and using a softer lead, you can establish a heavy volume of hair that, although tied up at the back in a 'bird's nest', frames the face.

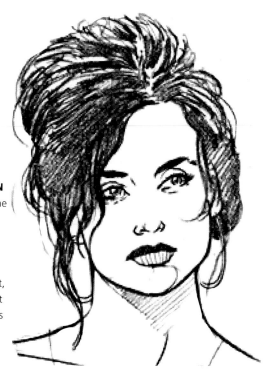

### DRAWING CONVINCING HAIR

Always draw the basic shape of the head before you draw the hair on top, otherwise you will end up with a very strange-looking character.

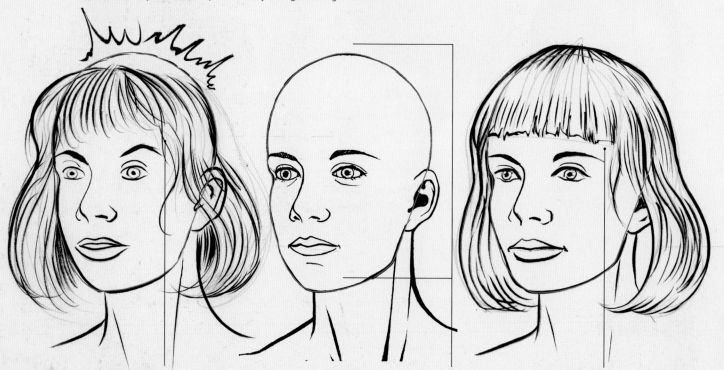

Incorrect: hair drawn without following basic shape of head.

Hair should cover this shape.

Correct: hair covers shape of head.

## COMB OVER

Sketching hair using an ink brush gives a shiny and dishevelled look due to the effects of the dry brush on the rougher texture of the paper.

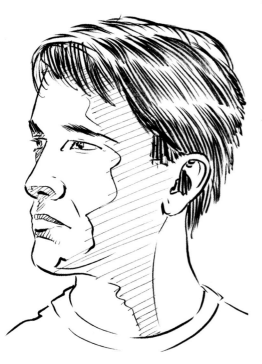

## BOB

This is a blonde younger woman whose hair is depicted by using fewer brushstrokes and lighter contour lines. She has been given a modern cut to define her character attributes.

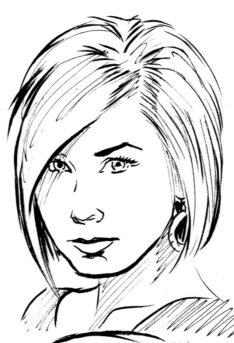

## SILVER HAIR

An older man will have fewer strokes of hair to represent the graying of his hair as well as heavy shadows for contrast and volume, achieved by using the ink brush loosely.

## FACIAL HAIR

Like hair, beards and moustaches can indicate character and type. They can make a figure look domineering or downtrodden, diabolic or divine. Styles in moustaches and beards seem to grow funnier as they vary – maybe because hair on the face seems so unnecessary and futile. Treat the beard or moustache the same as the hair: don't overdraw, and keep your lines sharp and clean.

### BEARD, STUBBLE, OR MOUSTACHE?

Five-o'clock shadow and visible bristles suggest a rugged character (immediate left), whereas a full beard suggests wisdom or slyness (far left). A moustache can be exaggerated for cartoon purposes to create different effects (right).

# YOUTH AND AGE

Everyone ages differently, but sagging and wrinkled skin, drooping eyelids, longer earlobes, a longer, more bulbous nose, and deep, permanent laugh lines will strike all to some degree as they age. The following pages teach you how to add youth or age to a face.

### DRAWING YOUNG CHILDREN

Infants are fun subjects to draw, but are extremely difficult to capture since they have different proportions to adults and children. Where adults have features that are proportionally even, babies have large eyes and small lips and noses. Also, infants are impossible to keep still. Your only hope to draw them is to use photo references or to draw them while they are asleep.

### DRAWING ELDERLY FACES

Drawing elderly people can be challenging. It takes some additional thought and skill to apply just the right amount of detail necessary to create an older look. However, by using lines and a little shading, you can make any of your characters look older.

Drawing wrinkles on a human face isn't simply a matter of drawing lines. Instead, as with any other form of drawing, you must learn to recognise and draw areas of light and shadow. First, determine what type of line you're dealing with. Is it a thick

## DRAWING A CHILD'S HEAD

**FRONT VIEW**

**1** Draw a vertical rectangle and divide in half both horizontally and vertically. Add a horizontal line about one third of the way up from the bottom, relative to the horizon line that establishes the eyes. Next draw in the basic features of the face: eyes on the horizon line, the nose just above the line where the mouth is drawn in. Notice how the corners of the mouth line up with the corners of the nostrils and eyes. Add in the ears as shown between the two horizon lines.

**2** Define the features more by adding in eyebrows. Remember this is a child, so their features are not yet well defined. Draw in a hairline as shown.

**3** Shade in the hair and the features for depth and tone.

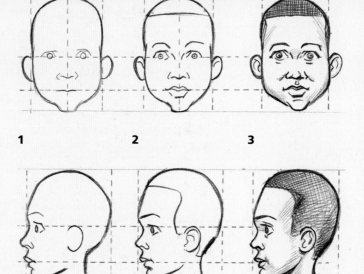

**SIDE VIEW**

**1** Draw a vertical rectangle and divide in half both horizontally and vertically. Add a horizontal line about one third of the way up from the bottom relative to the horizon line that establishes the eyes. Next draw in the basic features of the face: eyes on the horizon line, the nose just above the line where the mouth is drawn in. The top of the ear should start on the horizon line where the eye lies and curve down and back up to end where the child's nostril is placed.

**2** Define the features by adding in eyebrows. Draw in a hairline as shown.

**3** Shade in the hair and the features for depth and tone.

line? Fine line? A line in shadow or a line in light? Is the line stark and solid, or surrounded by a mound of flesh? When you learn to make these determinations, your ability to draw wrinkles on human faces will be much improved. Just as in previous chapters of the book, using photo reference will help you to understand the underlying structure and the proportions of the features before you 'age' a face. Turn over the page for more on adding age to a face.

## BABY'S HEAD CONSTRUCTION

The face of a baby is quite small in proportion to the rest of the head, taking up one-half of the head rather than the standard three-quarters on older people. Start with a square for each view, front and profile. Then reduce the width of the front-view square by approximately one-sixth. Divide this resulting rectangle and the profile square in half both vertically and horizontally. Then divide the lower half of both into four equal parts.

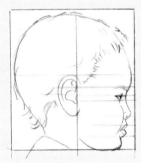

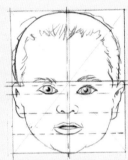

### VARIATIONS

The various examples display the shape, size and proportions of a child's head. What distinguishes one baby from the next are the type of hair they have, their ethnic background, skin colour, eyes, nose, cheeks and mouth. Ears, dimples, chin and freckles may be other features that give a baby their personality.

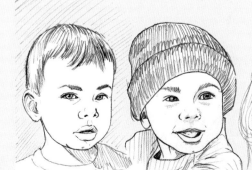
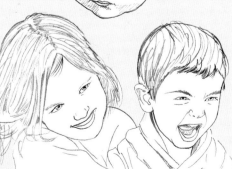

- The eyes fall well below the horizontal halfway line.

- The eyes are very large and are more than an eye's width apart.

- The upper lip is fuller and protrudes somewhat.

- The bridge of the nose is concave.

- The jowls obscure the neck in the front view; the profile reveals a chubby nape.

- The face is smaller in proportion to the rest of the head.

- Back of the head sticks out further and neck is smaller.

- Usually the ear is larger than the rest of the features.

- The iris or coloured part of the eye approaches adult size and in its small setting is nearly fully exposed.

- The eyes appear a little wider apart in very small children.

- Lashes appear longer; brows are much thinner.

- Early nose is usually upturned; centre septum is flatter in babies.

Youth and age

## ADDING AGE TO A WOMAN

### FRONT VIEW

The initial drawing should look like a young version of the old person you want to sketch, so that when you add the details, it will look as though you have drawn the same person, but older.

**1** Draw a circle. Divide it in half with a vertical line. Draw a horizontal line about one third of the way up from the bottom of the circle. Create a trapezoid from the horizon line as shown. Draw in the jaw line and chin.

**2** Sketch in two eyes, a nose and a mouth. Make the lips thin and bring the nose out a little further than normal. This will help you develop an older appearance when you begin adding lines and shading to your character.

**3** Shade and add lines to your character's face to bring out the age. Add light pencil shading below and in the corners of the eyes and around the edges of the nose. These shadings will lift the features away from the face and create depth. Sketch a full head of hair, then use your eraser to remove a little of the hair, thinning the initial hair and bringing the front hairline back. Draw several lines over the face to create wrinkles. Be sure to place vertical lines around the mouth and eyes and in other places they would naturally occur with age.

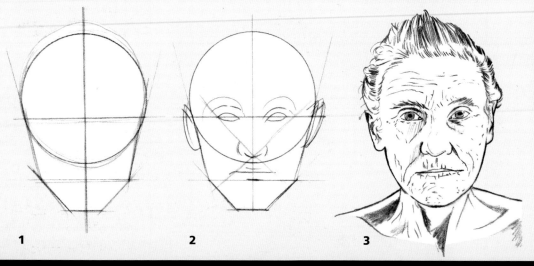

**1**

**2**

**3**

## ADDING AGE TO A MAN

### FRONT VIEW

Follow these basic steps to add age to a head-on male face.

**1** Draw a circle. Divide it in half with a vertical line. Draw a horizontal line about a third of the way up from the bottom of the circle. Create a trapezoid from the horizon line as shown. Draw in another shape that will become the jaw line and chin of the man.

**2** Sketch in two eyes, a nose and a mouth. Make the lips thin and bring the nose out a little further than normal. This will help you develop an older appearance when you begin adding lines and shading to your character.

**3** Shade and add lines to your character's face to bring out the age. Add light pencil shading below and in the corners of the eyes and around the edges of the nose. These shadings will lift the features away from the face and create depth. Sketch a full head of hair on your character, then use your eraser to remove a little of the hair, thinning the initial hair and bringing the front hairline back.

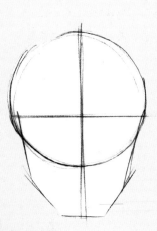
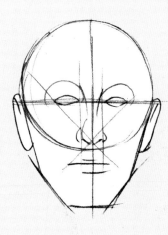
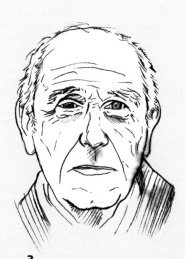

**1**

**2**

**3**

## THREE-QUARTER VIEW

Remember, a three-quarter view is any view from an almost-front view to an almost-profile view.

**1** Draw a circle and add a 'jaw' line appropriate for this three-quarter view.

**2** Bisect this form both horizontally and vertically. The vertical line determines the view of the head. Add a plane that forms the dividing point between the front and the side of the head. Note that eyes and lips need to curve around the head and are foreshortened. It is helpful to block in side planes on the head and nose to keep you aware of the dimensional view of the head.

**3** Add the features and head details as instructed in the front view steps.

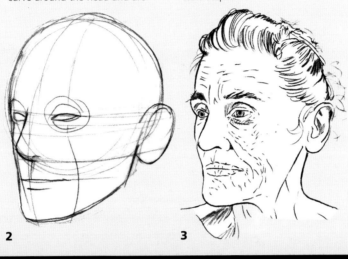

**1**     **2**     **3**

❱ Hair thins or turns noticeably white.

❱ Definite lines remain in forehead.

❱ Eyebrows may become sparse or scraggly.

❱ Eyelids have tendency to droop.

❱ Socket bone protrudes as eye sinks back.

❱ Wrinkles form around lower lid pocket.

❱ Slight depression may occur at temples.

❱ Cheekbones become prominent.

❱ Ears lengthen; lobe hangs pendant-like.

❱ Ball of nose may appear to swell.

❱ Mouth sinks back and wrinkles run off lips.

❱ Chinbone protrudes.

❱ Neck becomes gaunt; skin hangs in drapes.

## PROFILE

Follow these basic steps to add age to a male profile.

**1** Draw a circle and divide it into quarters. Carry the vertical line through the bottom of the circle and draw a diagonal line. Bring the line up to meet with the horizontal line, creating the jaw.

**2** Establish the eye line on the horizontal line. Draw another horizontal line, starting at the point where the bottom of the circle and jaw line intersect to the vertical line for what will be the bottom of the nose. Add the ear from the back of the jaw line to the top of the eye line. Lightly draw in the eye on the horizontal line and add a nose between the two horizon lines.

**3** Add the features and head details as instructed in the front view steps.

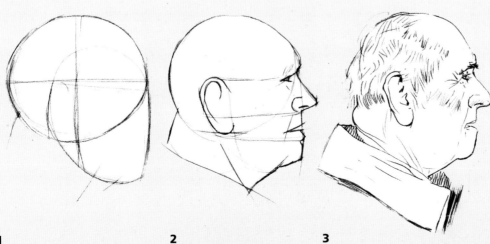

**1**     **2**     **3**

# 3

# DRAWING THE FIGURE

This chapter will teach you all you need to know about the human figure. First, you will learn about the skeletal structure, human musculature and male and female proportions. Then, we look at each part of the figure in isolation, so that you can really come to grips with the muscles and bones that make up the limbs, torso, hands and feet.

# INTRODUCING THE BASIC FIGURE

Thinking of the human body as made up of basic shapes will give you a solid, three-dimensional form to build your characters on, and will enable you to create figures that have depth and volume.

## THINKING IN SHAPES

View the body in terms of simple, basic forms to understand the masses of the separate parts and place them in their proper relationship. The figure consists of six basic parts – the head, the torso, two arms and two legs. As a comic book artist, you will not be held to the strict rules of anatomy. You may lengthen, shorten or otherwise distort any part of the figure you please, especially if it will help you portray the character you are trying to create. But regardless of your drawing style or exaggeration, you should adhere to the principles of three-dimensional form. With a solid form to build on, the adding of figure details and clothing is greatly simplified.

## 'DRAWING THROUGH'

When drawing the basic figure, you must 'draw through' to the other side, meaning that you draw the figure as if it were transparent. Even though a shoulder or arm will be hidden by another part of the body in the finished drawing, you must be aware that they exist. When all of the figure parts are accounted for by 'drawing through', the end result will be a figure that is convincing in structure and action.

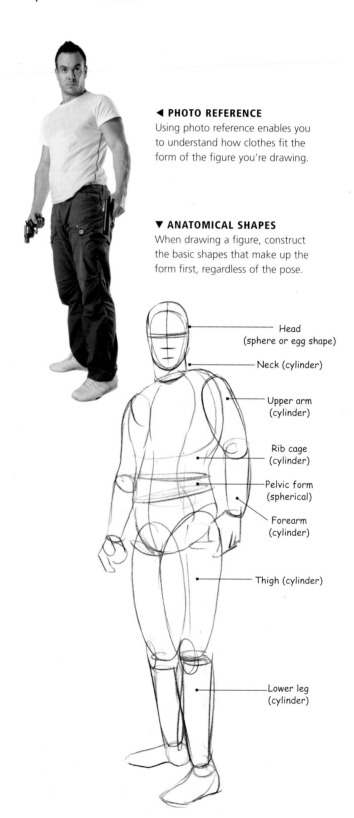

◀ **PHOTO REFERENCE**
Using photo reference enables you to understand how clothes fit the form of the figure you're drawing.

▼ **ANATOMICAL SHAPES**
When drawing a figure, construct the basic shapes that make up the form first, regardless of the pose.

Head (sphere or egg shape)

Neck (cylinder)

Upper arm (cylinder)

Rib cage (cylinder)

Pelvic form (spherical)

Forearm (cylinder)

Thigh (cylinder)

Lower leg (cylinder)

## PRACTISE DRAWING CLASSIC POSES

To render poses well and consistently, it is essential to study classic poses. When limbs stretch or bend, or the back arches, muscles express themselves in ways that give the physique of the figure a particular look. You must bring a solid understanding of this approach to your drawings.

**▶ PHOTO REFERENCE**
Models in well-fitted
clothes better accentuate
the underlying body form.

Head
(sphere or egg shape)

Neck
(cylinder)

Upper arm
(cylinder)

Rib cage
(cylinder)

Forearm
(cylinder)

Pelvic form
(spherical)

Thigh
(cylinder)

Lower leg
(cylinder)

**◀ ANATOMICAL SHAPES**
The basic figure can be reduced to
a series of cylinders and spheres.
The shapes simplify the body to its
essential masses. Every distracting
element has been eliminated.
Think of the figure as if it were
carved out of heavy wood – it is
solid, three-dimensional.

**▼ FINISHED DRAWING**
Notice how the creases in
the jeans suggest the form
underneath. See pages
94–117 for more on clothing.

**◀ FINISHED DRAWING**
Even when you add detail in the
finished pencil drawing you will
see how the neck, the arms,
the legs and the rib cage are
essentially modified cylinders.
A simplified anatomical
underdrawing is essential for
creating a convincing figure.

Introducing the basic figure

# BONES AND MUSCLES

A basic understanding of human anatomy is essential if you are to draw the human figure correctly.

### SKELETON

The human skeleton consists of both fused and individual bones supported and supplemented by ligaments, tendons, muscles and cartilage. It serves as a scaffold that supports organs, anchors muscles and protects organs such as the brain, lungs and heart. An understanding of which bones go where, however basic, will greatly aid your figure drawing.

### MUSCULATURE

Once you get a firm grasp of the skeleton, you need to learn how its supporting and covering musculature is structured, because this gives the body its form.

From the broad pectorals to the powerful thighs, the front of the body is swathed in a complex segmented shell of bunched muscles. Together they act in conjunction with the spine, supporting the skeleton, as well as the internal organs. The thick ribbon of powerful abdominal muscles clings to the underside of the rib cage and stretches to the groin and the tops of the thighs. It is designed for the anticipation, and release, of action.

The muscles of the back, spine, pelvis and legs are the solid foundation of the whole body's muscular support structure. The delicate vertebrae of the spine are held in place by leaves of supporting muscles, which are in turn swathed in layers of broad, strong muscle. The shoulder blades are held in place by bunching triangles of muscle that give the shoulders their imposing strength, while those of the calves really inject the power into running and leaping.

### DIFFERENCES BETWEEN MALE AND FEMALE MUSCULATURE

In general, male musculature is much larger than that of the female. The muscles of the male tend to ripple and bulge with definition, and are very large and visibly structured. Pectorals and deltoids are broad and powerful and the abdominals are very well defined. The female musculature is much more lithe, with softer contours and less definition, especially in the stomach and rib areas.

## MAJOR BONES

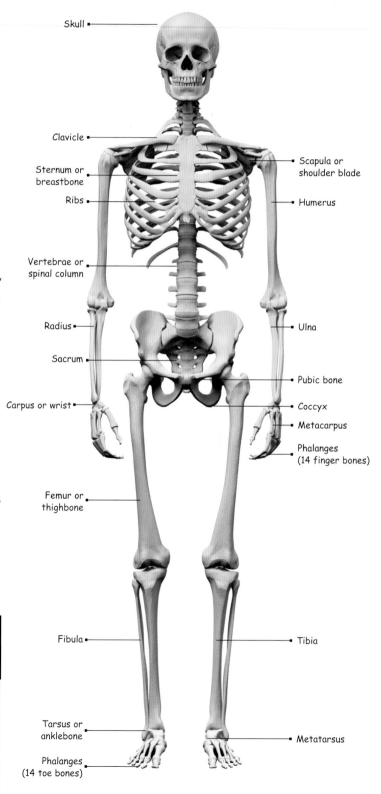

Skull

Clavicle

Scapula or shoulder blade

Sternum or breastbone

Humerus

Ribs

Vertebrae or spinal column

Radius

Ulna

Sacrum

Pubic bone

Carpus or wrist

Coccyx

Metacarpus

Phalanges (14 finger bones)

Femur or thighbone

Fibula

Tibia

Tarsus or anklebone

Metatarsus

Phalanges (14 toe bones)

# MAJOR MUSCLES

Sternomastoid

Pectorals

Biceps

Abdominals

External obliques

Adductors

Vastus muscle group, and the rectus femoris

Triceps surae (calf)

Trapezius

Deltoid

Flexor carpi radialis
Flexor carpi ulnaris

External carpi radials longus

Peroneus longus

Rhomboideus muscles

Triceps

Latissimus dorsi

External obliques

Gluteus maximus (buttock)

Biceps femoris

Triceps surae (calf)

# FIGURE PROPORTIONS

The average male stands eight heads high – that is, his height is eight times the height of his head. But the idealised or heroic male stands even taller. The proportions of the female figure differ from those of the male.

**AVERAGE MALE FIGURE**

The average male's shoulders are broad in relation to the width of his hips, and his fingertips, when his arms are down, reach to the middle of the thigh. The groin is located precisely halfway between the top of his head and the soles of his feet. It is worth your time to be familiar with these proportions of the average figure.

You can vary the average proportions of the human male to come up with interesting body types, but always base your exaggerations on a sound knowledge of the average figure.

**IDEAL MALE FIGURE**

The heroic scale (below) is based on nine heads in height. The shoulders are broad and this larger body frame creates a larger-than-life figure.

For the moment, you can only apply these specific proportional charts to erect figures, but soon you'll be able to 'eyeball' your action figures to correction. As a rule of thumb, if your figure looks short, redraw the head smaller; if too tall, redraw the head larger. Study these charts to understand the relationship of the size of the head to the height of the figure.

**MALE AVERAGE PROPORTIONS CHART**
Here, drawn to the proportions described above, we have the average male. The shoulders and upper torso are fairly muscular, but the waist and lower body are narrow and underdeveloped in comparison to the heroic male.

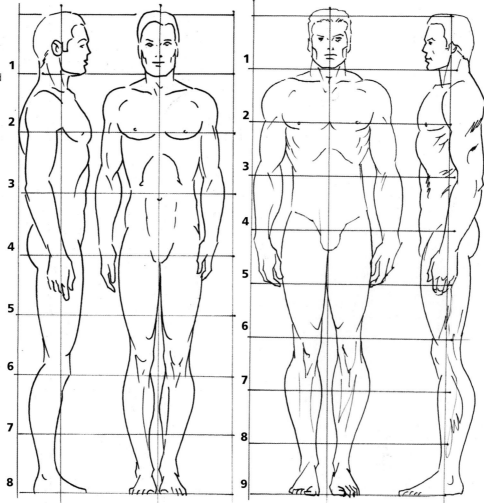

**MALE IDEAL PROPORTIONS CHART**
Here, drawn to the proportions described above, we have the ideal male. Larger bone structures and more body mass-to-muscle ratio typify the ideal male figure.

## AVERAGE FEMALE FIGURE

The average female figure (below) is eight heads high, with shoulders and hips about the same in width. The groin is located midway between the top of the head and the bottom of the feet.

## IDEAL FEMALE FIGURE

Successful comic book artists have found that slight exaggerations of the real-life female figure have paid off in reader interest. There has emerged an 'ideal' figure that the readers seem to like. This figure is depicted below. The head is drawn slightly larger and the hairdo exaggerated. Shoulders and waist are made smaller to emphasise the width of the hips. The groin may be drawn higher than halfway to create a short-waisted, long-legged woman, or lower to show a long-waisted, low-slung woman.

**FEMALE AVERAGE PROPORTIONS CHART**

Here, drawn to the proportions described above, we have the average female. Delicate bone structure and less mass-to-muscle ratio typifies the figure.

**FEMALE IDEAL PROPORTIONS CHART**

The ideal female figure is nine heads high with shoulders and hips about the same in width. Shoulders and waist are smaller to emphasise the width of the hips.

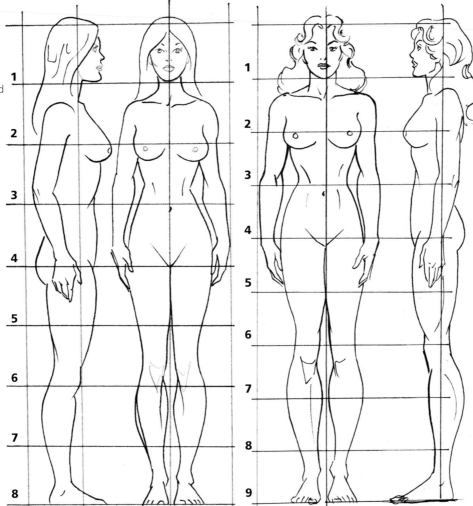

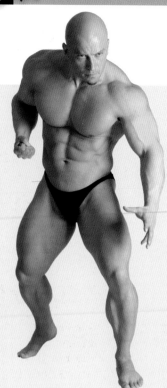

Study the muscular build from all angles as you practise drawing the muscular male figure (**1**).

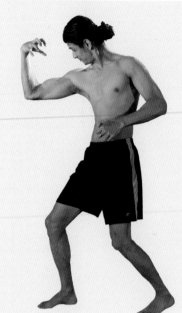

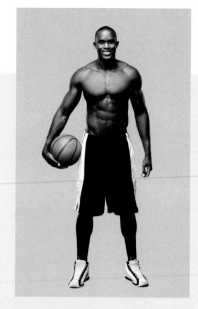

This male is lean but muscular, as opposed to the body builder to the left. This figure enhances his muscular build by flexing his bicep muscle (**2**).

This athlete's physique is ideal for action poses; not overly muscular like a body builder, but toned enough to express a heroic look that lends itself to action (**3**).

**1**

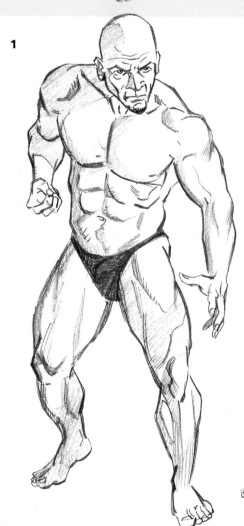

**2**

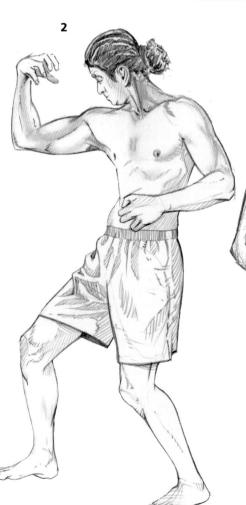

**3**

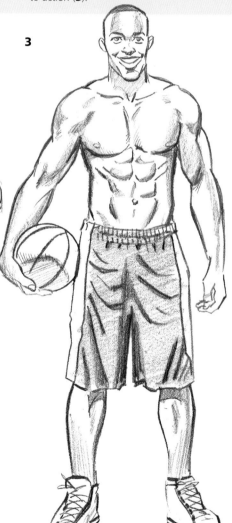

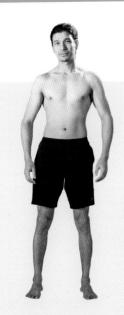

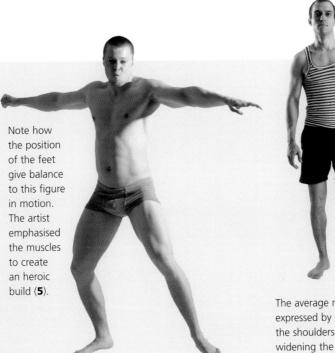

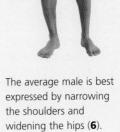
Note how the position of the feet give balance to this figure in motion. The artist emphasised the muscles to create an heroic build (**5**).

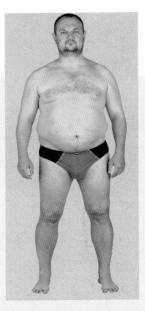

Lengthening legs and torso in relation to the size of the head creates a tall male (**4**).

The average male is best expressed by narrowing the shoulders and widening the hips (**6**).

Shortening the legs and torso in relation to the size of the head produces a larger, rounder version of the figure (**7**).

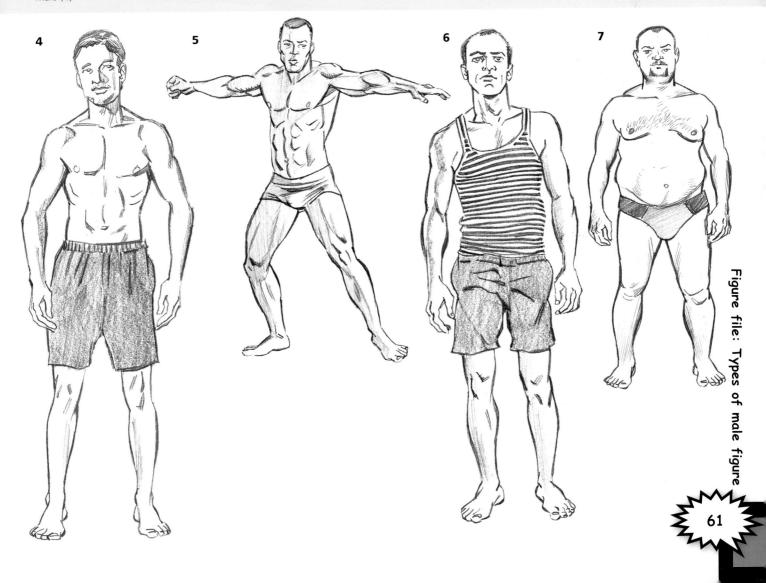

4

5

6

7

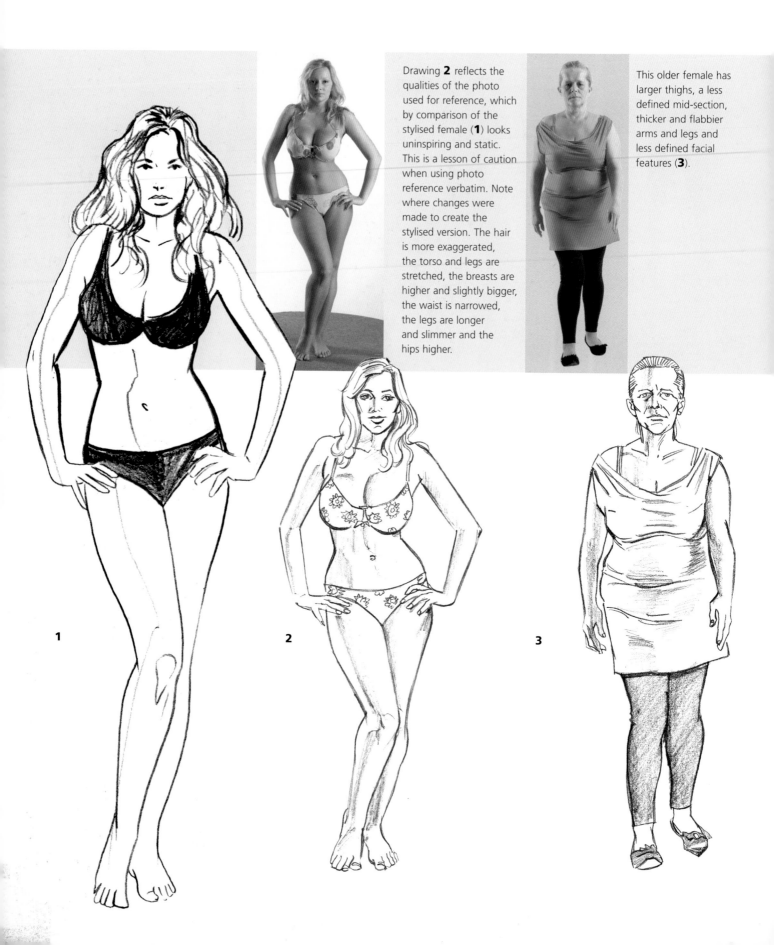

Drawing **2** reflects the qualities of the photo used for reference, which by comparison of the stylised female (**1**) looks uninspiring and static. This is a lesson of caution when using photo reference verbatim. Note where changes were made to create the stylised version. The hair is more exaggerated, the torso and legs are stretched, the breasts are higher and slightly bigger, the waist is narrowed, the legs are longer and slimmer and the hips higher.

This older female has larger thighs, a less defined mid-section, thicker and flabbier arms and legs and less defined facial features (**3**).

1

2

3

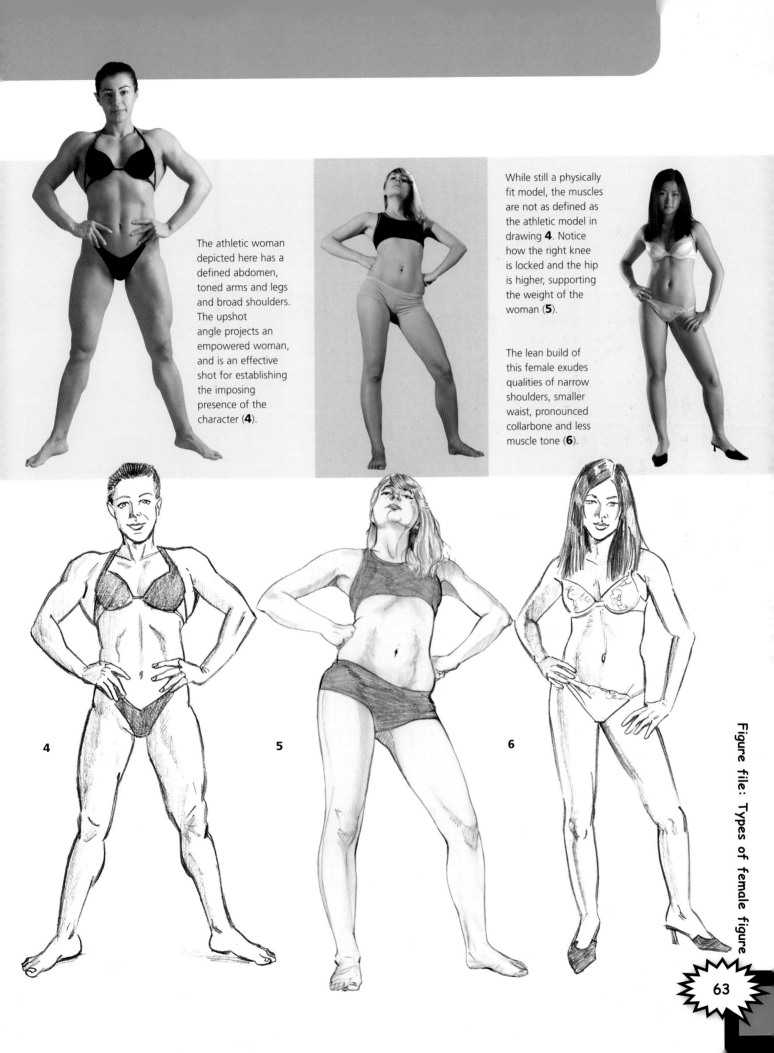

The athletic woman depicted here has a defined abdomen, toned arms and legs and broad shoulders. The upshot angle projects an empowered woman, and is an effective shot for establishing the imposing presence of the character (**4**).

While still a physically fit model, the muscles are not as defined as the athletic model in drawing **4**. Notice how the right knee is locked and the hip is higher, supporting the weight of the woman (**5**).

The lean build of this female exudes qualities of narrow shoulders, smaller waist, pronounced collarbone and less muscle tone (**6**).

4

5

6

# NOTES ON THE FEMALE FORM

Hips, ankles, thighs and buttocks are all important considerations when drawing convincing, well-balanced female figures.

### HIPS IN ACTION

Clothes can seldom be used to cover a bad drawing. And the key to a good figure drawing is the hip area. When the hips are drawn well, the figure will be active.

The 'opposition of forms' means that the shoulders will slant opposite to the hip line when the figure is in balance.

Keep the waist long and narrow – this will allow the buttocks to be full and round without being large.

Note how the examples of this rule give the thigh line a longer and more graceful sweep.

### PLACING ANKLES ON EXTENDED LEGS

A line extending from the rear of the thigh will give you the front instep line. A crossing line from the front of the thigh gives you the other side of the ankle. With the legs in a bent position, you'll have to pencil in a false thigh to check from, but the effort is worthwhile. Just remember that this and other formulas can be helpful, but formulas are no substitute for accurate observation.

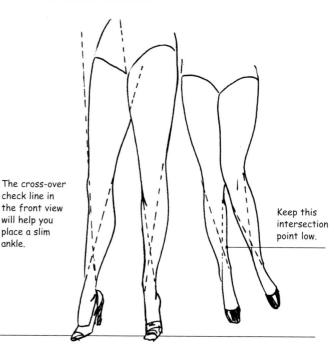

The cross-over check line in the front view will help you place a slim ankle.

Keep this intersection point low.

### CURVES

The ideal female's waist is long and narrow and her buttocks are full and round and in proportion with the hips. Slight changes to the natural curves and shapes of the female form result in idealised versions that may be more suitable for graphic novels.

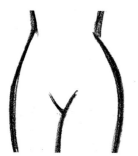

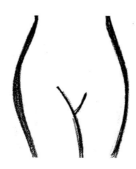

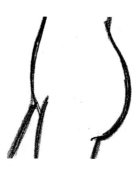

The hip lines are like this...

... but you should draw them like this.

You would draw the side view like this from life...

... but custom and style dictates this 'high and round' style.

## BALANCING THE FEMALE FIGURE

The figure in action will always be in balance. Note how the shifting weight of the figure dictates the direction of the hips and shoulders.

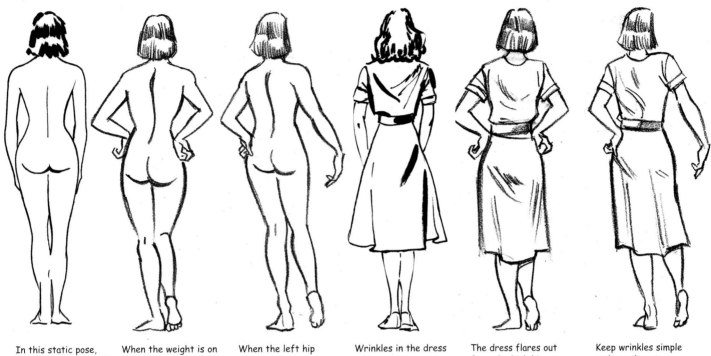

In this static pose, the balance is neutral.

When the weight is on the left foot, the left hip goes up.

When the left hip goes up, the left shoulder goes down for balance.

Wrinkles in the dress add some interest to a neutral pose.

The dress flares out from the high hip as the left hip goes up.

Keep wrinkles simple and use them to accent the action.

## LEGS DICTATE MOVEMENT AND BALANCE

Like the hips, legs suggest the movement and balance of the female figure. The examples below illustrate how one leg is always planted firmly to support the weight of the figure.

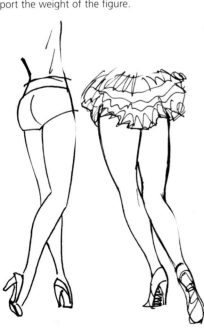

Drop a line from head centre to left foot. The girl would not be in balance without the extended right leg.

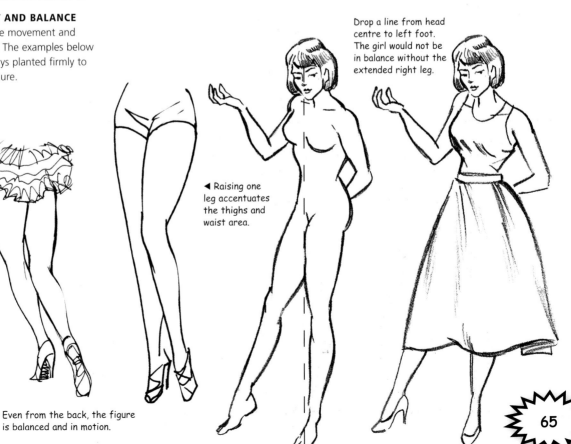

◄ Raising one leg accentuates the thighs and waist area.

Throw the weight on one leg for greater interest.

Even from the back, the figure is balanced and in motion.

# THE FIGURE IN ACTION

The cylinder and sphere are three-dimensional forms; they work perfectly in helping you establish the action and direction of the individual parts of the figure and of the figure as a whole.

## 'DRAWING THROUGH' THE ACTION
When you draw a figure, start by analysing the action and determining the direction the figure and its individual parts must go. In the early stages of pencilling the figure in action, it is important to 'draw through' (see page 54) even though certain parts of the figure will be hidden in the finished drawing.

## THINKING OF THE FIGURE AS A WHOLE
Any action involves the whole figure, not just individual parts of it. A standing figure cannot be changed into a running figure by giving a running action to the legs only. The result would be a stiff, static-looking and unconvincing drawing. Be sure that you show the action of the figure as a whole from the very first sketch. In a running

action, for example, visualise the forward lean, which suggests speed, and the opposing twist of rib cage and hips (see below). The clearer the mental picture, the easier it will be to put it down successfully on paper.

## ACTION AS STORYTELLING
Action is the key to good storytelling. Many good ideas have been destroyed by poorly drawn action, and many weak ideas have been improved upon by well-constructed figures in action.

Action does not necessarily mean violence or exaggeration. The way a character sits in a chair is action, even if he isn't moving. Observe and note how each of your friends has their own way of sitting in a chair; some may slouch, others sit erect. A comic book artist with a realistic style must keep

## CONSTRUCTING A RUNNING FIGURE

The figure was composed from imagination before shooting photo reference to accurately illustrate the figure in the action pose.

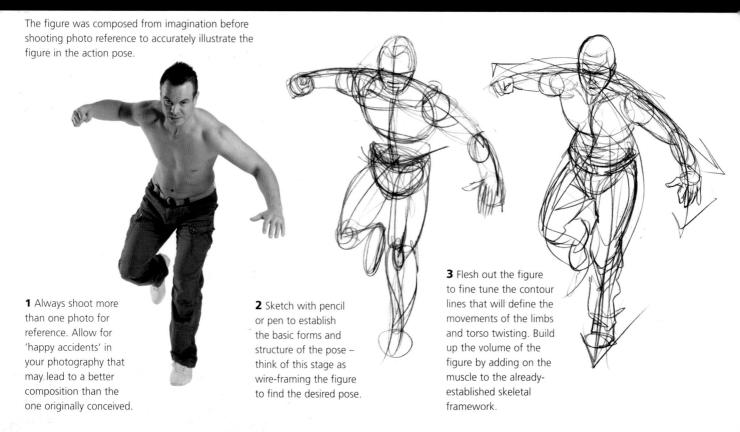

**1** Always shoot more than one photo for reference. Allow for 'happy accidents' in your photography that may lead to a better composition than the one originally conceived.

**2** Sketch with pencil or pen to establish the basic forms and structure of the pose – think of this stage as wire-framing the figure to find the desired pose.

**3** Flesh out the figure to fine tune the contour lines that will define the movements of the limbs and torso twisting. Build up the volume of the figure by adding on the muscle to the already-established skeletal framework.

his action close to what the real human figure is capable of doing. Then again, an all-out comic or 'big-foot' style cartoonist can do anything with the action of his figures that he or she can think of, or – more importantly, perhaps – that he or she can draw.

Speed, or expression, lines can help the figure perform its action. A running man is sped up by a few straight lines flowing out from behind, as though he were cutting a path through the air. However, the basic approach should govern everything you draw in comics. Too many speed lines and effects can start distracting your reader from the action you're trying to draw.

Your reader's first glance at a page must sell them on the idea of reading it. Interesting action gets attention; lack of it loses readers. Keep this in mind, have fun and spend plenty of time on this all-important part of your drawing.

## KEEP YOUR CHARACTERS MOVING

Try to have your characters doing something at all times. In a comic book that is carried by the word balloons, don't have your figures stand or sit in the same position throughout the whole series of panels. Even if they just scratch their heads, or use their hands while they talk – keep them moving.

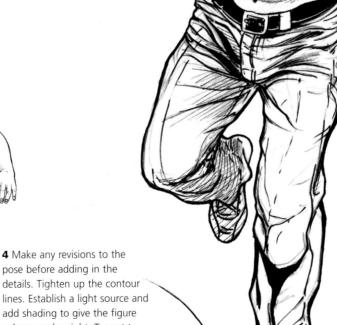

**4** Make any revisions to the pose before adding in the details. Tighten up the contour lines. Establish a light source and add shading to give the figure volume and weight. Try not to overdraw the figure with too much detail.

**5** Finishes to the figure were rendered in India ink with a Winsor & Newton Series 7 Sable brush #2, a Rotring Rapidograph .18 pen for the finest details and Pro White for corrections and highlights.

## ACTION AND CHARACTER

Action and character are inseparable. As you think out the action of the character, you must also feel their emotional makeup and how it is reflected in the action. There is no substitute for knowing and understanding the type of people you are drawing. Any comic book artist can draw a sloppy-looking overweight man, but the artist who can make the reader feel the emotional sloppiness of the character expressed through the body language, facial expression and messy clothes is the one who gets the job.

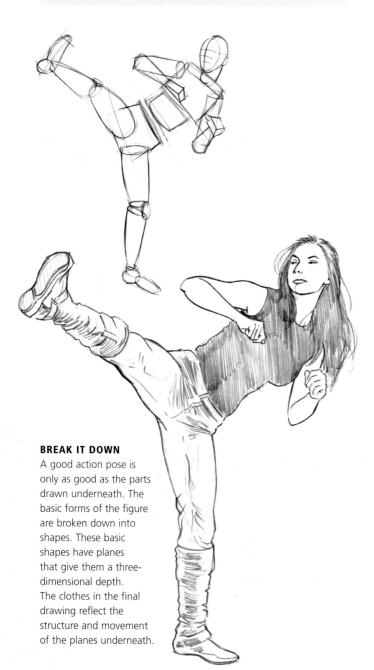

### BREAK IT DOWN
A good action pose is only as good as the parts drawn underneath. The basic forms of the figure are broken down into shapes. These basic shapes have planes that give them a three-dimensional depth. The clothes in the final drawing reflect the structure and movement of the planes underneath.

## CONSTRUCTING A KNEELING FIGURE

This step-by-step sequence not only gives you a procedure for constructing solid three-dimensional figures, but it also helps you to think and feel the character while you construct it.

**1** Once you have determined the type of character and action, sketch in the general form lightly. Establish the action as a stick figure or gesture-action sketch.

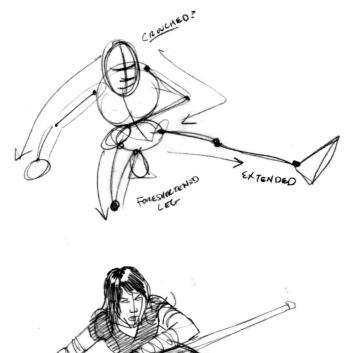

**4** Now that the figure has been constructed solidly, you have a sound basis for drawing the clothing on it and developing your character. Keep in mind that the clothing should follow and reveal the solid figure underneath.

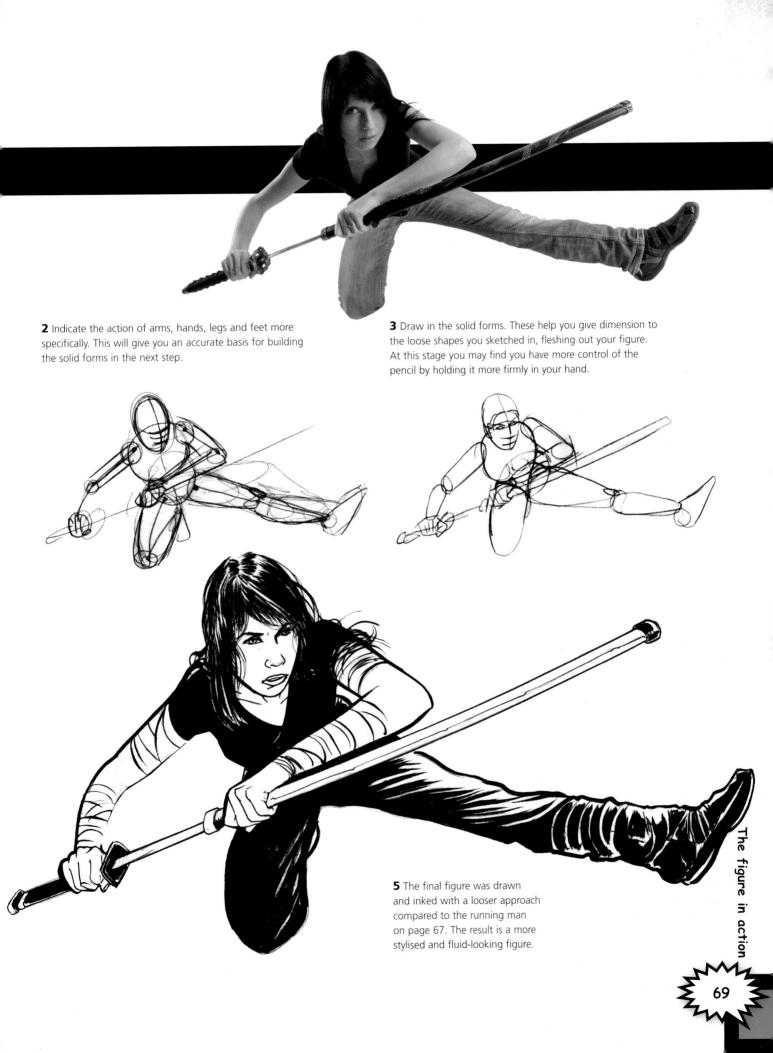

**2** Indicate the action of arms, hands, legs and feet more specifically. This will give you an accurate basis for building the solid forms in the next step.

**3** Draw in the solid forms. These help you give dimension to the loose shapes you sketched in, fleshing out your figure. At this stage you may find you have more control of the pencil by holding it more firmly in your hand.

**5** The final figure was drawn and inked with a looser approach compared to the running man on page 67. The result is a more stylised and fluid-looking figure.

The gymnast in the photo here was inspiration for the drawing, which was a concept sketch for a character swinging off a fire escape (**1**).

The classical dance pose was constructed first as a wire-frame sketch (**2**). This dynamic pose is effective for a couple of reasons. It's convincing because her weight and balance is supported by her left arm and bent legs. Notice the folds on the clothes, indicating the movement of the form underneath (**3**).

**1**

**2**

**3**

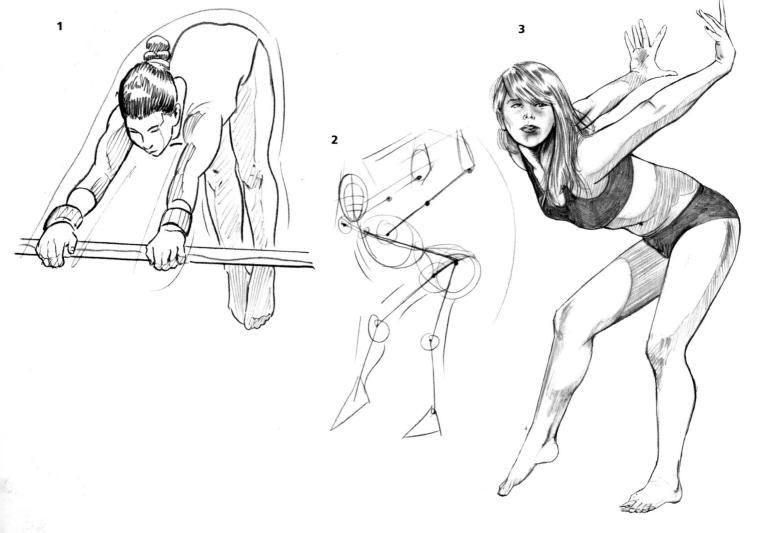

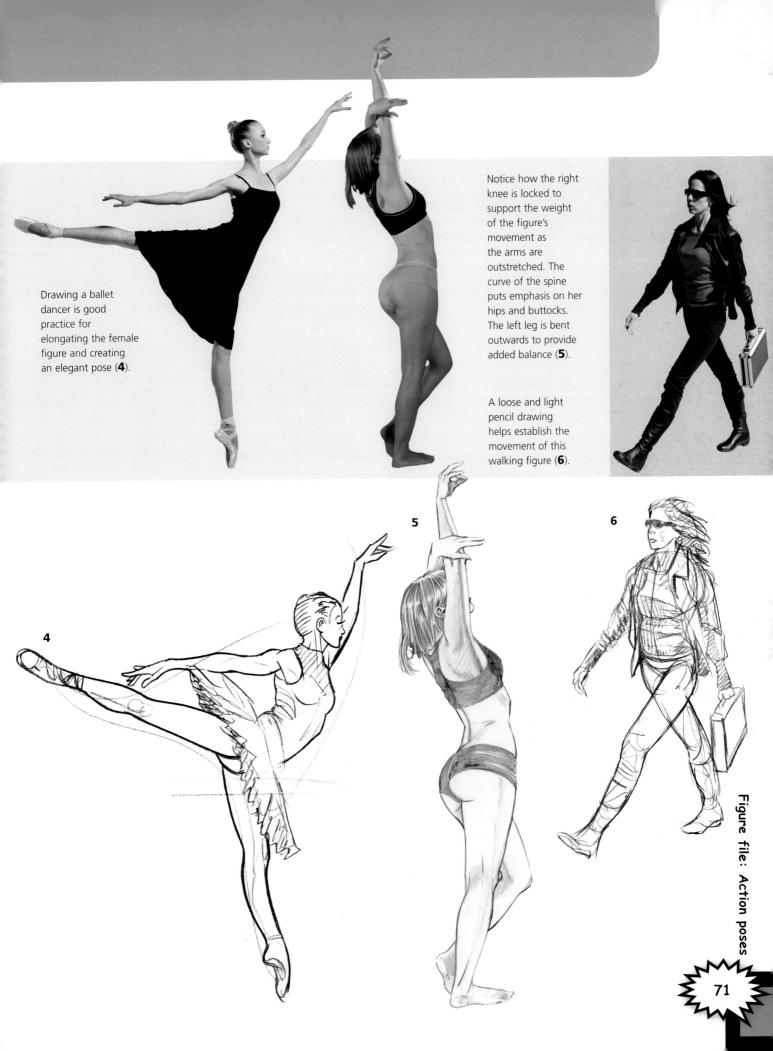

Drawing a ballet dancer is good practice for elongating the female figure and creating an elegant pose (**4**).

Notice how the right knee is locked to support the weight of the figure's movement as the arms are outstretched. The curve of the spine puts emphasis on her hips and buttocks. The left leg is bent outwards to provide added balance (**5**).

A loose and light pencil drawing helps establish the movement of this walking figure (**6**).

5

6

4

# FIGURE FILE: ACTION POSES

The drawing in its simplest form is a diagonal line from head to toe, as the right arm is reaching forward and the right leg pushes off for support and speed (**7**).

Even couch potatoes are interesting to draw, particularly if you're looking to reveal something about the character. Remember, action doesn't have to imply movement, rather it is dictated by a character's intention (**8**).

Martial arts poses are great for practising figures in action. Notice how the left foot is pointed down just before the character kicks. Action, in this instance, is anticipated (**9**).

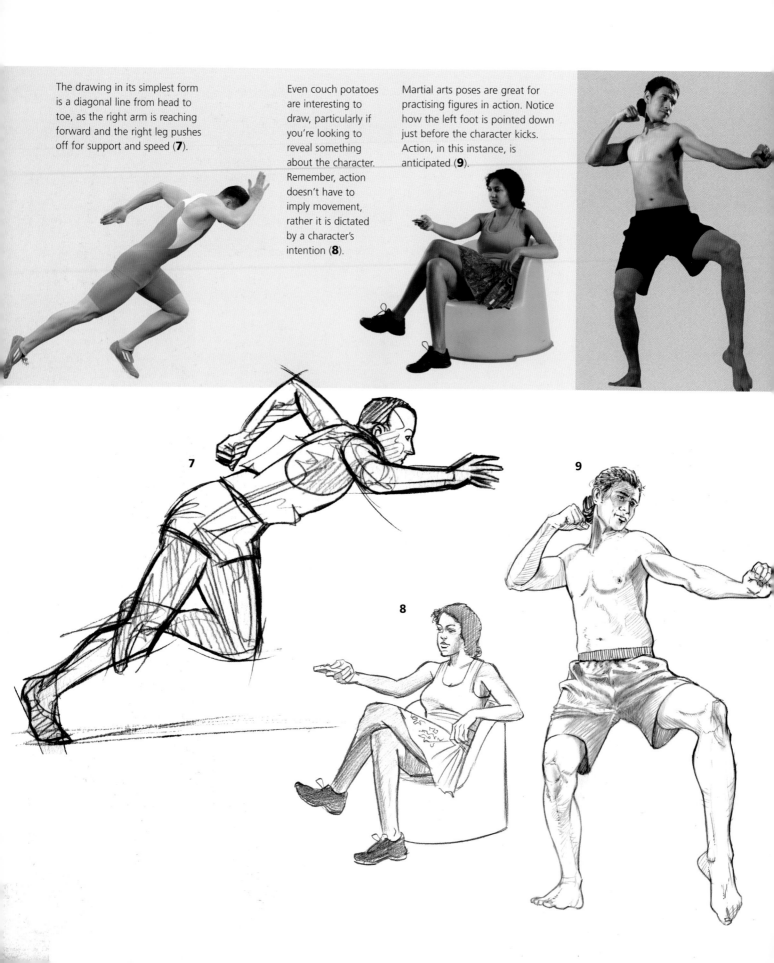

7

8

9

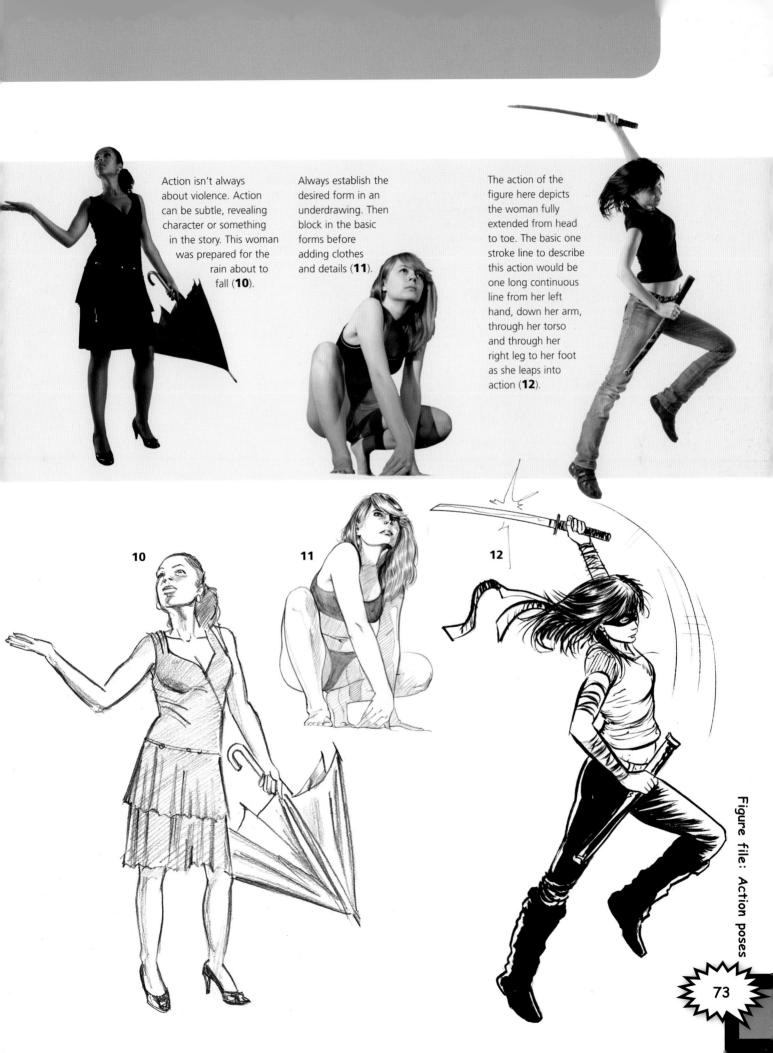

Action isn't always about violence. Action can be subtle, revealing character or something in the story. This woman was prepared for the rain about to fall (**10**).

Always establish the desired form in an underdrawing. Then block in the basic forms before adding clothes and details (**11**).

The action of the figure here depicts the woman fully extended from head to toe. The basic one stroke line to describe this action would be one long continuous line from her left hand, down her arm, through her torso and through her right leg to her foot as she leaps into action (**12**).

10

11

12

# FORESHORTENING THE FIGURE

Foreshortening is a drawing technique that creates the illusion of depth, and must be carried out with confidence to effectively trick the eye.

**FORESHORTENING AND ONE-POINT PERSPECTIVE**

The majority of your foreshortened figures will be drawn in one-point perspective. One-point perspective occurs when you and the one side of the object you see are on parallel planes. There will be a single vanishing point. Think of the way a road, a row of pylons and a fence often all seem to converge at a single point on the horizon. Find the centre of each plane by drawing from end to end diagonally. From here, divide each plane as needed for a guide to construct your figure, as shown right.

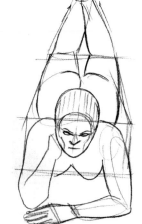

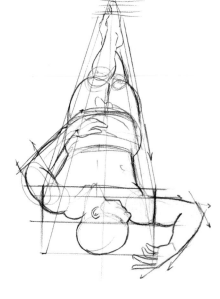

## FORESHORTENING TIPS

❯ Sit up straight; no slouching! Sketching in a slouched position can drastically affect the drawing of a foreshortened limb.

❯ Draw what you see and not what you think it looks like.

❯ Elements of your drawing will appear closer to you due to seemingly larger proportions, while objects away from your point of view will seem further away.

❯ Apply the use of line weights – vary your lines from thick to thin from foreground to background. Bold lines jump out, while thinner lines recede.

❯ If you're struggling to get the proportions of your foreshortened figures right, get your hands on a copy of *The Atlas of Foreshortening*, a reference book for drawing figures.

❯ Take a photo of yourself or a friend leaning or bending forward towards the camera in different poses. Add these photos to your photo reference library under the category of foreshortened figures.

❯ Keep in mind that the body parts closest to the camera are often slightly exaggerated. Try making them 'larger than life' and draw them with thicker contour lines.

Notice how the arms break free of the rectangle, which was created as a guide for constructing the figure. Sketch simple cylindrical shapes before building up the arms and hands.

This reclining figure is created in one-point perspective. Drawing a three-dimensional cube or rectangle around the figure will help you to interpret the perspective. Notice how the arms recede from the camera as the upper body comes forward.

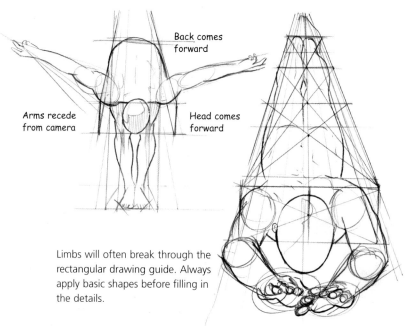

Back comes forward

Arms recede from camera

Head comes forward

Limbs will often break through the rectangular drawing guide. Always apply basic shapes before filling in the details.

Large hands

Arms come forward, breaking box plane

## FORESHORTENING AND TWO-POINT PERSPECTIVE

Two-point perspective occurs when the object you see is at an angle to you. There will be one edge or corner that is closest, called the leading edge. Both sides of the structure that recede from this leading edge will have their own vanishing points, hence the term two-point perspective. When drawing a foreshortened figure in two-point perspective, it is a good idea to first determine where your vanishing points are. Draw a rectangle around the figure. Here, the right leg is pushing forward, creating a foreshortened effect.

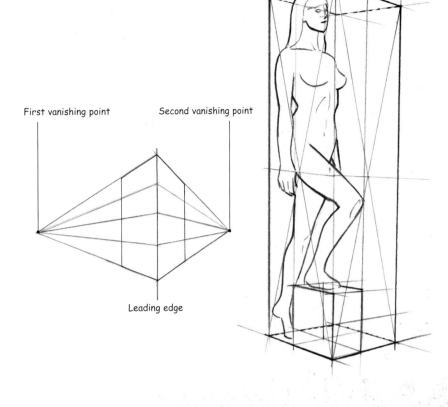

First vanishing point    Second vanishing point

Leading edge

## FORESHORTENING IN CONTEXT

Foreshortening occurs when a figure or a body part moves towards or away from the camera or reader.

**1** Here we have a woman holding a gun at her side. Notice how the gun is turned slightly in her hand, creating two planes (the figure is straight-on; the gun is seen from the side).

**2** Here, the gun is raised a little. This time, the top of the gun is showing as the woman's wrist twists the weapon in her hand. Note the elbow protruding out away from the body, just enough to imply movement.

**3** Now the gun is at a foreshortened angle, pointing towards the camera (or reader). There are two planes at work here on the raised arm (the top of the arm is straight-on; the lower arm is pointing towards the reader).

**4** The woman's arm is raised up even further. This drawing is more convincing than the last image. Why is this? The gun is slightly exaggerated in size – almost the size of her head – and the contour lines are thicker.

**5** The vanishing point is just behind the woman's head, focusing the reader's attention on the gun and the figure's face at the same time. The gun is pointed just off-centre to give the illusion of it coming towards the reader.

75

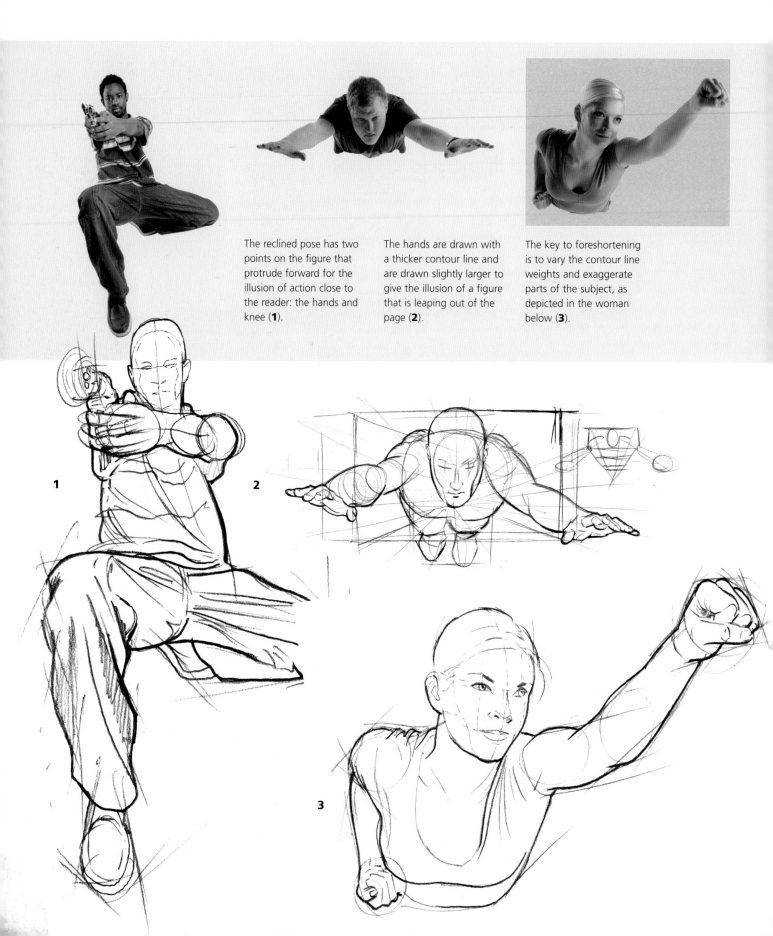

The reclined pose has two points on the figure that protrude forward for the illusion of action close to the reader: the hands and knee (**1**).

The hands are drawn with a thicker contour line and are drawn slightly larger to give the illusion of a figure that is leaping out of the page (**2**).

The key to foreshortening is to vary the contour line weights and exaggerate parts of the subject, as depicted in the woman below (**3**).

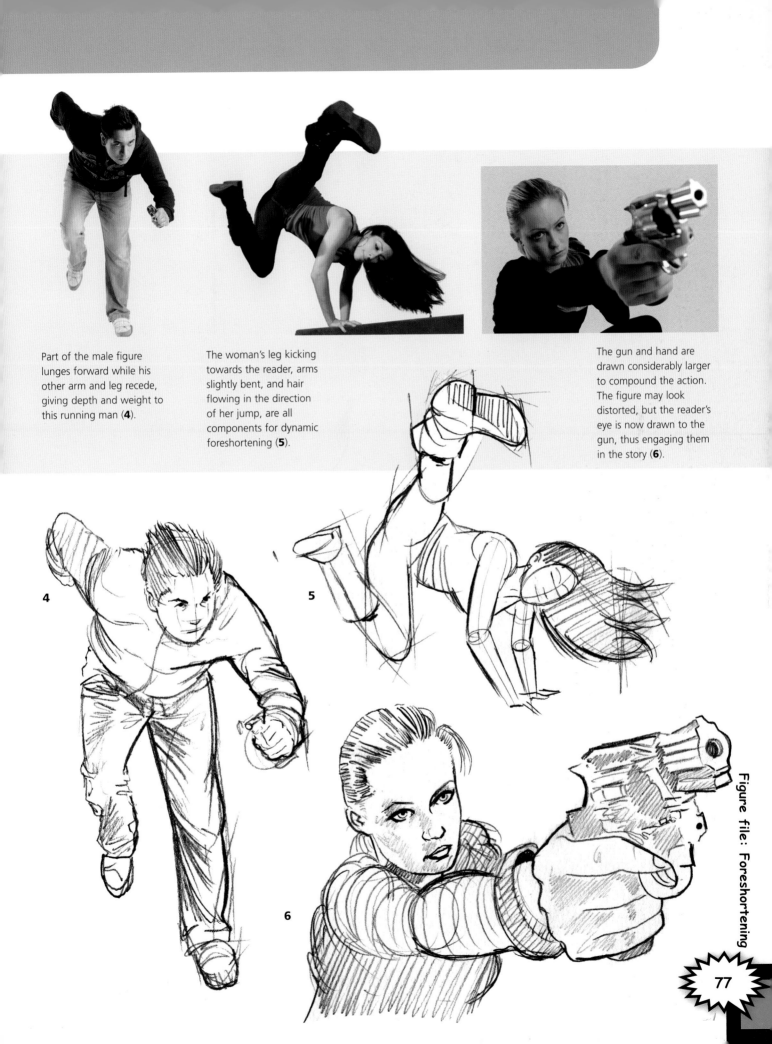

Part of the male figure lunges forward while his other arm and leg recede, giving depth and weight to this running man (**4**).

The woman's leg kicking towards the reader, arms slightly bent, and hair flowing in the direction of her jump, are all components for dynamic foreshortening (**5**).

The gun and hand are drawn considerably larger to compound the action. The figure may look distorted, but the reader's eye is now drawn to the gun, thus engaging them in the story (**6**).

4

5

6

To achieve a menacing, empowered character, the composition was drawn as an upshot. The gun in hand is coming at the reader with a heavy contour line (**7**).

The exaggerated hand and added weight to the contour line lend depth as the hand reaches towards the reader (**8**).

Foreshortening isn't always defined as the subject coming towards the reader, but away – as depicted here. From the waist down, the figure is closer to the reader as the upper body recedes (**9**).

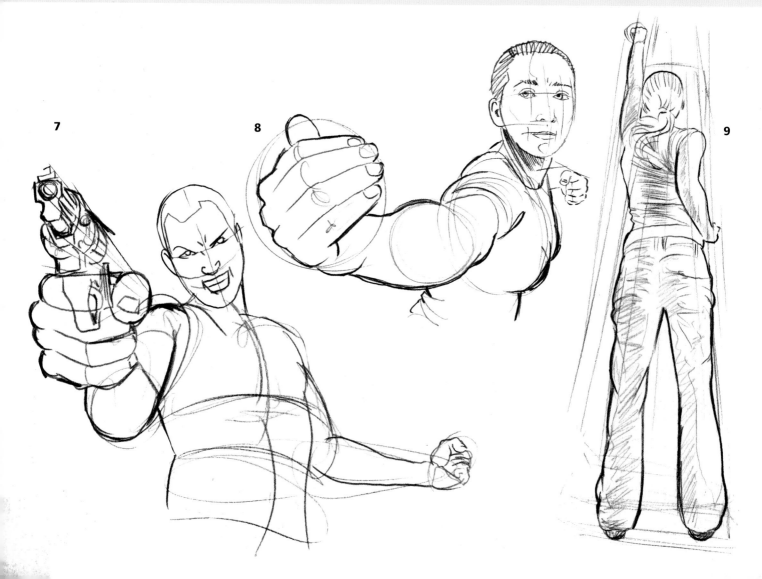

7

8

9

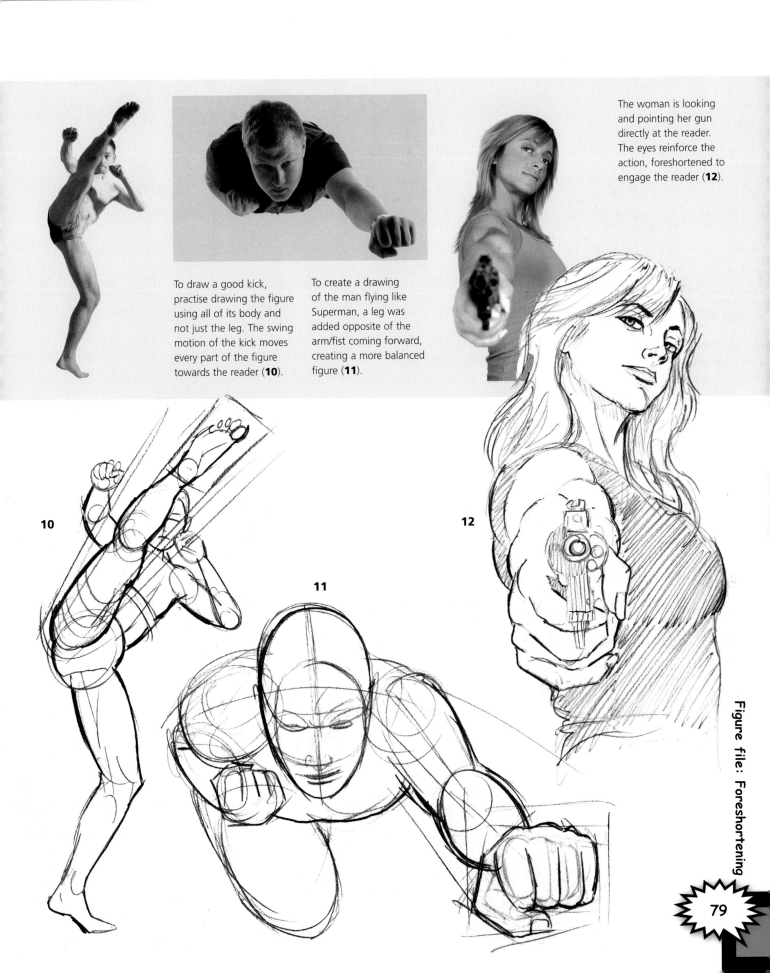

The woman is looking and pointing her gun directly at the reader. The eyes reinforce the action, foreshortened to engage the reader (**12**).

To draw a good kick, practise drawing the figure using all of its body and not just the leg. The swing motion of the kick moves every part of the figure towards the reader (**10**).

To create a drawing of the man flying like Superman, a leg was added opposite of the arm/fist coming forward, creating a more balanced figure (**11**).

10

11

12

# THE TORSO IN DETAIL

The human torso is made up of two forms: a rib cage and pelvis joined together by a flexible spine, which permits movement in all directions.

## RIB CAGE, SPINE AND PELVIS

Even figures in comparatively static poses can be given the feeling of action by simply twisting the rib cage and pelvis in opposing directions – a movement permitted by the flexible nature of the spine, which joins them. Study the curve of the spinal column. The slant of the shoulders and hips and the turning of the body are due to the twisting of the vertebrae (small bones that make up the spinal column). Each vertebra of the spine moves a little, and the movement in the entire spinal column acts as the connecting rod between the upper and lower portions of the torso as well as the head, which, of course, is at the upper tip of the spine. If you understand it thoroughly, it will add greatly to your ability to draw the figure in action from every angle.

## BACK AND CHEST MUSCLES

There are a great many muscles in the human frame – some large and apparent to the eye, others small and hidden. You don't have to know all of them; you only need to be familiar with those that show on the surface when the figure performs different actions. The twisting, thrusting or pulling of any part of the figure causes muscles to assume different shapes and positions. In strong pulling or twisting actions, the muscles stretch taut and become longer and flatter. In pushing actions, they become compressed and tend to bulge. Apply these two principles to make the actions of your characters more convincing. The illustrations on the opposite page depict realistic drawings of back and chest muscles.

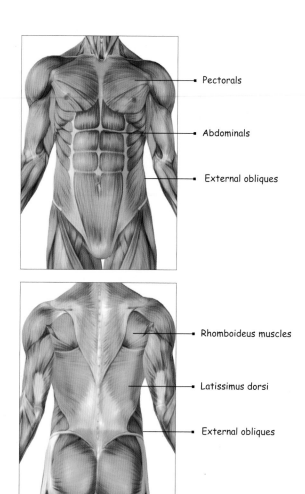

- Pectorals
- Abdominals
- External obliques

- Rhomboideus muscles
- Latissimus dorsi
- External obliques

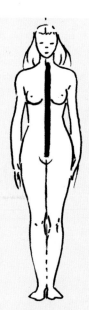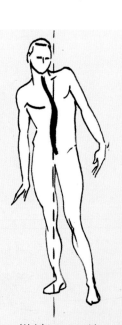

**THE SPINE IN ACTION**
Observe how the spine affects the poses of the human figure. You'll be able to render the figure in action from every angle. The dotted vertical line represents the balance based on how the foot is positioned to support the weight of the figure.

Neutral        Weight on one side

### THE TORSO UP CLOSE

The upper torso is basically a cylinder like a drinking glass. The lower form is more like a sphere cut in half. When the two forms tilt, the spine curves.

Centre lines on both forms establish the degree to which each form is turned away from dead centre (just as the centre line on the head shows the direction it faces).

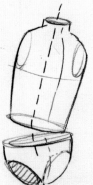

Opening for arms and legs are drawn diagonally across the forms to allow arms and legs to be attached at a proper angle.

### CHEST MUSCLES IN ACTION

The images here show how the muscles change based on how the torso and arms move. Whether they're crunched together or stretched from bending, reaching or lifting, the muscles express themselves differently.

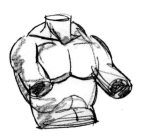

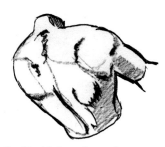

Shoulder blades pull away from the spine.

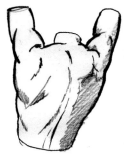

The action of the arms compresses the chest muscles.

The backward pulling action results in the chest muscles being stretched and becoming flat.

If the arms are supporting a heavy weight, the back muscles will be compressed and bulky. However, if the arms are merely upraised, these muscles will be stretched and flat.

The biceps and shoulder muscles become more pronounced as the arms thrust a heavy object up, resulting in raised chest muscles.

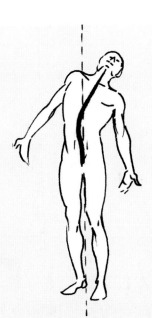

Leaning back a little

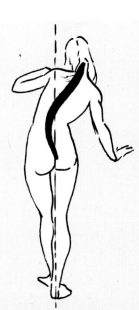

Twisting body to one side

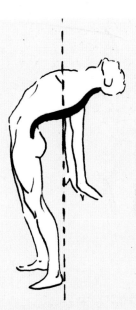

Leaning far back

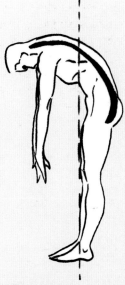

Leaning forward

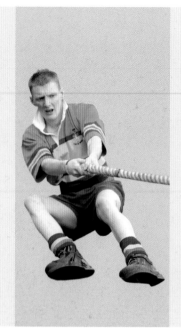

The chest compresses as the arms pull inwards. The knees bend, working simultaneously as resistance and to help the pulling action (**1**).

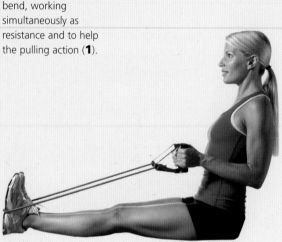

The pulling action of the arms compresses the biceps and tightens the back and chest muscles (**2**).

The twisting action of the woman reveals the movement of the torso as both feet are firmly planted for balance (**3**).

1

2

3

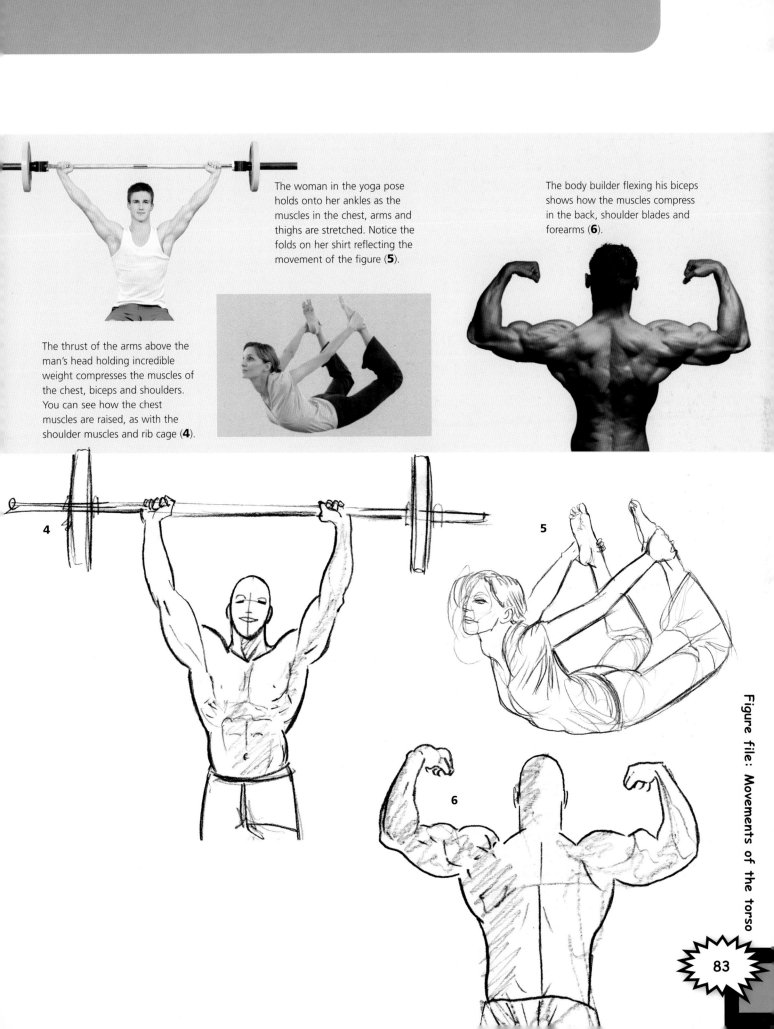

The woman in the yoga pose holds onto her ankles as the muscles in the chest, arms and thighs are stretched. Notice the folds on her shirt reflecting the movement of the figure (**5**).

The body builder flexing his biceps shows how the muscles compress in the back, shoulder blades and forearms (**6**).

The thrust of the arms above the man's head holding incredible weight compresses the muscles of the chest, biceps and shoulders. You can see how the chest muscles are raised, as with the shoulder muscles and rib cage (**4**).

4

5

6

# THE LIMBS IN DETAIL

If the face and the hands are the most expressive part of the body, then the arms and legs are the workforce conveying the action. Arms and legs support the movement of the figure in action.

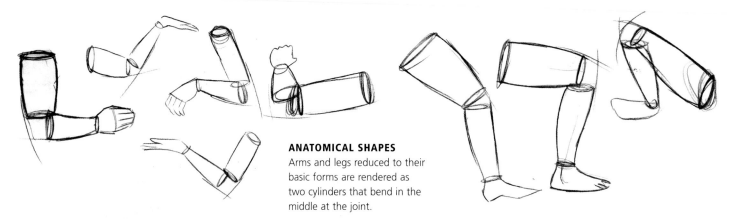

**ANATOMICAL SHAPES**
Arms and legs reduced to their basic forms are rendered as two cylinders that bend in the middle at the joint.

## THE ARMS

The upper and lower arm are modified cylinders. The main difference between the arms and legs is that they bend in opposite directions. The principal and most easily seen muscles of the arm are the shoulder muscle (deltoid), the biceps and triceps and the extensor carpi radials longus. The latter is merely a fancy name for a long muscle, which begins above the elbow and extends to the wrist. The extensor carpi radials longus twists the forearm. The biceps muscle bends the elbow and flexes the forearm. The triceps muscle, which runs the length of the upper arm, acts in opposition to the biceps.

## THE LEGS

Reduced to their basic forms, the upper and lower leg are both modified cylinders about equal in length. There are many lumps and bumps created by the muscles in a well-developed leg. Two important muscles govern the shape and action of the leg. These are the triceps surae (made up of the gastrocnemius and the soleus) and the biceps femoris. These two muscles, in combination, create alternating curves, which give pleasing form to the leg, and it is this overall form that should be established first. Muscle detail, no matter how well drawn, should always be kept subordinate to overall form.

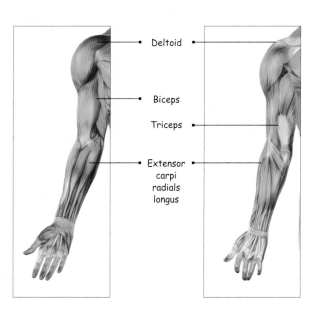

Deltoid

Biceps

Triceps

Extensor carpi radials longus

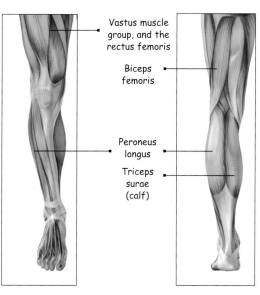

Vastus muscle group, and the rectus femoris

Biceps femoris

Peroneus longus

Triceps surae (calf)

## ARM MUSCLES IN ACTION

The arm muscles most often drawn in comics are the shoulder muscle (deltoid), the biceps and triceps and the muscle running from above the elbow extending to the wrist (extensor carpi radials longus).

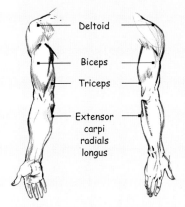

- Deltoid
- Biceps
- Triceps
- Extensor carpi radials longus

In bending the arm, the biceps becomes short and thick.

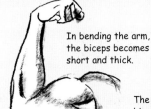

The action of the biceps may be represented fairly realistically in a figure.

In a straight pushing/thrusting action, the triceps and extensor carpi radials longus become prominent. The biceps, in contrast, tends to flatten out.

In a violent pushing action, the forearm muscles become short and thick.

## 'DRAWING THROUGH'

When forms overlap in a strong bending action, as depicted here in both the simplified and the rendered drawing, 'draw through' the forms to establish the desired pose. Once the proportions of the pose are established, you can add on the muscles.

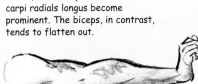

## LEG MUSCLES IN ACTION

The leg muscles that govern the shape and the action of the leg are the triceps surae (calf) and the biceps femoris (thigh), depicted below.

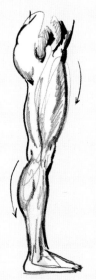

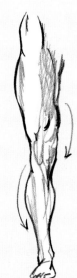

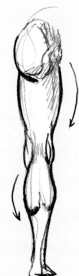

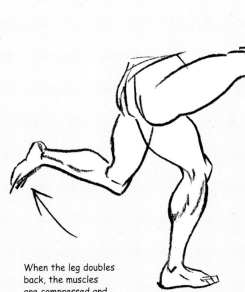

Note the rhythmic relationship between the front of the thigh and the bulging calf muscle.

The curve of the sartorius muscle (from the hip to the inner knee) is continued in reverse by the curve of the lower leg.

Establish these fluid-like relationships between thigh and lower leg before drawing individual muscles in detail.

When the leg doubles back, the muscles are compressed and become shorter and thicker.

With the leg extended, the muscles become longer and smoother. The action of the leg determines the shape or prominence of the muscles. When the leg supports the weight, calf muscles are more prominent.

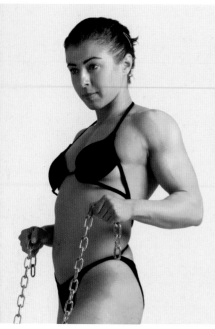

The pulling action of this muscular woman reveals the prominent muscles of the deltoid and biceps at work as they are compressed. The chest is raised, the shoulders fall back and the mid-section is defined as the abdominal muscles go to work (**1**).

The bending at the knees and the outstretched arms help this figure retain her balance as the muscles in the legs and arms are used. Notice the good posture in the drawing below (**2**).

This female is stretching her calf and thigh muscles while putting up resistance against a wall or another figure, using the arms and legs for action (**3**).

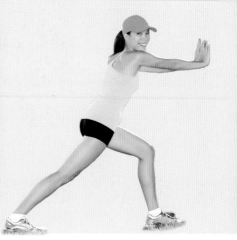

**1**

**2**

**3**

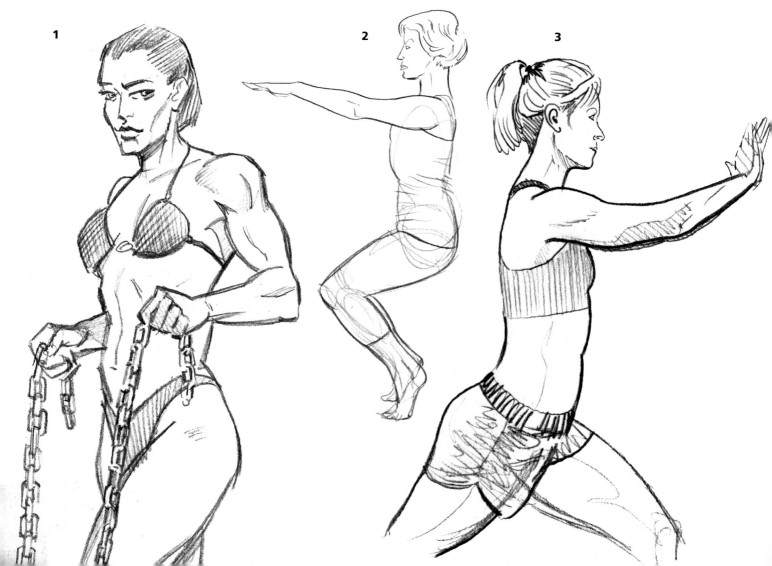

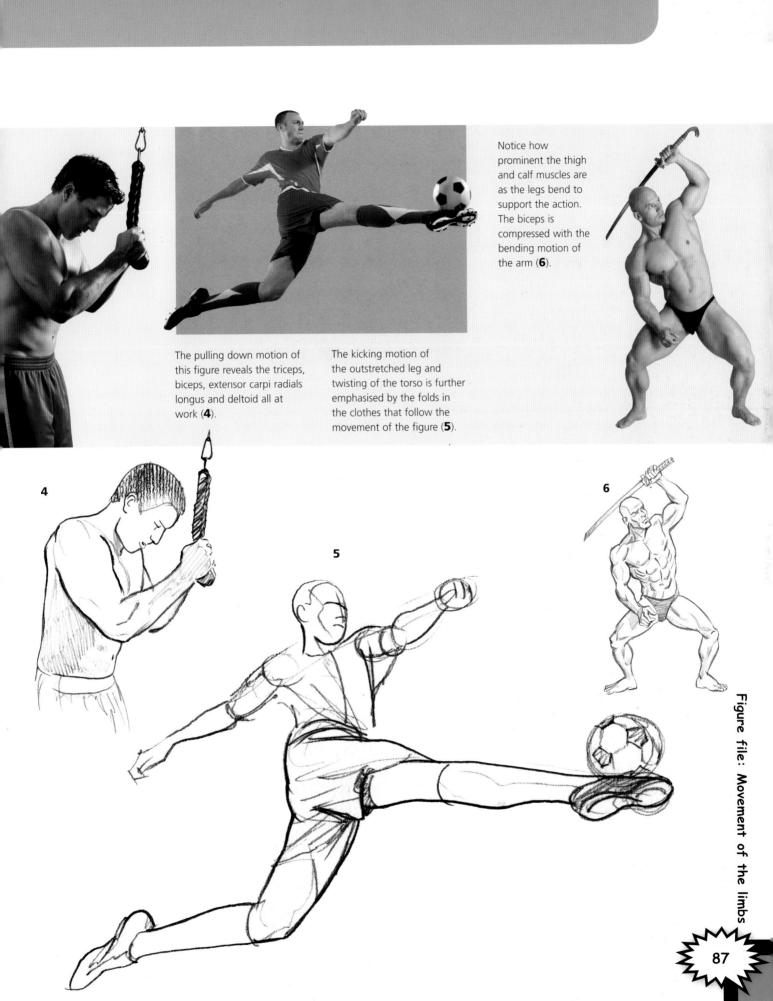

Notice how prominent the thigh and calf muscles are as the legs bend to support the action. The biceps is compressed with the bending motion of the arm (**6**).

The pulling down motion of this figure reveals the triceps, biceps, extensor carpi radials longus and deltoid all at work (**4**).

The kicking motion of the outstretched leg and twisting of the torso is further emphasised by the folds in the clothes that follow the movement of the figure (**5**).

**4**

**5**

**6**

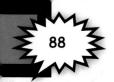
# FEET IN DETAIL

There are few occasions when the comic book artist is called upon to draw bare feet. More often than not, however, you will be asked to draw the shoes – which is an art in itself.

Feet and shoes are great fun to draw because they have plenty of character and play a big part in expressing the personality of the figure. However, they can be difficult to draw well. The human foot has a limited action. This action is further limited by the shoe, which inhibits the ability of the toes to bend upwards or curl under – both very expressive actions. This makes it even more important that you add character and personality to the feet and shoe.

Many good figure action poses are ruined because the feet are too set or stiff, so, when it is called for, try to give the feet expressive action by a little exaggeration. However, exaggerate only such actions as the foot actually can perform, or your figures will appear awkwardly out of joint.

Regardless of how you draw shoes, remember they must fit the rest of the character. Don't draw the same kind of shoes on all of your characters.

Don't overlook the bottoms of shoes. A man running away from you will show the bottom of the foot that is behind. There is a lot of 'feeling' to the bottoms of shoes. Say, for example, you want to draw a man that has been knocked down. One way of making him look really 'out' would be to show him with his feet towards the reader, and the bottoms of his shoes toed in.

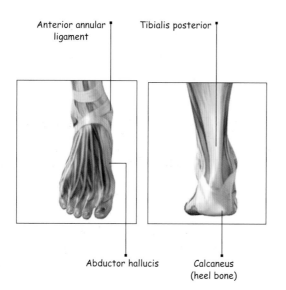

Anterior annular
ligament

Tibialis posterior

Abductor hallucis

Calcaneus
(heel bone)

## MALE FEET AND FEMALE FEET

The male foot is longer and wider than the female foot. The average male has denser muscle mass and the female has less cartilage between the bones (female muscles are generally more flexible). Beyond these general attributes, both male and female feet can be wide/narrow, high-arched/flat footed, long-toed/short-toed, etc.

Female feet

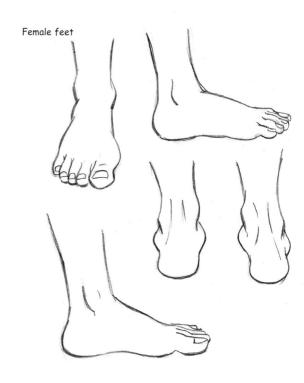

Male feet

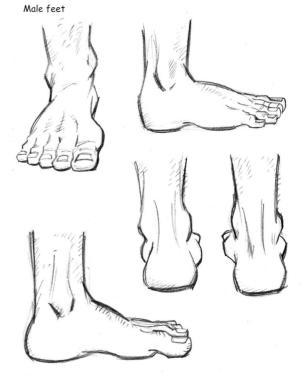

## ANATOMICAL FEATURES OF THE FOOT

An anatomical understanding of how the foot performs is essential.

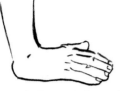

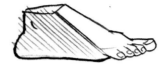

The foot is similar to the hand, except that it is built like a concrete bridge support carrying the weight of the body.

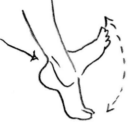

The foot can move from side to side and up and down.

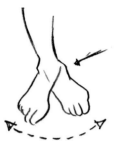

Where the foot joins the ankle, you can think of it as fitting into a slot in the ankle that allows it limited motion up, down and sideways for walking.

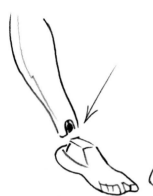

When the heel rises at the beginning of a step, the toes flatten out as they bear the weight of the figure. Bending action occurs at the ball of the foot.

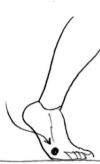

Toes can bend upwards or curl under the foot.

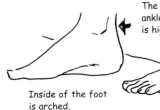

The inside ankle bone is higher.

Outside ankle is lower.

Inside of the foot is arched.

Outside of the foot is level.

Women's shoes should be simplified and stylised down to a point where they are graceful and well structured, and do not draw attention away from the rest of the figure.

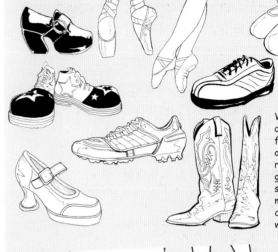

What distinguishes feet from one another, regardless of gender, are the shoes. Footwear must reflect the character who wears them.

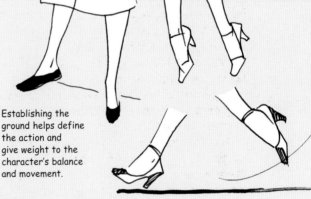

Establishing the ground helps define the action and give weight to the character's balance and movement.

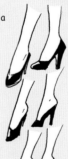

Depicted here is a progression from a realistic pair of shoes to a stylised pair of shoes.

To avoid drawing two right feet, shift the figure's weight to view one foot from a different angle.

## THE CUFF RULE

When you see the top of the cuff, you will see the top of the foot; when you are looking up at the cuff, you will see the bottom of the foot.

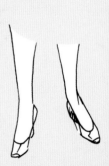

Looking down at the cuff

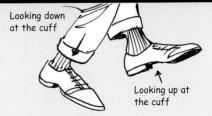

Looking up at the cuff

# HANDS IN DETAIL

Look at any number of comic books and you will have trouble finding a hand that follows true, anatomical construction. However, no matter how loosely the artist draws hands, a good artist knows what a real hand looks like.

The best reference for hands are your own. They'll show you the positions hands can assume, and these different positions will add character to your figure drawings. In telling a story and showing expression, the hands are second only to the face, so learn to draw them in every action.

The hands of a trapeze artist attached to the arms of an academic would look out of place; an elderly gent's wrinkled and gnarled claws on a teenager would make your drawing look decidedly strange; and hands with slender tapering fingers, although fine for a hairdresser or piano virtuoso, would hardly belong to a lumberjack. Always give your characters hands suitable for their occupation or personality.

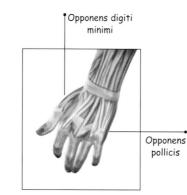

Abductor pollicis brevis

Opponens digiti minimi

Palmaris brevis

Opponens pollicis

## HAND TYPES

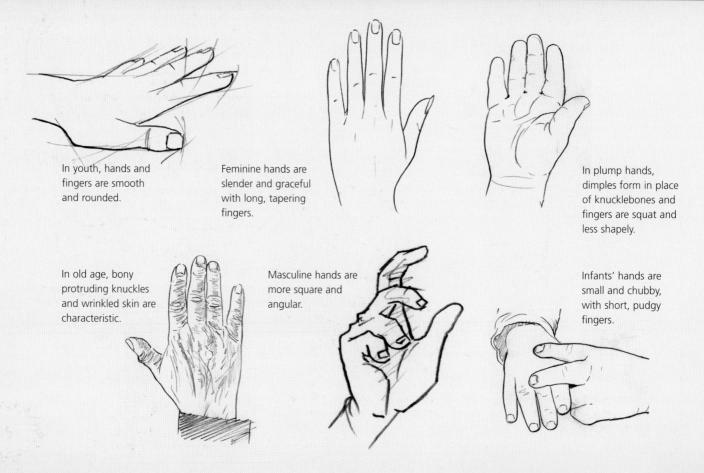

In youth, hands and fingers are smooth and rounded.

Feminine hands are slender and graceful with long, tapering fingers.

In plump hands, dimples form in place of knucklebones and fingers are squat and less shapely.

In old age, bony protruding knuckles and wrinkled skin are characteristic.

Masculine hands are more square and angular.

Infants' hands are small and chubby, with short, pudgy fingers.

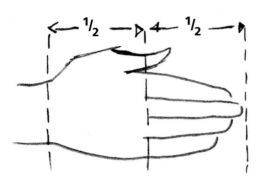

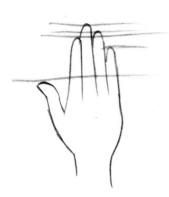

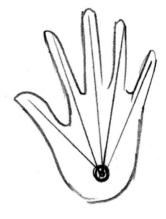

Note proportion of fingers to the body of the hand.

Each finger is a different length.

Fingers and thumb all radiate from the same point.

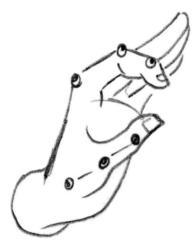

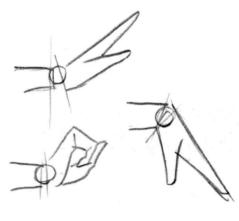

The fingers and thumb each have three joints.

In size, the hand reaches from chin to hairline.

The great variety of wrist movements in combination with the action of the arm gives a complete range of movement.

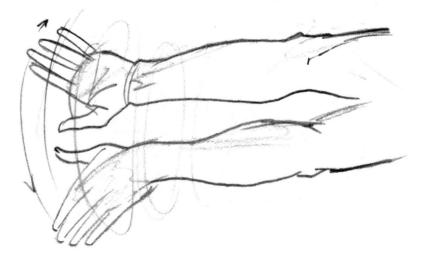

The thumb is attached to the wrist and swings independently of the rest of the hand.

The hand in conjunction with the arm can turn completely around.

## SIMPLIFYING HANDS

In old Chinese brush drawing there is an aphorism that says, 'it isn't what they put in – it's what they leave out'. Good artists simplify their hands, but you can't simplify until you understand the actual construction. Every line that has the appearance of careless informality is the result of past study of actual anatomical detail on the part of the artist who has drawn it.

This detailed drawing would be fine in a comic book showing a close-up view of the hand, but otherwise it's a bit too complicated for an average drawing.

Here's a simpler version of the same hand. Still fairly realistic but with most of the detail omitted.

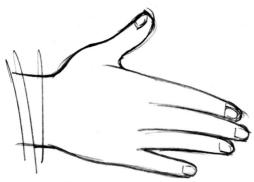

Further simplification gives an exaggerated version of the hand.

### DRAWING THE HAND IN MITTEN FORM

Drawing the hands in mitten form is an easy and quick way of getting around difficult-to-draw hands. Only follow this approach if the emphasis of your figure is something other than the hands.

**1** Draw two interlocking circles – one to represent the palm and the other the fingers.

**2** Draw tapering horizontal lines touching the edges of the circles and a curved vertical line between them.

**3** Add a thumb and you have the basic mitten shape.

**4** Complete the hand by drawing the fingers.

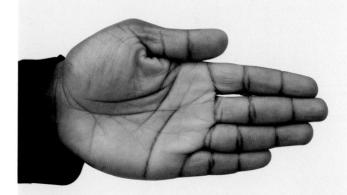

# FIGURE FILE: HANDS

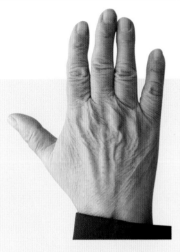

A closed fist shows the creases in the thumb. Lines are formed from the compression of the palm, and the knuckles become more pronounced when the fingers bend (**2**).

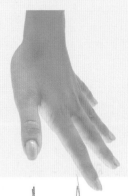

The hand stretches down and outwards. The fingers are pointed and the knuckles are more pronounced (**4**).

As a person's hand ages, their skin becomes more wrinkled, the bones in the knuckles protrude and veins and spots may become more present (**1**).

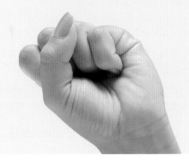

This hand shows how expressive the fingers can be. Notice how the index finger is slightly bent to keep the pen in place (**3**).

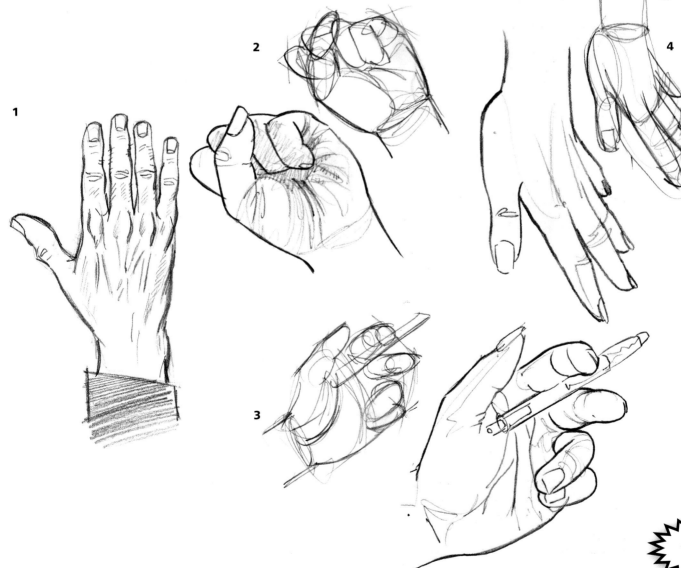

1

2

3

4

# 4

# DRAWING THE CLOTHING

One of the most important drawing skills a comic book artist can develop is the ability to draw folds. The instructions throughout this chapter are intended to serve only as a springboard to continue your development of drawing clothing. Apply the principles of these drawing mechanics to improve drawing from life and build a visual vocabulary based on your observations.

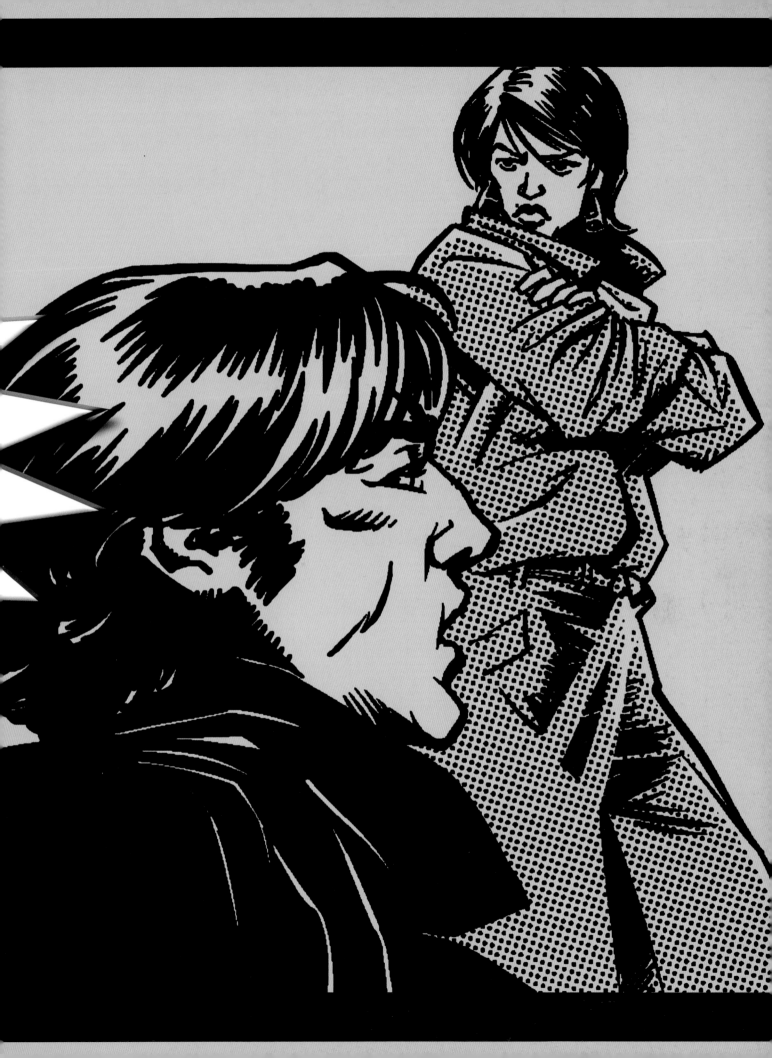

# LAW OF FOLDS

Folds are caused mainly by tension occurring at various points: shoulder–arm connection, elbow, waist, leg–torso connection and the knee. A study of the general character of each group of folds is necessary to drape the figure well.

When a clothed arm, torso or leg bends or changes direction, the cloth slackens on the opposite side of the tension. This cloth obviously does not change in amount; it just condenses. As it condenses, it creates folds that behave in definite ways in different places. The way they behave is determined by gravity, tension, support and action.

In this section, we run you through some carefully selected graphic diagrams of folds. You must understand the basic direction and structure of each fold before you can apply the principles of that fold to a clothed figure. Folds are irregular by nature: you should be aware of the irregularities present in all folds before you attempt any drawings of garments.

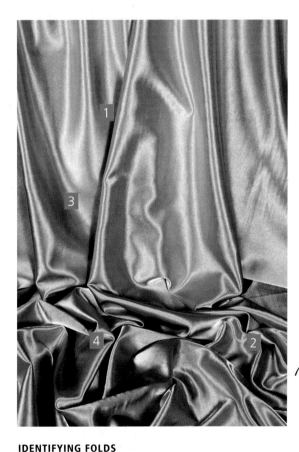

**IDENTIFYING FOLDS**

It is rare that you will only find one type of fold in a given garment or piece of fabric. Fabrics are capable of folding in many different ways all at the same time. Notice how this fabric contains pipe folds, inert folds, diaper folds and zigzag folds. Can you spot any more?

## SEVEN BASIC FOLDS

Folds are irregular by nature but, broadly speaking, they can be identified as falling into seven basic categories. These seven folds are best described graphically as follows. You will discover more about these folds over the next pages.

**PIPE FOLD (1)**
See right.

**ZIGZAG FOLD (4)**
See page 98.

**CONCERTINA FOLD**
See page 98.

**INERT FOLD (2)**
See right.

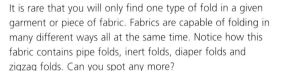

**DIAPER FOLD (3)**
See page 100.

**HALF-LOCK FOLD**
See page 100.

**DROP FOLD**
See page 101.

## PIPE FOLD

The pipe fold is the most straightforward form of drape. The fold occurs from one point of suspension, or when pulled between two tension points. Always draw this fold with the understanding that it is the condensing of a large area of cloth into a smaller area. It is usually dictated by gravity, having a more or less smooth, consistent pattern.

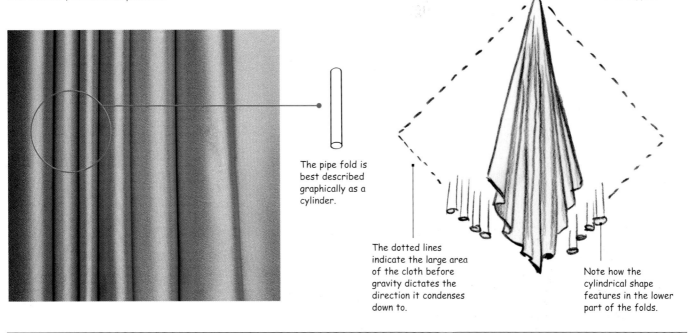

The pipe fold is best described graphically as a cylinder.

Point of support

The dotted lines indicate the large area of the cloth before gravity dictates the direction it condenses down to.

Note how the cylindrical shape features in the lower part of the folds.

## INERT FOLD

An inert fold is commonly referred to as a 'dead' fold. We say this because it is not active, or in use, but lies inertly. It can have all manner of individual folds on its top surface. Its basic characteristic is that it is lying limp, on an inactive surface. Its overall feeling and direction will be characteristic of the surface upon which it is resting.

The shape of the surface upon which they are resting governs inert folds.

The inert fold is best described graphically as a wavy horizontal line.

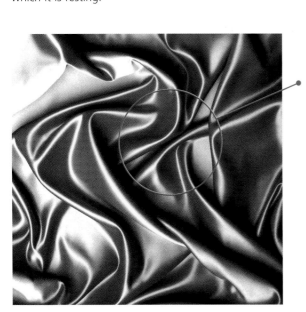

▶ Inert folds occur when the fabric rests on a horizontal plane and has nowhere else to go, thus forming a 'puddle' of folds.

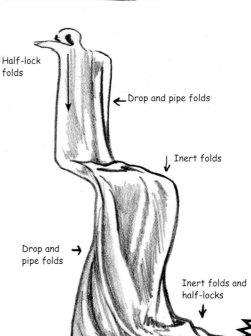

Half-lock folds

◀ Drop and pipe folds

↓ Inert folds

Drop and pipe folds →

Inert folds and half-locks ↓

## ZIGZAG FOLD

This fold refers to the pattern when a pipe fold is bent and the zigzag fold is created on the slack side of the bend. Observe someone wearing a jacket with their hand in the jacket's pocket. Notice how the fabric that makes up the sleeve bends. The outside of the fabric, where the tension is created by the elbow, is stretched, while the inside buckles into itself.

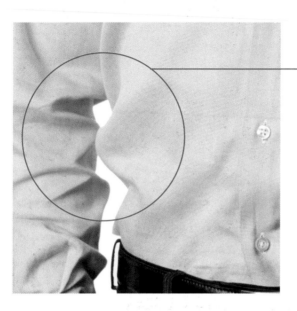

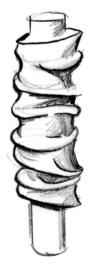

The slack area of the fabric may twist and fold as it descends.

Note how one fold fits into the other. The folds underneath are relaxed.

The zigzag fold goes in alternating directions. The type of fabric determines the fold. The more rigid the fabric, the more prominent the fold.

## CONCERTINA FOLD

This fold is commonly found wrapped around a tubular form. Concertina folds can change direction as the origins of support and tension vary depending on the form. Sleeves and trouser legs are good examples of the concertina fold in context.

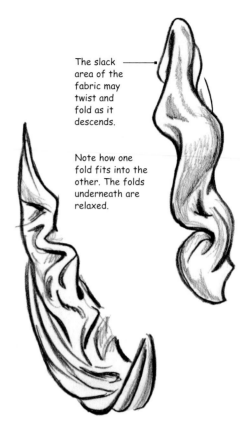

Concertina folds most commonly revolve around a form. Imagine a piece of cloth wrapped around a cylinder, with about the same amount of slack found between the cloth and cylinder.

The concertina fold is best described graphically as tubular, with a feeling of continuity in an ascending or descending manner.

Because of the slack between the cloth and the cylinder, the cloth condenses, and as it does so, creates concertina folds.

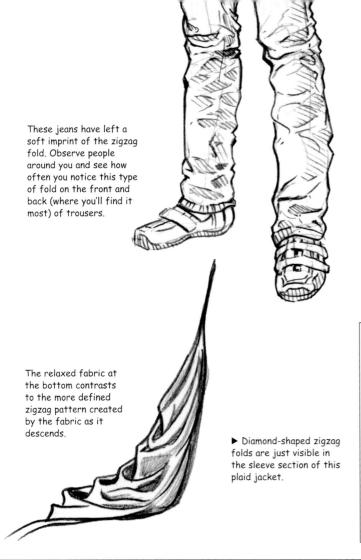

These jeans have left a soft imprint of the zigzag fold. Observe people around you and see how often you notice this type of fold on the front and back (where you'll find it most) of trousers.

The relaxed fabric at the bottom contrasts to the more defined zigzag pattern created by the fabric as it descends.

Notice the diamond shapes formed in the sleeve where the elbow bends. The top and bottom fold towards one another to form two triangular planes that meet in the middle.

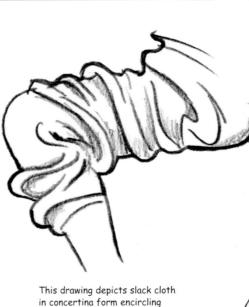

▶ Diamond-shaped zigzag folds are just visible in the sleeve section of this plaid jacket.

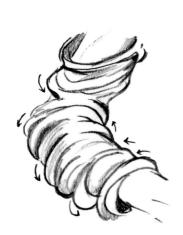

A well-drawn concertina fold will follow the form beneath it and change direction when the form changes direction.

This drawing depicts slack cloth in concertina form encircling a leg. The direction of the concertina moves towards the slight tension in the fold. If the tension increases, the concertinas will tighten around the form.

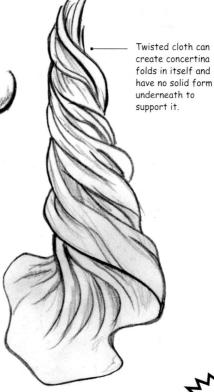

Twisted cloth can create concertina folds in itself and have no solid form underneath to support it.

## DIAPER FOLD

The diaper fold occurs at the break or turn of the cloth. This is usually on a wide, flat surface, rather than on a tubular piece of cloth. The top of the curve is usually sharp, and the lower side of the fold is relaxed. The slant and sweep of the fold will change in character with different qualities of material. As the points of support vary, the angle of the dip changes.

Notice how prominent the triangular shape is, even in the fully rendered drawing.

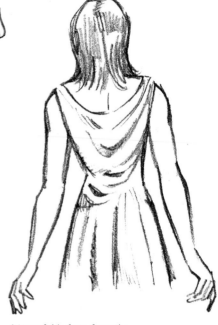

This fold is triangular in shape, dropping away in a curving manner from one point to another on a horizontal line. Sometimes this has an angular, rather than a curved, change of direction.

Diaper folds form from the anchored points of the shoulders, creating the Grecian neckline, an elegant style used for centuries in fashion and still commonly found in figure drawing today.

## HALF-LOCK FOLD

The half-lock fold occurs when tubular or flat pieces of cloth change direction due to the action of the form underneath. The fold generally occurs on the slack side of the form. To draw the half-lock, first sketch in the general form of the drape.

The point shown by the arrow indicates where the two parts of cloth pass each other, creating a double half-lock fold. The fabric must turn back on itself as it is part of a single continuous flow of material.

The half-lock fold is best described graphically as a change in direction.

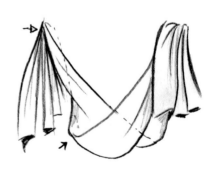

The half-lock generally occurs at the change of direction. The dotted line indicates the direction of the cloth behind the fold.

## DROP FOLD

From a point of suspension, the drop fold twists and turns. Sometimes it hangs straight, like a pipe fold; at other times, a curved edge will give it a concertina effect. The important characteristic is that it is dropping. Drop folds will contain small zigzags, concertinas and half-locks, but they all contribute to the entire drop of the cloth.

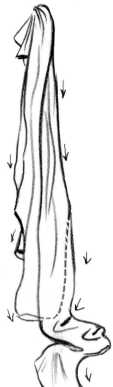

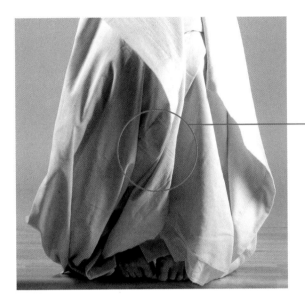

The drop fold is best described graphically as a shape that falls freely from a point or area of support.

Unlike a pipe fold, the drop fold may feature unevenness in its shape and irregular pleats.

The tighter underside of this cloth gives another variety of fold, but this is still a drop fold since it is dropping downwards.

---

▼ Note that the angle and direction of these half-lock folds are only slightly irregular. The change of direction here is mostly in the fold itself and is caused by the relaxed nature of the cloth.

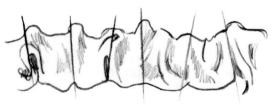

The arrows indicate three half-lock folds, where the fabric changes direction and the slack areas meet.

▶ Here, the half-lock folds are illustrated from a three-quarter view, allowing you to see them on a bent leg and a slightly more relaxed leg. The folds are created from the tension points of the knees.

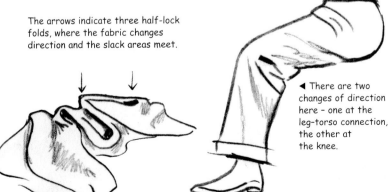

◀ There are two changes of direction here – one at the leg-torso connection, the other at the knee.

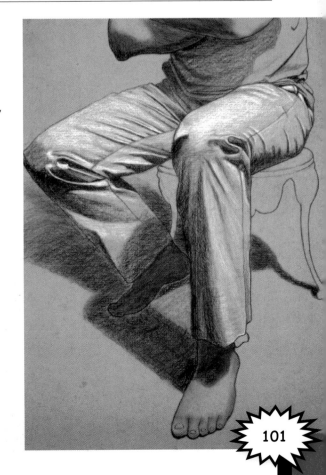

# CLOTHING THE MALE FIGURE

The folds on a male figure, caused chiefly by the laws of gravity, are most commonly supported at two places: the shoulders and the waist.

### LOCATING THE FOLDS IN A STANDING FIGURE

Before you draw any clothed figure, it is important to first block in the underlying human figure, and then to locate the main direction of the folds acting upon that figure.

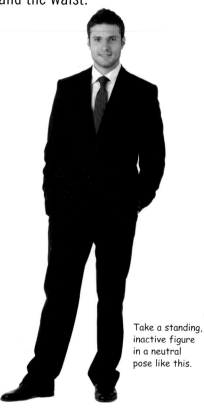

Take a standing, inactive figure in a neutral pose like this.

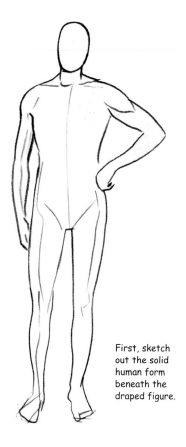

First, sketch out the solid human form beneath the draped figure.

### IN MOTION

When the figure is in motion, the direction of the folds follow the action of the body.

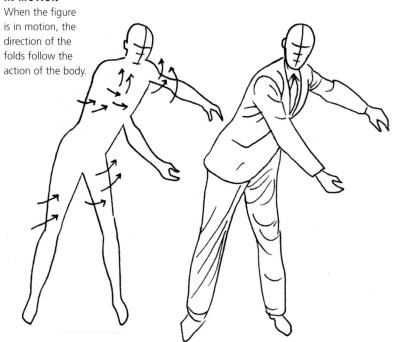

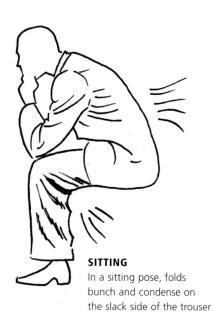

### SITTING

In a sitting pose, folds bunch and condense on the slack side of the trouser leg, opposite the point of tension.

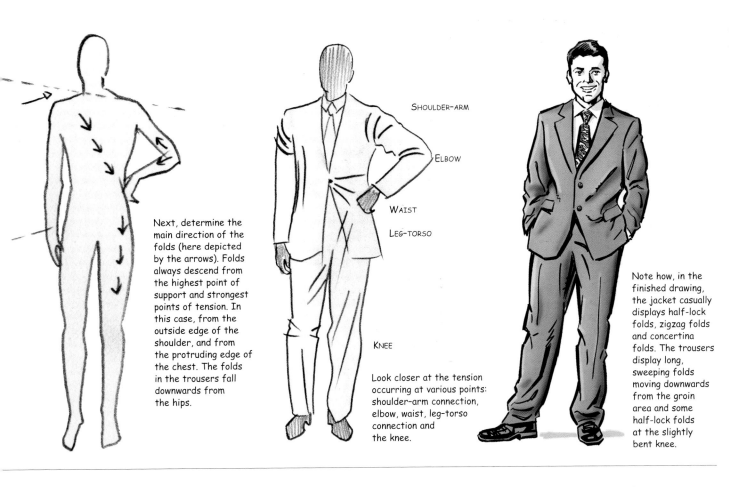

Next, determine the main direction of the folds (here depicted by the arrows). Folds always descend from the highest point of support and strongest points of tension. In this case, from the outside edge of the shoulder, and from the protruding edge of the chest. The folds in the trousers fall downwards from the hips.

SHOULDER-ARM

ELBOW

WAIST

LEG-TORSO

KNEE

Look closer at the tension occurring at various points: shoulder-arm connection, elbow, waist, leg-torso connection and the knee.

Note how, in the finished drawing, the jacket casually displays half-lock folds, zigzag folds and concertina folds. The trousers display long, sweeping folds moving downwards from the groin area and some half-lock folds at the slightly bent knee.

## ARMS OUTSTRETCHED

With the arms outstretched under a buttoned coat, a group of tight condensed folds occurs at the shoulder–arm connection. They radiate in a curving manner from the shoulder to the point of tension at the button.

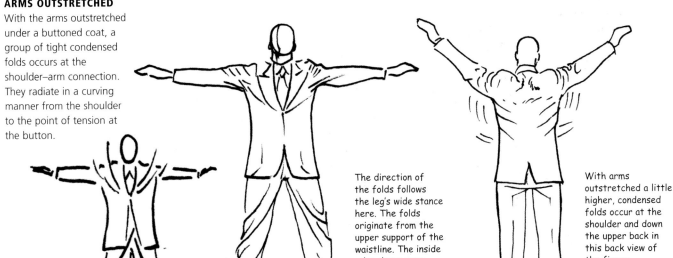

The direction of the folds follows the leg's wide stance here. The folds originate from the upper support of the waistline. The inside edge drops away, influenced by gravity.

With arms outstretched a little higher, condensed folds occur at the shoulder and down the upper back in this back view of the figure.

## TROUSERS

The high place of support is at the waist. The larger the width of the hips, the greater they dictate the folds because they become a point of support. You must consider the form beneath the trousers. The lower body is cylindrical. In male clothing, the trousers are made to cover the cylinders with sufficient slack to allow freedom of action. The drape of the cloth must go around the form, and also obey the laws of gravity, support, tension and function.

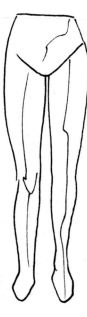

▶ Trousers are supported at the waist, but 'hang' from the hips and buttocks. The pressed seam drops straight down due to gravity. Other slight sweeping folds follow the contour of the limbs.

◀ Beneath the trousers are the legs. Remember this as you draw the clothing.

▶ In these side views, the folds pull upwards or downwards to the point of support. This causes long, sweeping pipe and drop folds.

SUPPORT POINT.

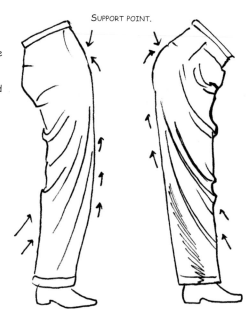

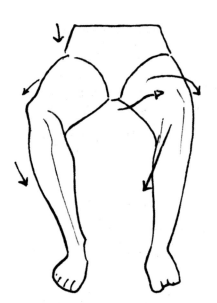

Note the points of tension acting on the muscles in this sitting position.

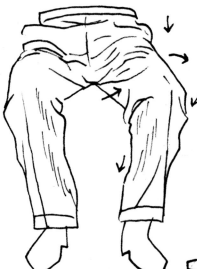

When clothed, the concertina folds condense at the leg-torso connection and follow the direction and shape of the upper leg. Pipe folds occur from the knee down.

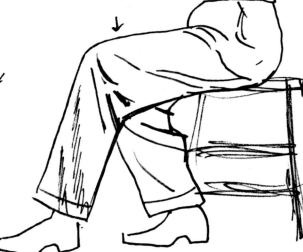

The trouser folds descend from the tension point of the leg as a result of gravity. The folds can only descend as far as the length of the fabric.

▶ The leg on the left is straight. The other is bent at the knee. The change of direction creates half-lock folds on the under or slack side of the bent leg. Where the leg on the left joins the torso, other tight half-locks and pipe folds occur.

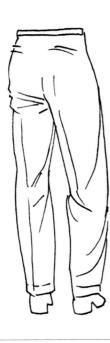

▶ The leg on the right is bent slightly back. This causes a 'pull' from the support point at the waist. A long, sweeping pipe fold descends to the calf. The tension causes small concertina folds at the buttocks.

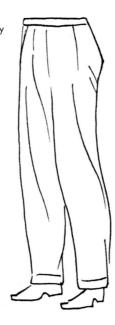

▶ There are three important folds featured here. The first is at the top of the leg, the second is at the knee and the third on the left leg, caused by a tension-free trouser leg.

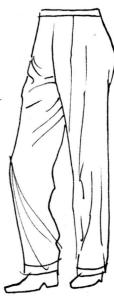

## THE SLEEVE

These drawings of the sleeve in various positions are made up almost entirely of half-locks, concertinas and zigzags. There is one basic half-lock that always occurs on the upper side of the arm opposite the elbow. The black accents show the half-lock folds.

The outstretched arm displays mostly memory folds of half-locks and zigzag folds.

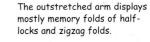

This view of the bent arm displays half-locks and concertinas. Notice the tension point in the elbow.

The slightly raised arm displays defined half-locks and zigzag folds throughout the sleeve.

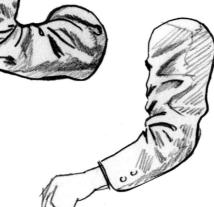

In this side view, the tension point at the elbow displays prominent folds up the sleeve and zigzag folds in the forearm.

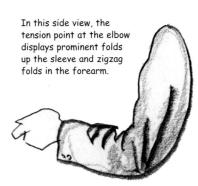

Half-locks and zigzag folds are more defined, with a relaxed concertina fold on the upper arm.

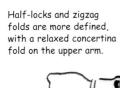

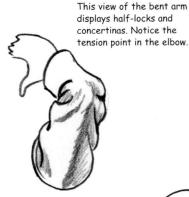

In this side view, the bent arm displays half-locks and some memory zigzag folds from the fabric being worn.

## THE COAT

The coat or jacket is supported from the shoulders. Its range of folds is greater than the trousers; first, because of the increased action of the arms; second, because it can be buttoned or unbuttoned; and third, because of the greater variety of garment design. The form and action of the torso and arms must be understood to draw these folds correctly. The shoulders and arms create most of the folds because of their greater range of motion when compared to the limited range of the torso action.

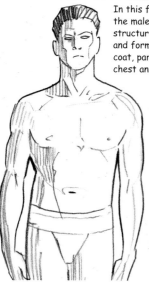

In this front view of the male torso, the basic structure gives support and form to the man's coat, particularly in the chest and shoulders.

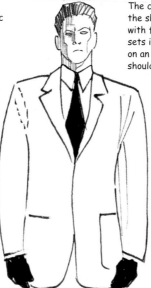

The coat is supported from the shoulders and descends with few folds. The sleeve sets into the body of the coat on an angle where the arm and shoulder join.

When the arm is lifted, a tension occurs on the cylindrical sleeve that condenses the folds at the armpit in concertinas and half-locks.

The back view of the coat reveals long sweeping folds falling from the shoulder, halfway down and across the back. Note the half-lock and zigzag folds in the bent arm and slight drop folds in the right arm.

Notice the large half-lock fold that occurs at the waist button position on the coat. This occurs because the figure is bent sideways and there is a great deal of slackness in the garment.

When the coat is not buttoned and the arms are raised, the folds are well defined at the shoulders and relax as they drape down the coat.

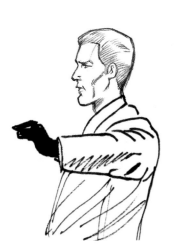

The tension comes from the shoulder-arm connection, creating folds along the back, from the coat button and the elbow.

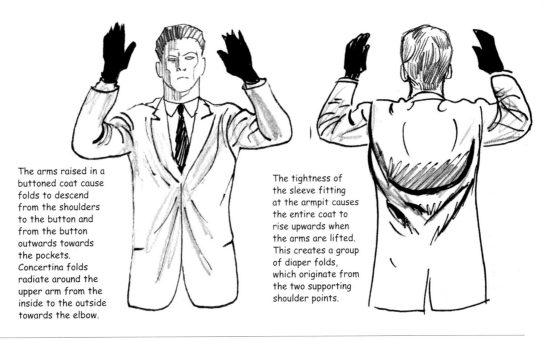

The arms raised in a buttoned coat cause folds to descend from the shoulders to the button and from the button outwards towards the pockets. Concertina folds radiate around the upper arm from the inside to the outside towards the elbow.

The tightness of the sleeve fitting at the armpit causes the entire coat to rise upwards when the arms are lifted. This creates a group of diaper folds, which originate from the two supporting shoulder points.

## THE SHIRT

The main difference between the shirt and the coat is that the shirt is held taut at the waist. The shirt contains drop folds and pipe folds, radiating from the waist to the shoulders. They vary in character in relation to the degree of tension present. A twist of the body will sometimes give them a tight concertina character, while a relaxed attitude will create numerous diaper folds.

Because dress shirts have a yoke across the shoulders, folds descend from the yoke to the waist rather than from the top of the shoulders. These are pipe folds and drop folds. A change of tension caused by the lifting of the arms will change them to diaper folds.

In this side view of the man bending down, the folds are created from the tension point of the arm, which is moving forward, and the upper back.

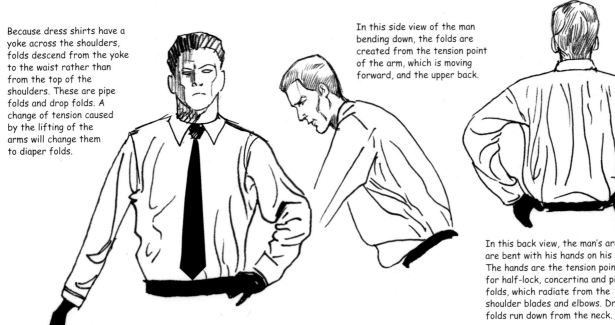

In this back view, the man's arms are bent with his hands on his hips. The hands are the tension points for half-lock, concertina and pipe folds, which radiate from the shoulder blades and elbows. Drop folds run down from the neck.

**107**

# CLOTHING THE FEMALE FIGURE

Because of the variety in female clothing, you should always sketch in the form of the figure first, and then drape the form. This gives you something to build on.

The garment may be gathered at the waist and fall from the bust to the waist, to the hips – and then descend. Or it may be a separate blouse and a skirt. The skirt extends out from the waist and falls due to gravity from the hips. This attire is generally considered to be a traditional female costume, just as a man's costume is a coat, trousers and shirt.

Always follow the fold through. That is, draw it completely around from start to finish by drawing its volume, its depth and its contour. When you do this, the fold that is controlled by tension will follow the form. Those folds controlled only by gravity will find the protruding edge and descend from there.

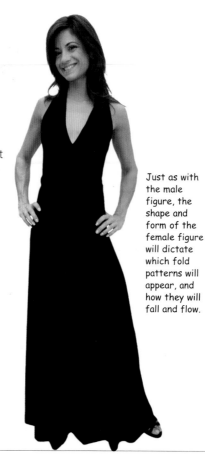

Just as with the male figure, the shape and form of the female figure will dictate which fold patterns will appear, and how they will fall and flow.

Look at this basic shape of a female figure similar to the one on the left, and be mindful of its shape and stance, and the shift of the body's weight.

## POSTURE AND CUT

Garments hang differently when manipulated in different ways, and when a figure changes her posture. Study the outlined figures beneath the dress and the dotted line, which shows the contour and volume of the bottom of the skirt.

Take, for example, this simple garment...

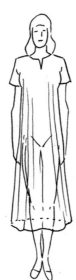

◀ Placed on a figure in a neutral pose, it hangs straight.

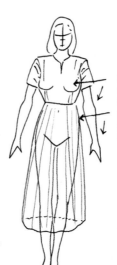

Gathered at the waist, the cloth condenses into pipe folds and puts a tension over the bust.

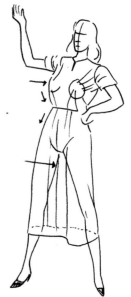

When the figure stands with her legs apart and back bent, the cloth drops from the bust over the stomach and falls between the legs.

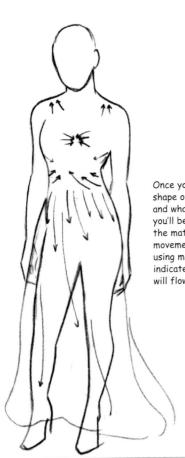

Once you've considered the shape of the figure, her pose and what style of clothing you'll be drawing, note how the material will fall in movement with the body, using motion arrows to indicate how the material will flow and move.

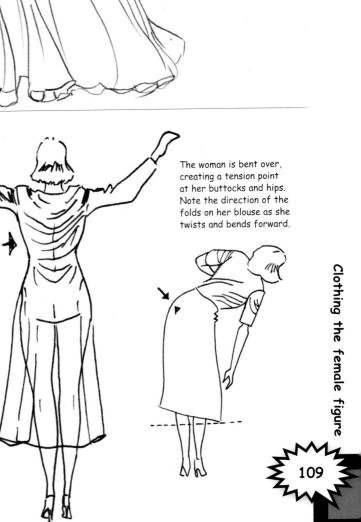

No matter how fanciful the clothing, or how expressive the figure's pose and posture, you must adhere to the basics learnt on pages 96–101. By understanding these basics, you can successfully clothe your figure in any style you can imagine. Note the extravagant drop folds in this dress, which are amplified by the hip action of the figure beneath.

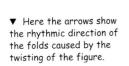

▼ Here the arrows show the rhythmic direction of the folds caused by the twisting of the figure.

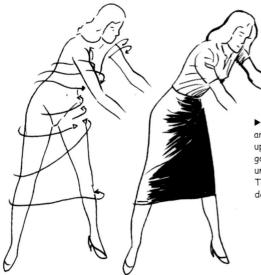

► All of the tension points are under strain. On the upper torso the diaper folds go from the back, up and under the extended arms. The folds from the waist down fall as drop folds.

The woman is bent over, creating a tension point at her buttocks and hips. Note the direction of the folds on her blouse as she twists and bends forward.

## THE SKIRT

The skirt is a cylindrical piece of cloth, narrower at the waist than at the hem. You must always be conscious of the underlying form, since it governs all the folds of the skirt through the action and stance of the figure.

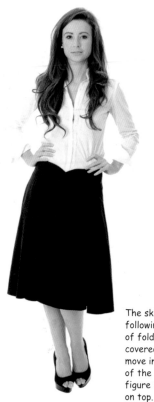

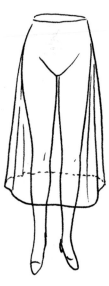

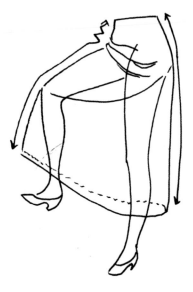

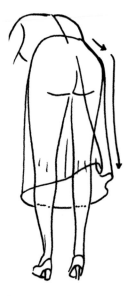

The skirt, while following the rules of folds we've covered so far, will move independently of the garment the figure is wearing on top.

By studying the figure inside the skirt, you can study the points of support and tension.

The two long arrows show that the skirt is the same length on both sides. The basic points of tension here are at the knee of the extended leg and the hip. This creates a long, sweeping diaper fold from knee to hip in the slack area of the skirt.

As the figure leans over, the skirt lies flat on the rump for a short distance before it descends. This forward extension of the torso has caused the skirt to raise in the back. Usually one or two large pipe folds drop from the protruding edges at the buttocks.

This side view shows how the rump lifts the skirt as the figure leans forward.

On loose-fitting skirts like this one, the movement of the legs may not affect the garment folds at all.

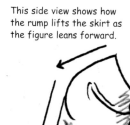

HALF-LOCK FOLD AT DIRECTION CHANGE

PIPE FOLD

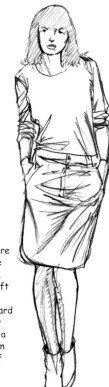

▶ As the hand lifts this full skirt, several large diaper folds occur. The points of support are the hands, the hips and the waist.

▶ Although the figure here appears to be standing still, the slight shift in her weight and the forward stance of her knee creates a unique pattern to the fold of the skirt.

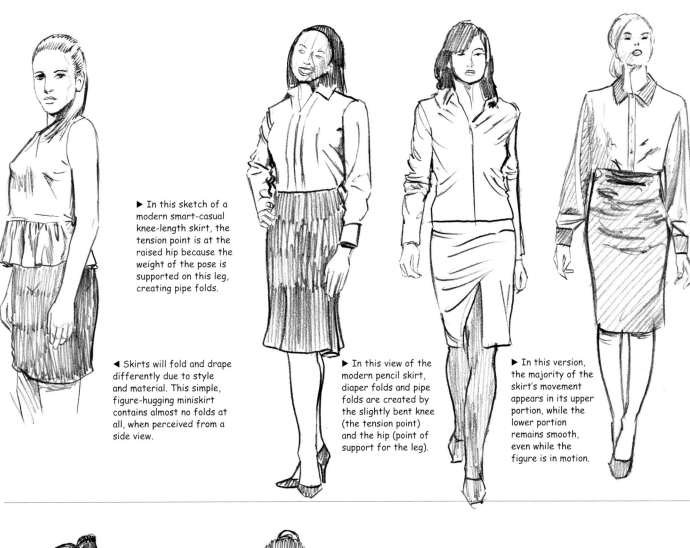

► In this sketch of a modern smart-casual knee-length skirt, the tension point is at the raised hip because the weight of the pose is supported on this leg, creating pipe folds.

◄ Skirts will fold and drape differently due to style and material. This simple, figure-hugging miniskirt contains almost no folds at all, when perceived from a side view.

► In this view of the modern pencil skirt, diaper folds and pipe folds are created by the slightly bent knee (the tension point) and the hip (point of support for the leg).

► In this version, the majority of the skirt's movement appears in its upper portion, while the lower portion remains smooth, even while the figure is in motion.

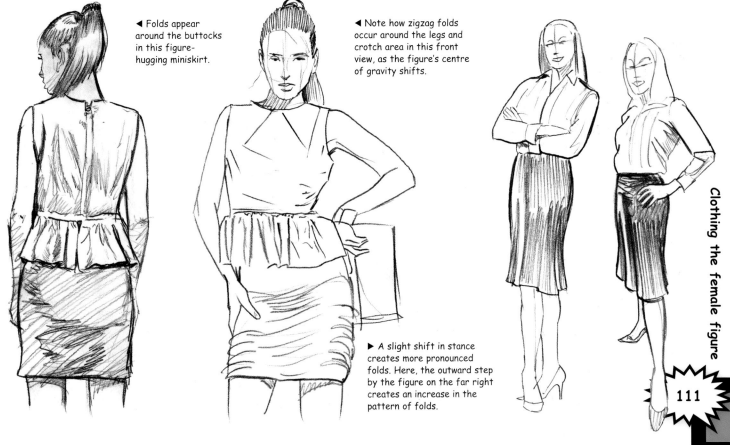

◄ Folds appear around the buttocks in this figure-hugging miniskirt.

◄ Note how zigzag folds occur around the legs and crotch area in this front view, as the figure's centre of gravity shifts.

► A slight shift in stance creates more pronounced folds. Here, the outward step by the figure on the far right creates an increase in the pattern of folds.

## THE BLOUSE

A woman's blouse is not that different in cut from the man's shirt, but we must be mindful of how different the figure beneath it is. The shape of the female form will of course be reflected in the folds of the blouse's fabric.

When drawing the blouse, take note of the style of the clothing. The fashions and trends of women's blouses tend to be much more varied than the basic shirts most often worn by men.

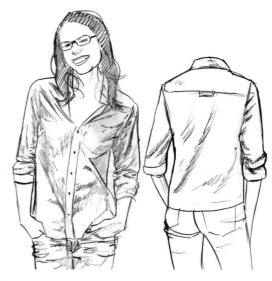

On the chamois or denim-style blouse the sleeves and front follow the patterns we've already observed in mens' shirts, as they follow the curve and form of the arms and torso. Additional folds may accumulate around the breasts, depending on your model. The back of the blouse tends to remain flat and smooth.

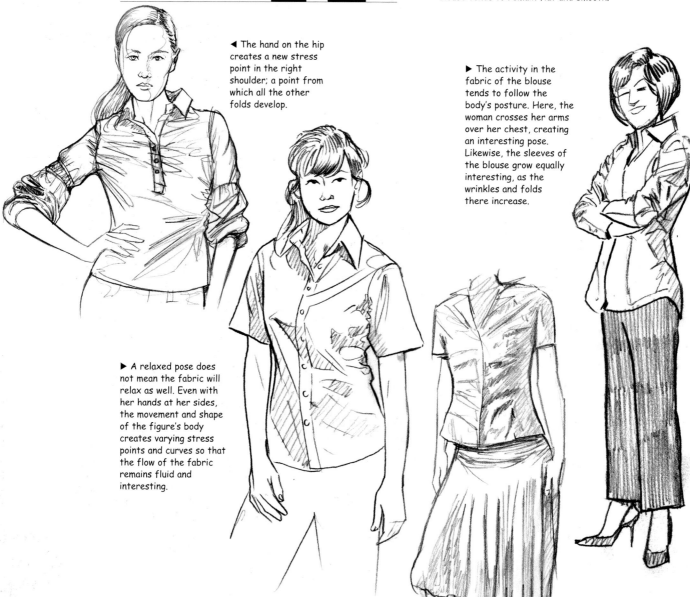

◄ The hand on the hip creates a new stress point in the right shoulder; a point from which all the other folds develop.

▶ The activity in the fabric of the blouse tends to follow the body's posture. Here, the woman crosses her arms over her chest, creating an interesting pose. Likewise, the sleeves of the blouse grow equally interesting, as the wrinkles and folds there increase.

▶ A relaxed pose does not mean the fabric will relax as well. Even with her hands at her sides, the movement and shape of the figure's body creates varying stress points and curves so that the flow of the fabric remains fluid and interesting.

## THE SUIT

In the jacket, the folds are similar to those in a man's coat, with the exception of the extended bust.

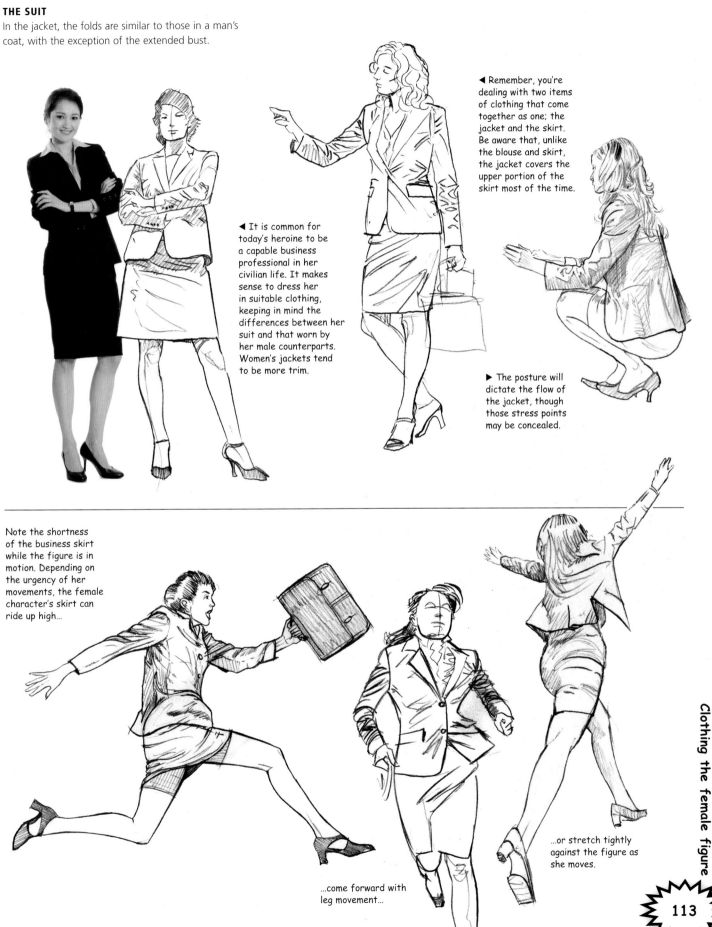

◄ It is common for today's heroine to be a capable business professional in her civilian life. It makes sense to dress her in suitable clothing, keeping in mind the differences between her suit and that worn by her male counterparts. Women's jackets tend to be more trim.

◄ Remember, you're dealing with two items of clothing that come together as one; the jacket and the skirt. Be aware that, unlike the blouse and skirt, the jacket covers the upper portion of the skirt most of the time.

► The posture will dictate the flow of the jacket, though those stress points may be concealed.

Note the shortness of the business skirt while the figure is in motion. Depending on the urgency of her movements, the female character's skirt can ride up high...

...come forward with leg movement...

...or stretch tightly against the figure as she moves.

Drawing the clothing

## THE DRESS

Most dresses fall into a combination of these basic designs: light or loose bodices and full or tight skirts. Different types of folds occur when the bodice is loose, as compared to one that is tight. This change demands careful study; it will show how the degree of tension affects the character of the folds. This applies to either the skirt or the bodice. Below we show the basic types. Study the differences in folds between the tight and loose garments.

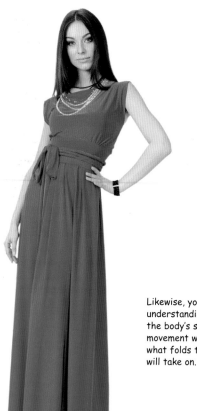

Drawing the dress on the female figure can be a joy. By observing the folds of the dress, you can get a strong indication of what the body is doing beneath it.

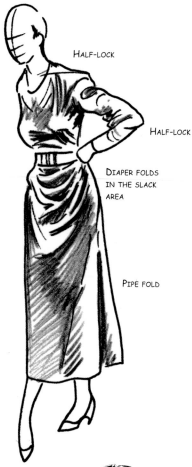

HALF-LOCK

HALF-LOCK

DIAPER FOLDS IN THE SLACK AREA

PIPE FOLD

Likewise, your understanding of the body's shape and movement will indicate what folds the dress will take on.

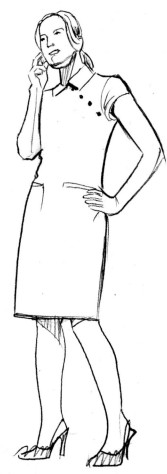

Some dresses, such as a plain uniform, can seem shapeless. But bear in mind that there is a person beneath them, and even smaller wrinkles at the waist and shoulders can go a long way to define the figure.

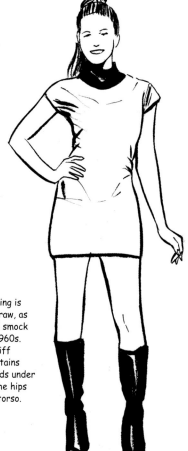

▶ Period clothing is great fun to draw, as with the go-go smock dress of the 1960s. Even one of stiff polyester maintains interesting folds under the arms, at the hips and along the torso.

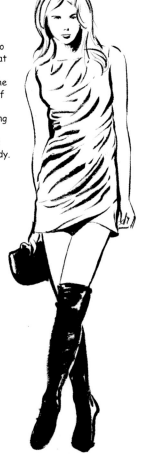

▶ The sack dress tends to take on a great many folds. Notice how the simple shift of one shoulder creates flowing folds that spread across the entire body.

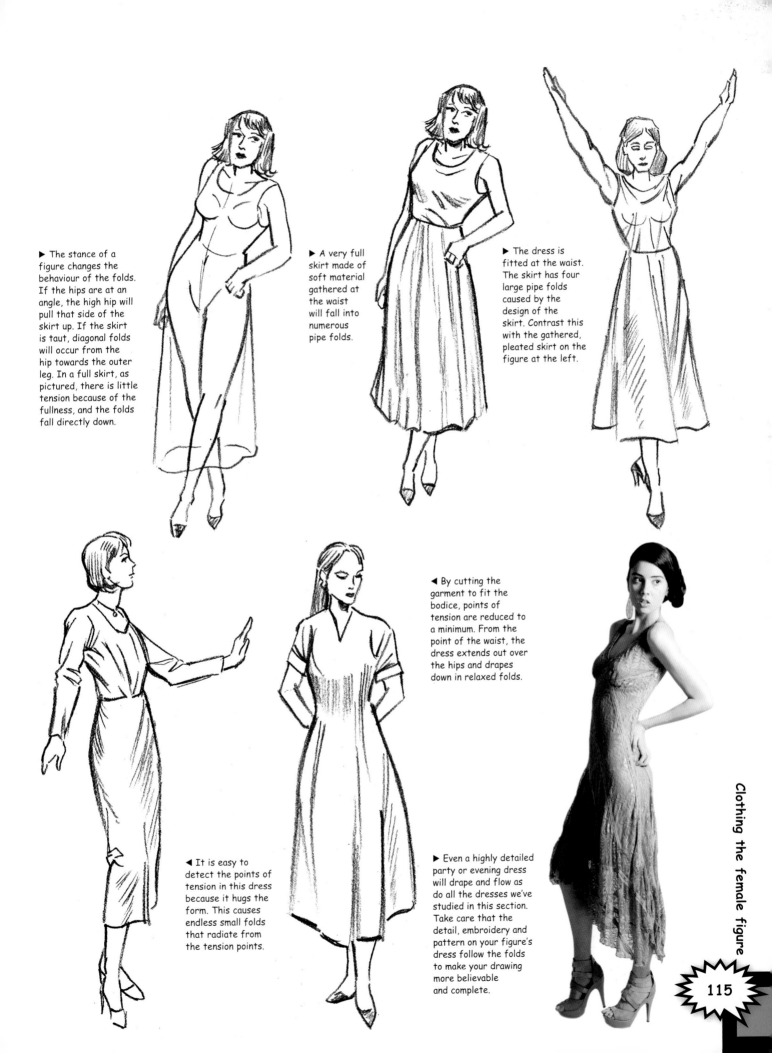

▶ The stance of a figure changes the behaviour of the folds. If the hips are at an angle, the high hip will pull that side of the skirt up. If the skirt is taut, diagonal folds will occur from the hip towards the outer leg. In a full skirt, as pictured, there is little tension because of the fullness, and the folds fall directly down.

▶ A very full skirt made of soft material gathered at the waist will fall into numerous pipe folds.

▶ The dress is fitted at the waist. The skirt has four large pipe folds caused by the design of the skirt. Contrast this with the gathered, pleated skirt on the figure at the left.

◀ By cutting the garment to fit the bodice, points of tension are reduced to a minimum. From the point of the waist, the dress extends out over the hips and drapes down in relaxed folds.

◀ It is easy to detect the points of tension in this dress because it hugs the form. This causes endless small folds that radiate from the tension points.

▶ Even a highly detailed party or evening dress will drape and flow as do all the dresses we've studied in this section. Take care that the detail, embroidery and pattern on your figure's dress follow the folds to make your drawing more believable and complete.

# ARTIST IN RESIDENCE: CHRIS MARRINAN:
## Clothing the figure in action

### ABOUT THE ARTIST
Chris Marrinan graduated from the Academy of Art in San Francisco with a BFA in Illustration. He began his art career doing advertising illustration but quickly gravitated towards comics. Beginning with small publisher Eclipse, and then Heroic Comics, he then began finding steady work with Marvel and DC Comics. Chris has drawn comics for many publishers over the years, including Image Comics, where he created his own titles, *HeadHunters* and *Ms. Fortune*. Now, Chris finds time to illustrate for advertising clients, and to continue creating comics, while teaching for the Academy of Art University online.

### CHOOSING A REFERENCE PHOTO
I chose this photo because it had the action elements I wanted, but left room for changes to make her pose a little more dynamic, so I could demonstrate how to use a photo as a starting point, without being completely dependent on it.

### PENCIL DRAWING
I didn't trace the photo, but kept it next to my drawing board, and referred to it while drawing this rough sketch to get the stance the way I wanted it. I wanted her legs bent more, as if bracing herself for firing her gun. Note the erased areas where I had her legs in different positions, seeing what worked best.

### CLOTHING THE FIGURE
#### Superheroine
This was the first of the finished series, and the costume went through several permutations before arriving at this, the goal being to have her look clearly like a superhero without looking too generic or camp. I spent a lot of time changing the gun until it looked right to me as well, to give it the appearance of advanced fantastic weaponry that still appears believable.

#### Tough broad
Sometimes my biggest challenge is drawing real people in normal clothes. I looked at other artists' versions of characters in trench coats, and with hairstyles and makeup from old Hollywood movies to give her that gangster period look. I was unsatisfied with her look until I gave her the hairstyle depicted here. I also made her right leg go off at a different angle than it was in my rough sketch and the photo. I liked this so much, that I changed the superheroine's right leg to this position as well, which you can see.

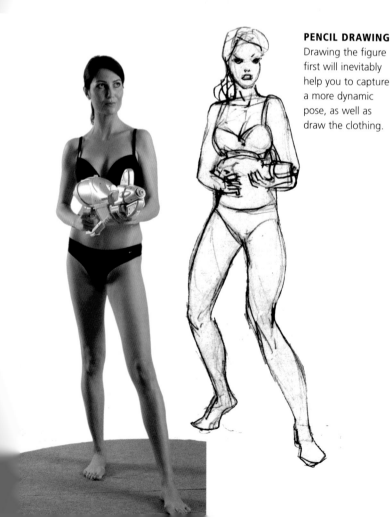

**PENCIL DRAWING**
Drawing the figure first will inevitably help you to capture a more dynamic pose, as well as draw the clothing.

## SUPERHEROINE

While the stance and attitude of these two heroines are similar, their attire couldn't be more different. Look for the differences in the folds and creases in their individual outfits. The superheroine wears a cape and loincloth sash that show a number of drop folds. Note as well the creases in her tall boots, particularly at the knees.

## TOUGH BROAD

The tough-as-nails, street-smart heroine may be dressed less flamboyantly than the superheroine beside her, but the multiple layers of her outfit provide different stress points in her clothing and thus different patterns of folds. Her trench coat reveals how different types of folds can appear in a single garment, along its open length in front as well as on the sleeves at the elbow. The short skirt, while pulled taut over the legs, still shows a number of folds below the waist nearly down to its hem.

# 5

# BACKGROUNDS

In the following pages, we'll be looking at backgrounds, details and props, how to adequately simplify your backgrounds, how to respond to a script and how to create the correct context for your figures. You'll learn about the three planes of depth, how to work with camera shots and angles and how to use perspective to its best advantage to show off your figures in action.

# PROPS AND DETAILS

The comic panel is your stage and it is here that your characters will act out the parts you have planned for them. To help tell your story and create an atmosphere, you must build up a background for your actors. You accomplish this by using props and details.

### TERMINOLOGY

'Props', a contraction of the word 'properties', means anything put into the panel other than the figures. Clouds, trees, furniture, mountains, rocks, water, etc., are all props. Details are the small parts of the prop. A table is a prop. Carving on the legs of the table would be a detail. A car is a prop. The headlights, steering wheel, wheels, windshield – these are all details. The combination of props in a given scene or panel make up the background.

You could draw a comic book without any backgrounds, but why? You're only making the story difficult to the reader who is trying to understand what is happening. When drawing comics, always draw the 'who', the 'what', and the 'where'. The characters are the 'who', the action and use of props are the 'what', and the background is the setting of 'where' your story takes place.

### ACHIEVING REALISTIC BACKGROUNDS

Without backgrounds in your story the characters have nothing to work with or live in. When drawing a background it is important to achieve a sense of realism. No matter how well the drawing is done, if it lacks authenticity or realism, your drawing will not serve its purpose.

To achieve realistic backgrounds that work in the context of who your characters are and what they do, you must invest time in gathering the resources necessary to draw backgrounds the reader can believe in. This is where photo reference comes into play once again.

### SIMPLIFYING DETAILS

Most beginner artists think that, by drawing a great deal of detail, they can achieve realism in their background. This thinking cannot be further from the truth. Sometimes the whole point of a background is to reinforce the context of the character, but their actions won't 'speak' if they are lost in a busy panel. See pages 122–123 for more on simplification.

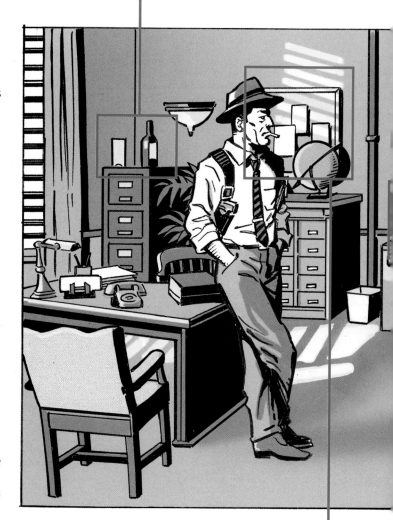

**ALCOHOL**
The spirits bottle reveals that the detective likes to have a drink while on or off the job. The art deco light fixture locates the scene firmly in the 1920s or 30s.

### ARE PROPS NECESSARY?

In some successful graphic novels, you'll notice the occasional panel with no props at all, only a figure and a sword, for example. But that is done only where the setting has been well established in the panel that precedes it. The omission of props here and there takes experience and good decision-making. Don't underestimate the importance of props. They must be there in your reader's mind whether you draw them or not!

## SPEED BAG

The speed bag and punching bag hint at the detective's pastime. Perhaps he was a boxer before he was a detective? Or maybe he takes his frustration out on the punching bag when up against a particularly tough case. Props like these help give a scene character, and add insight to the character acting in them.

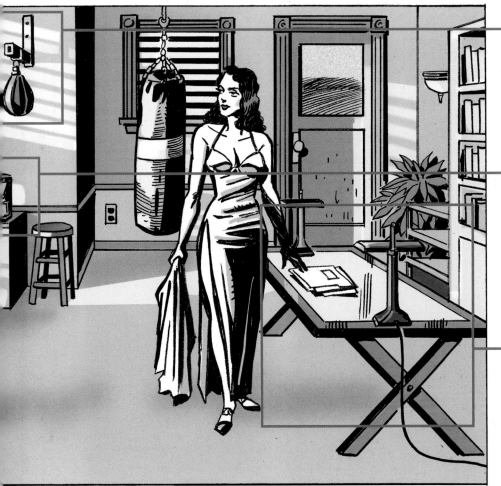

## COFFEE MAKER

The coffee maker is a prop; the style of the coffee maker (the make, the era it is from, even the shape of its handle) is a detail.

## CORKBOARD

The corkboard enhances the detective's investigative work and the notes, newspaper clippings, photographs and maps imply a very important case.

## GLASS TABLE WITH LAMPS

The large table with two lamps is relatively empty, but its role in the scene is practical: it is something for the woman to lean against. It is part of the setting instead of just being a background drawing.

# SIMPLIFICATION OF BACKGROUNDS

Simplification means leaving out unnecessary details in props. For instance, if your character is honking the horn of an old car, you should draw the horn button. If he's just driving the car, however, the horn button might stick out like a sore thumb. So, when and why do you simplify?

## WHY SIMPLIFY?

Below left is a photo of a subject crossing a busy street in New York City. You could spend hours copying every detail, but this may be a waste of your time, especially if you can communicate the same environment and sensation in a simplified drawing. Draw only what is needed to convey what the object is, and any details that reveal how it is relevant to your character or story. Simplify and let your reader's imagination fill in the details.

## SIMPLIFY CONSISTENTLY

Consistency is key to good visual storytelling, so don't draw realism in one panel, and then stylise the next. A panel that is drawn too simply compared to the rest of the visuals on the page may jar. Be aware of this as you learn to omit what is not needed. Too much detail in a prop is like an overly written story with too much dialogue. You will lose your reader if you bore them with unnecessary details.

### STARTING REFERENCE PHOTO

The photo used here makes good reference because it establishes a setting and a mood. The Empire State Building is iconic and recognised worldwide. People crossing the street and cars going in every direction give the setting life. In fact, the background has more than enough information to give the reader a sense of where this scene takes place. It is the artist's job to simplify it and use only what's relevant for the scene.

### SIMPLIFIED PENCIL DRAWING

A simplified version of the photo leaves no doubt what this is to the reader. The character is the focal point, while the background, 'suggested' in a simple way, allows the reader's imagination to fill in the details.

## DRAWING OUT THE IMPORTANT DETAILS

This is a 'fuller' version of the simplified pencil drawing. The protagonist hails a cab in the foreground, and the background complements the context of his actions. Designing a location is just like designing a character for your story. The look and feel of a location suggests a personality that may reflect that of the main characters who live there.

# CREATING A BACKGROUND FROM A SCRIPT

Some scriptwriters will give you all the details you need to follow verbatim; others will allow the artist to exercise some creative license. The follow excerpts are from various scripts that give different descriptions of backgrounds. The captions explain how you, as the artist, might interpret them.

The script examples provided here reveal the different approaches writers have to the task of writing a script for a graphic novel.

There are two types of scriptwriting, generally regarded as 'plot first' and 'full script'.

## PLOT FIRST (OR MARVEL STYLE)

The Marvel Method is a form of comic book writer–artist collaboration in which the artist works from a story synopsis, rather than a full script, creating page-by-page plot details on his or her own. The technique takes its name from its widespread use at Marvel Comics beginning in the 1960s, primarily under writer-editor Stan Lee and artists Jack Kirby and Steve Ditko.
ADVANTAGES: The writer knows exactly what the art looks like, and how much room there is for text when scripting.
DISADVANTAGES: The writer gives up some control over pacing and composition, and may get undesired results from the artist. You can't use this method unless you have an existing relationship with the artist and editor.

## FULL SCRIPT

This is generally the more accepted writing style for comic book scripting. A writer breaks the story down in sequence, page by page and panel by panel, describing the action, characters and sometimes backgrounds and 'camera' points-of-view of each panel, as well as all captions and dialogue balloons. For decades, this was the preferred format for books published by DC Comics.
ADVANTAGES: Writer has full control of the story and pacing; writer can improve on their original idea; writer is not relying on anyone else to get the job done.
DISADVANTAGES: You may need to trim or otherwise revise your dialogue and captions after seeing the art. Full scripts take longer than plot-first scripts.

**EXTREMELY THOROUGH TREATMENT**
As you can see, Gaiman writes a thorough scene for this panel, detailing all background and giving enough visual information for the characters in it. A good writer will give the artist enough visual information on both the background and the character(s) to tell the story clearly and effectively.

### FROM NEIL GAIMAN'S *SANDMAN: SEASON OF THE MISTS*

#### PAGE ONE, PANEL ONE

A long panel down the left-hand side of the page. Okay, Kelley, now get whatever reference you think you'll need for this – it's as if we're in ninth-century Norway, or at least, the ninth-century Norwegian idea of what a great palace would be. So the hall is built of woven rushes – no windows, smoky. Forget all the Kirbyish SF stuff: this is dirty and primitive and old-fashioned: almost no metals, just wood and stuff. The floor is mud, strewn with rushes. Odin sits in his chair. At his feet sit two huge grey wolves, sprawled one on each side of him, huge green wolf eyes staring straight at us. Odin sits on a huge wooden chair, sitting staring at us through his one good eye. He is bare headed. He has grey hair, thinning, shoulder length, and a short grey beard and moustache. In his left hand he holds a goblet – made of gold, ornamented with jewels. The room is dark and gloomy and muddy. Odin wears a simple leather jerkin; it goes down to his knees and is drawn in at the waist by a heavy leather belt; his legs are covered by cloth leggings, crisscrossed by leather thongs running all the way up his legs. (Check out any good reference on the Vikings.) Odin's face is long and thin and drawn. He doesn't look like a nice man – he looks dangerous, like an ageing hired killer, his one good eye cruel and nasty. You may want to keep his face fairly shadowy here, so that all we can see is one glowing eye. Steve – get as far from the brightly coloured Kirby Asgard as you can here: this is the Asgard of the Old Norse, a bitter, dangerous place, in which all is dull grey and brown, alleviated occasionally by a glint of gold. Odin's right eye is missing – the eye on the left-hand side of his head, as we look at it.

## FROM ANDREW MAYER'S *OM NOM NOM NOM*

### PAGE ONE, PANEL ONE

INT. POLLY PRESSER'S HOME – DAY

OPEN ON: A crowded mantelpiece, loaded with the most atrociously adorable figurines you could imagine; Hummels, porcelain unicorns with ribbons, tiny clowns in crinoline dresses, china dogs. It's all the crap that lonely old ladies buy from the shopping channel at 3AM. Standing in the centre of it all is a faded photograph trapped in a hideous frame festooned with colourful little wooden hearts glued onto it.

The photo is in colour (if we're doing colour), but it has that slightly fuzzy and overly contrasted look that you get from pictures from the 1970s. The woman and man in the picture are in their early 30s, and they both have a dangerously grim look on their faces. The man is gaunt and thin, the woman next to him is round. Her hair is straight and flat. She has a pair of big 1970s glasses that make her face look even wider than it naturally is. They're both wearing non-descript polyester 1970s clothes, corduroys and knitted shirts; the kind of things you would find if you went shopping at Sears back then.

## FROM BRIAN K. VAUGHAN'S *THE RUNAWAYS*

### PAGE ONE, PANEL ONE

Okay, we open strong with this largest panel of the page. It's daytime now, and we're on the front lawn of the White House (here's a website for reference). In the middle of this lawn, Captain America is raising his shield to protect himself from none other than the Incredible Hulk (old school: big, green, purple pants, etc.), who is raising both of his fists up to squash Cap like a gnat. There's no way Cap could survive a direct hit from the Hulk, but he doesn't look scared. Instead, he's calmly speaking to someone off-panel.

### DETAILS AND PROPS CREATE THE SETTING

There is no set limit for how much or how little information should be drawn from each panel description; character traits, objects or placement need to be considered when drawing each panel.

### THOROUGH BUT WITH SOME CREATIVE LICENSE

The script excerpt is pretty detailed, but these panel descriptions are just suggestions according to the writer. So if you're the artist on this script, the writer suggests to contact him if you ever see a better way to lay out a page or frame a shot. So, even with a detailed panel description for the characters to act in, the artist has some creative license with it.

## CASE STUDY

The examples depicted here illustrate how artist Jeff Himes interpreted the script I wrote for him for the supernatural thriller, *Atomic Yeti*, and the decisions he had to make in order to achieve the final outcome for the sequence.

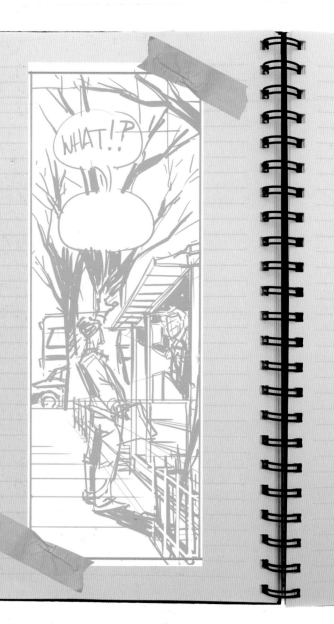

### FROM DANIEL COONEY'S *ATOMIC YETI*

#### PAGE ONE, PANEL ONE

Medium shot of casually dressed man holding the tabloid while gesturing to it as he looks at the newsstand vendor who is handing off change to another customer. It's the early am workday on a clear and cold February day in NYC. Building in background with woman pushing a pram surrounded by trees with a newsstand in the foreground. It should be clear that the setting in New York City is during winter.

#### PAGE ONE, PANEL TWO

Establishing shot of Lane about to cross a congested street of automobiles, taxi cabs, delivery trucks and a good amount of people surrounding him on the corner. His mobile phone rings and he's holding it to his ear.

#### PAGE ONE, PANEL THREE

Upshot of Lane crossing the street, paper tucked under his arm, half-eaten apple in hand and phone in the other. The New York Times building can be seen in the background.

**STICK TO THE SCRIPT**
The most important thing to remember: if it isn't in the script, do not overdraw by pencilling objects and details that are not necessary. Clarity is your priority with each and every panel for characters, objects and backgrounds to work together.

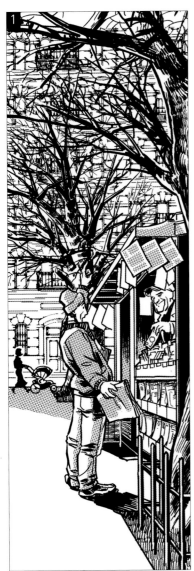

## PANEL 1

I like Jeff's decision to silhouette the woman pushing the pram because the focus is on the man buying the newspaper in the foreground at the newsstand. The background gives enough information that this scene is taking place outside in a city during a cold day. How do we know it's cold aside from reading the script? The winter clothes of a hat, scarf and heavy jacket, along with the lack of leaves on the trees, give visual clues that it must be winter.

## PANEL 2

The description doesn't mention a downshot for this panel, but it works well because it has everything in it that I wrote for the scene. Jeff framed the featured character with a traffic light and crosswalk sign to help the reader know where the focal point is for the panel. Two more aspects were added to emphasise the focal point here: the cast shadows of the people and the black jacket the main character is wearing add contrast, making the protagonist distinctive in the crowd.

## PANEL 3

This scene can be drawn a variety of ways. By breaking up the action into several panels, or by combining the action in one panel (depicted here). The background is established as the main character walks from left to right, a technique that is aesthetically pleasing but which also directs the reader's gaze from left to right.

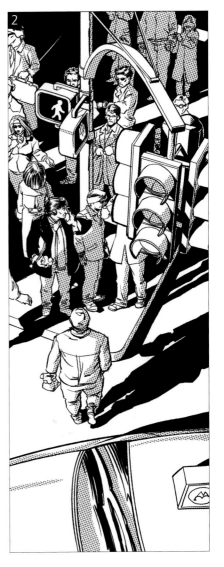

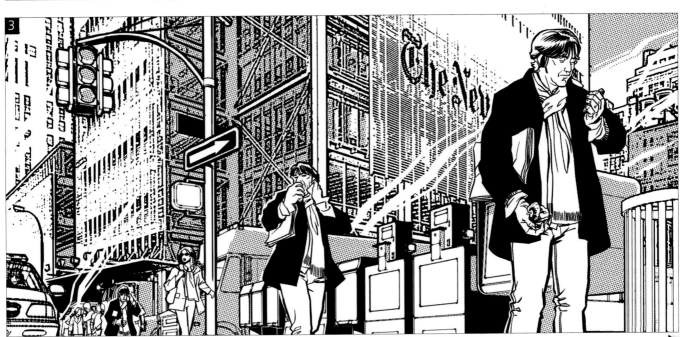

Creating a background from a script

127

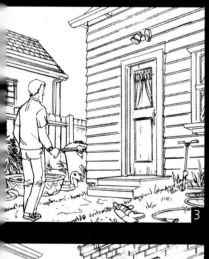

# CREATING CONTEXT

When creating the background for any given situation, different props and details will often do the whole job of changing the scene.

### BACKGROUND VERSUS NO BACKGROUND

Drawing backgrounds can be a downright chore, which explains why many artists do not draw them. Ever notice on a comic page that some panels have a character in complete darkness or surrounded by no background at all? Sometimes a character may carry an umbrella standing at a bus stop waiting for the bus, but aside from the umbrella, bench and bus stop sign, there is no background to be seen, much less a pavement for the character to stand on.

Yes, sometimes less is more, but only if you established a clear setting with enough visual information for your characters to act in before illustrating a minimalist approach in the following panels of action.

Once the background is established and your character leaps into action, then yes, adding a few brushstrokes or speed lines behind them as they swing their sword or fire a weapon is effective because you established the setting the action takes place in in the preceding panel.

When you first learn to draw, you start out with a figure or a person. The fun part for most artists is drawing these figures in various poses of action and not drawing boring inanimate things like buildings, hallways, bedrooms and spokes on a bicycle. The truth is, you need to draw backgrounds, because they are almost, if not equally, as important as your main characters.

Imagine if you drew an incredible shot of a flying superhero catching a construction worker who has fallen off scaffolding on the sixtieth floor of the Empire State Building (see right). Now imagine just drawing the superhero flying through the air and catching a construction worker and drawing nothing else. Are you missing something? The element lacking here is context. The image of the superhero's heroic feat would not be as spectacular if you could not see how high the worker is. The Empire State Building and all of the surrounding buildings put the level of danger that the worker was in into context. Think of the background as another major character in the script that you need to draw.

### BACKGROUNDS TELL STORIES

On your left there are four basic drawings of the same scenario: a character walking up to enter a building. By changing the props and details, three different scenes are created. Note how the character's appearance changes with the setting in each drawing, thus reflecting the background he lives in.

**1** Basic drawing of the side of a building showing the character, the door and the window.
**2** With the addition of props and details, the artist has created a front garden.
**3** Here, we change the basic drawing into a back garden.
**4** To move the building into the city, we change its construction to brick and draw in the proper details.

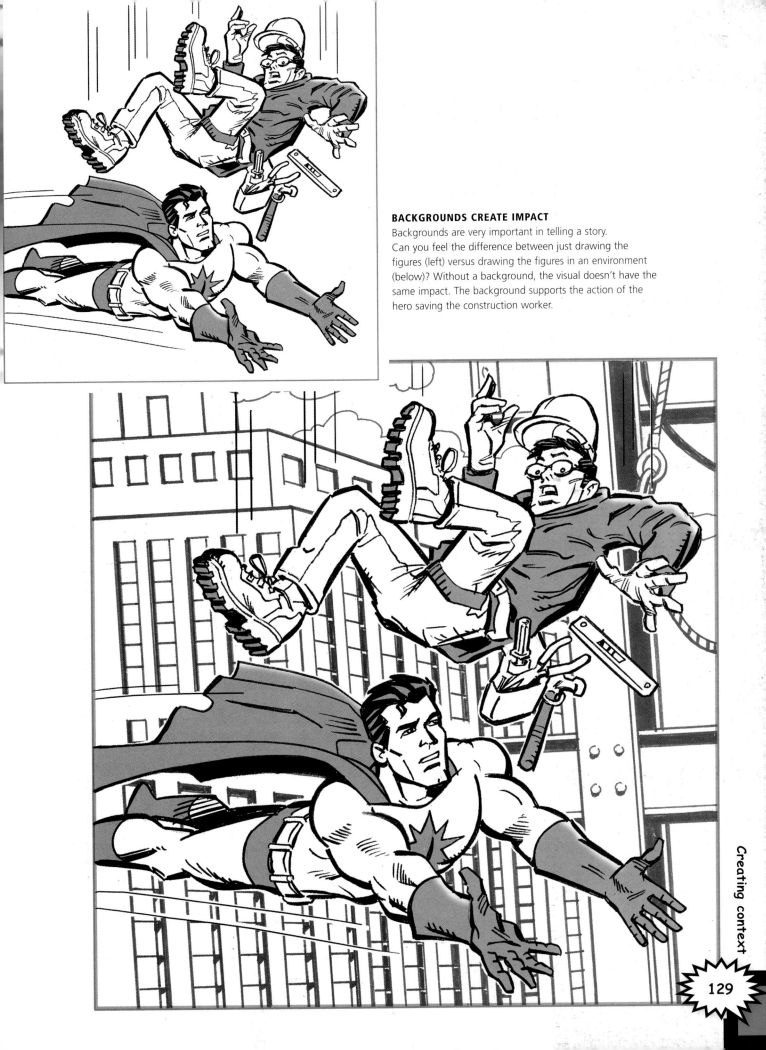

## BACKGROUNDS CREATE IMPACT

Backgrounds are very important in telling a story. Can you feel the difference between just drawing the figures (left) versus drawing the figures in an environment (below)? Without a background, the visual doesn't have the same impact. The background supports the action of the hero saving the construction worker.

# FOREGROUND, MIDDLE GROUND AND BACKGROUND

The foreground, middle ground and background in a composition are generally divided into three planes. The foreground of a composition is the visual plane that appears closest to the reader, while the background is the plane in a composition that is furthest from the reader. The middle ground is the visual plane located in between.

The foreground is often the most dominant due to the larger perceived scale of the image's objects. This is not always the case, however, as definition and other factors can shift the dominance of the composition.

Visually, we often refer to the scale of one object to another. As objects come forward in space, towards the reader, they appear larger. As they recede into the background, their scale gets perceptually smaller. The main subject (often in the middle ground) should dictate all of the action in the background and foreground.

## CREATING DEPTH WITH INK WORK

If you choose to create action on three different planes, then it is your responsibility to create depth with your inks. Adding black ink creates contrast between movable and immovable objects as well as establishing the illusion of depth, as does the variation of line weight on subject and background. Things in the background should have less line weight and detail than those in the foreground. This can be achieved by making the drawing less comprehensive. Drawing a little looser in the background will help accentuate what is occurring.

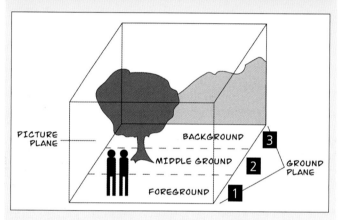

**THREE PLANES OF DEPTH**

Your attention to foreground, middle ground and background elements is critical when you stage action. Great action should have something interesting happening in the foreground (stick men), middle ground (tree) and background (mountain range).

There is no need for a background here as the three are engaged with one another from a low angle point of view. Even at close proximity, there are three planes of depth in this tightly composed shot. The man's heavily inked coat plays a part in adding contrast, especially in regards to the light-coloured hair of the female in the foreground.

WHAT!! LINNEA!! PAY ATTENTION TO WHAT I SAY!! YOU'RE GOING WHERE WE GO AND YOU'RE DOING AS I SAY!! DO YOU UNDERSTAND ME?!

YES...

7-28

The focal point here is the two figures in the foreground. This is reinforced by the shadow that is cast from the tree behind them, and the leaves silhouetted around the top half of the panel. The woman's foot points outwards, drawing the reader's eye towards the two characters in the background: an effective visual technique that navigates the reader's eye around the panel.

A close-up of the two figures in the foreground frames the focal point: the figures in the background. Another component the artist used is contrast, with the dark curtains and the lights fading into the distance, giving the illusion of depth.

There are two components in the foreground at work here: the stage light, to give the reader a sense of where this scene is taking place, and the woman on the right, who is the subject of the drawing. Props like the stage light can be just as important as the characters – they establish a setting for the character to act in. The artist chose to dress the woman in lighter colours, creating contrast with the background.

## MIDDLE GROUND IS THE FOCAL POINT

> BUT YOU'LL STILL BE ANGRY! IF I PROMISE TO BE GOODER THAN GOOD WILL YOU FORGIVE ME?

> DO YOU WANT TO KNOW WHAT *REALLY* MAKES ME FURIOUS? YOU *ROBBED* ME!

The focal point of the drawing is in the middle ground of the panel, further emphasised by two techniques: using the foreground objects to frame the trailer, and the use of shadows for contrast. The background is suggested with just a few lines to complete the drawing. Again, the artist only draws enough to keep the focal point clear and to illustrate the illusion of depth by using scale, proximity of objects to the camera and contrast.

▼ This technique of employing two subjects as silhouettes by using the shadow from the tree establishes them as the focal point in the middle ground of the drawing.

> WHY? BECAUSE I LOVE HER!... LIKE PETE LOVES HER... LIKE EVERYONE WHO EVER SAW HER! ALL THE TIME WE WERE ASSOCIATED SHE NEVER ASKED FOR ANYTHING! WELL... NOW SHE'S ASKING!

> THERE'S SOMETHING ELSE...

▲ The figures in the middle ground are the focal point due to the artist establishing two things: the lines in the foreground that converge on them, and the use of shadows and silhouettes to frame them.

> THAT'S *EXACTLY* RIGHT! AMATEUR PRODUCTION OR NOT I *DO* TAKE IT SERIOUSLY! I'VE ALWAYS *LOVED* THE THEATER! IN FACT, I'M GOING TO NEW YORK MYSELF!!

> MY GOODNESS! IT SEEMS *EVERYONE'S* GOING!

The focus here is the silhouetted figure at the back. Note how objects close to the reader's point-of-view frame the subject. The word balloon helps lead the eye, but the artist's job is to establish clarity through visuals first and foremost.

The silhouette in the foreground of the stairs and stage props help frame the figures in the background as the focal point of the drawing.

The figures appear like ants in the drawing but can be seen by the reader because of the composition, use of shot angle and the word balloons that literally point to the focal point.

This is a simple panel composed of a woman opening a door, the stage light in the foreground, and the light that reveals the woman from outside the door. The focal point is emphasised by the overwhelming shadows that lock her into focus.

Foreground, middle ground and background

133

# CAMERA SHOTS AND ANGLES

Graphic novels succeed because their pictures give a visual clarity for the reader, which is supported by a sound story structure. One way of ensuring your figures are dynamic and varied is to use a variety of camera shots and angles.

**▲ ESTABLISHING SHOT**
A mandatory shot that is essential for establishing the setting of the story. The establishing shot can be used for any location, just as long as you give enough visual information for the reader to grasp where the action occurs. Usually, a rule of thumb would be to use an establishing shot for every scene change, each time a new element is introduced in the scene, or when a character moves through a scene.

## CAMERA SHOTS
The worlds of cinema and comics have some similarities and differences. Both tell stories through words and pictures, all the while using technology to achieve the end result. Film terms apply to the use of storytelling direction in comics, so let's take a look at some examples. These are some of the most important storytelling devices you will use for making comics and graphic novels.

**▼ WORM'S-EYE VIEW**
This view is from underneath the main action, and is effective for showing the impact of a scene and its imposing nature.

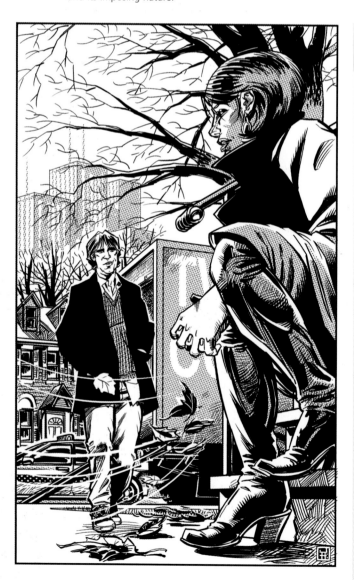

## TERMINOLOGY

These four aspects are essential for keeping your reader involved with the story you're illustrating. The camera shots and angles you choose will prompt the reader to see the story unfold, as if through their own eyes.

❯❯ **A panel** is simply a window you choose to best frame the character, place and situation of the story. Every panel in a page layout has to contain at least one of these aspects that make the story work visually.

❯❯ **Character** is the 'who' in your story – and the focal point.

❯❯ **Place** is the 'where' in your story, establishing a setting.

❯❯ **Situation** is the 'what' in your story.

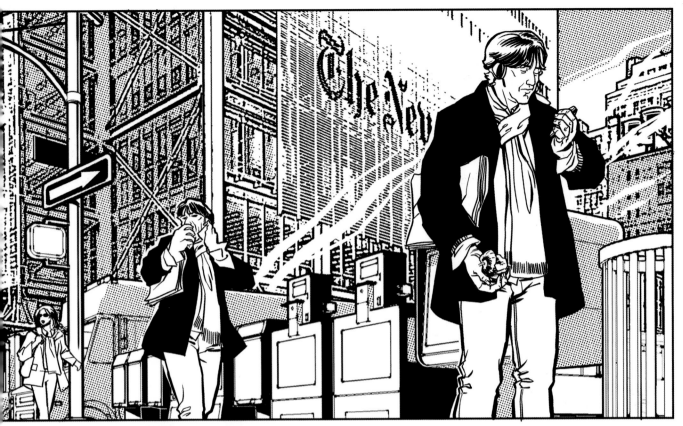

**◄ MEDIUM SHOT**
A panel featuring the subject from the waist up – with a background that may be very detailed or not detailed at all.

**▼ CLOSE-UP**
A panel that emphasises the subject and can include a facial expression, with or without hand gestures. Close-ups can be used to frame an object a character is holding (like the apple in this panel) for a detailed look, or to visualise the object up close.

**◄ LONG SHOT OR FULL SHOT**
Imagine a figure illustrated in full from head to toe – with an emphasis on the background the character occupies. Distance is key here, with the camera far enough away to show the location and who is involved in the scene.

**▶ POINT-OF-VIEW SHOT**
This shot is as if the reader were looking through the eyes of a specific character.

**◀ EXTREME CLOSE-UP**
The eyes or the mouth of a character fill the entire panel.

**▼ OVER-THE-SHOULDER SHOT**
This is a shot of someone or something taken over the shoulder of another person. The back of the shoulder and head of this person is used to frame the image of whatever (or whomever) the camera is pointing towards. This type of shot is very common when two characters are having a discussion and will usually follow an establishing shot that helps the reader place the characters in their setting.

## CAMERA ANGLES

There is a great variety of camera angles to choose from, any of which can add an interesting perspective to the content of the panel. Sometimes the camera angle can greatly influence the reader's interpretation of what is happening on the page.

### ▶ HIGH ANGLE SHOT

Also known as the bird's-eye shot, the camera looks downwards, generally shot from just above head height. This angle can make a subject look vulnerable.

### ◀ THE TILT ANGLE OR DUTCH TILT

A cinematic tactic often used to portray the psychological uneasiness or tension in the subject matter. A Dutch angle is achieved by tilting the camera off to the side so that the shot is composed with the horizon at an angle to the bottom of the panel.

### ▼ LOW ANGLE SHOT

Also known as the worm's-eye shot, the camera looks upwards towards a subject, and can make the subject look powerful.

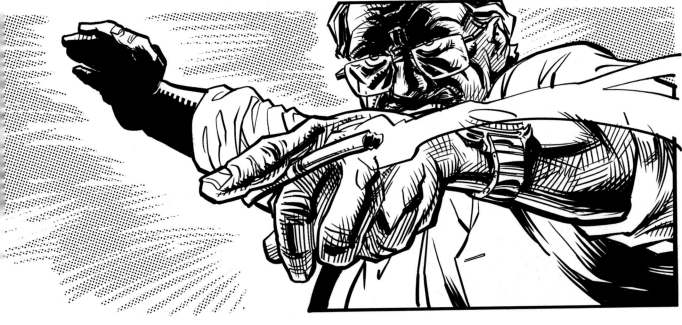

# PLAYING WITH PERSPECTIVE

Objects appear to get smaller the further away they are. Linear perspective is simply a tool that will allow you to create a sense of distance and scale in your images, to show objects overlapping, getting smaller or converging in an orderly way.

Being conscious of how the subject moves through space is essential to creating a captivating visual. Making a subject small (far away from the reader) in one panel and then big (close to the reader) in the next panel produces an interesting effect. It suggests movement between the two panels. Many artists use speed lines to convey movement. This should not be your first option when attempting to illustrate movement with your character. Instead, convey the movement first with the actions of your character and then with the components with which they interact. Objects coming at the reader within the panel have more of an impact than those travelling left to right. To have an object coming straight at the reader engages them into the visual narrative of the action. The examples here all display a creative use of perspective.

**READER'S POV**

In the film *Raiders of the Lost Ark*, the main character Indiana Jones is running for his life out of a cave as a boulder comes rumbling down towards him. The viewer feels a part of the action because the camera angle is composed from their point-of-view. By having the action come at the viewer, as opposed to side-to-side, the scenes feel more alive and leap from the pages, making it more of an enticing experience for the reader.

**LONG SHOT**

When a character or object is coming right at you, the perspective of every element in the background should reinforce its direction. This will draw your eye even more strongly to the subject. If you apply a heavy shadow to that figure or object, it will create weight and make it more dramatic as it comes at the reader.

### DUTCH TILT

This panel alters a familiar perspective to create speed and intensity as the car races down a desert highway, evading police. Observe how the entire panel and all of its elements are drawn at an angle to emphasise the direction of the car speeding towards the reader.

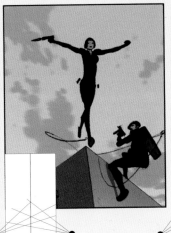

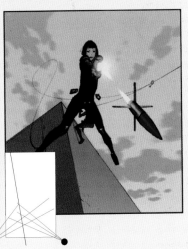

### CHANGING PERSPECTIVES

This action sequence from Duval & Cassegrain's *Code McCallum* is effective for a couple of reasons. The first panel introduces us to the two characters on a rooftop overlooking a stained-glass ceiling. In panel two, the artist composes the action from an upshot as the character leaps out and down towards the reader and moves even closer towards the camera in the next panel, but still using the same camera angle. In the last panel, the camera angle shifts back to her partner as he looks down at his partner descending into the explosion. The visual sequence is kinetic due to the various camera angles and proximity of the character to the camera.

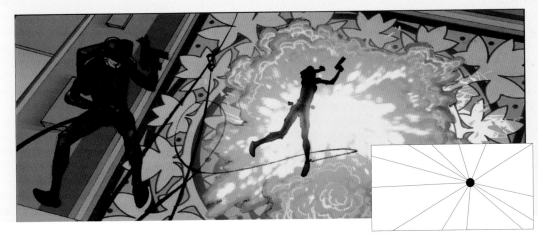

Playing with perspective

139

# WORKING UP A BACKGROUND

Consider keeping your backgrounds simple so the message remains clear, yet dynamic enough to inform and engage the reader. These step-by-step drawings illustrate how to go about working up a background, from initial pencil sketch to adding details and colour rendering.

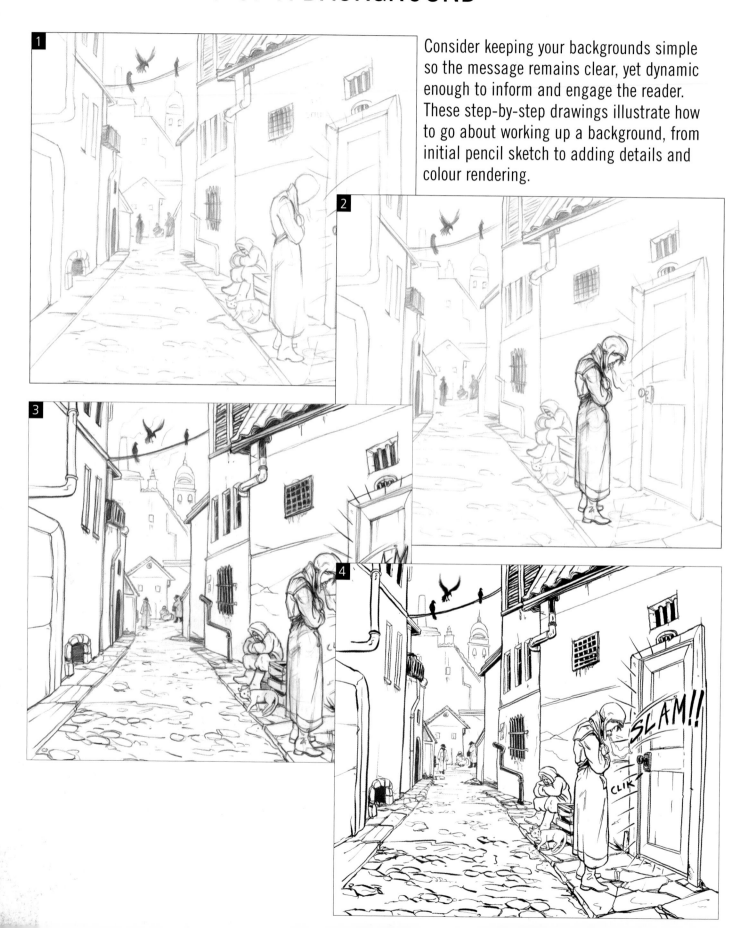

**1** First decide what kind of background your story or idea calls for to establish the setting. Here, a one-point perspective was used near eye level on the horizon line to create construction lines for the street, buildings and people in the street. Sketch everything lightly when constructing the human figure. Sketch to 'find' the desired background and start drawing in what is relevant to the scene; do not be concerned with details at this stage.

**2** Now build up the background by solidifying contour lines and shading to indicate where shadows might fall for contrast and depth. Notice how the woman at the door is rendered more completely with the pencil.

**3** The last stage before inking should be finishing the details of the panel. Work from the background to the foreground. Line weights should be applied for atmospheric perspective to establish a sense of depth.

**4** Ink the figure and then the background. Let it dry before erasing the pencils. Correct any mistakes (you will make them) or bad lines with Pro White or white gouache using a brush. Sand down any buildup in case you need to ink over the corrected areas again.

**5** Colour is another component of figure drawing in sequential art. In this example, the colour temperature is kept cooler to match the sombre mood of the scene.

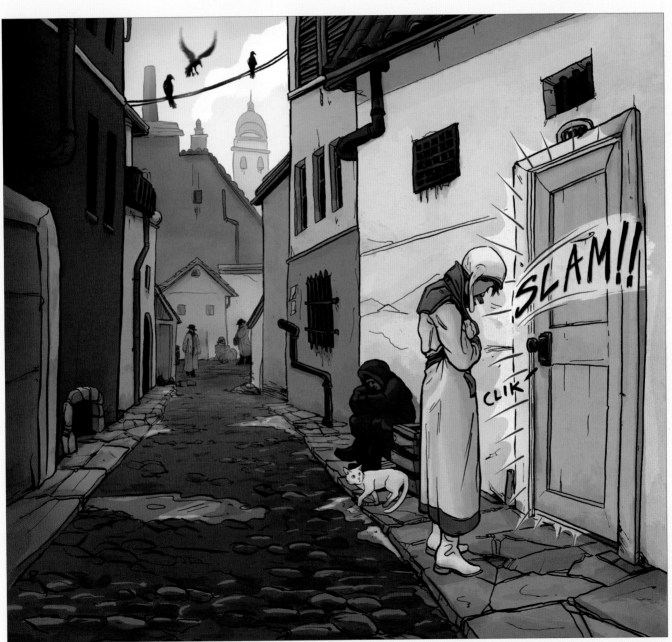

5

## ARTIST IN RESIDENCE: MARK SIMMONS:
## Quick and not-so-quick backgrounds

### ABOUT THE ARTIST
Since graduating from the Academy of Art University in 2009, Mark Simmons has been working on comics for Archaia Studios and Making Fun, storyboards for Unicorn Studios and assorted secret projects, teaching and giant robot-related consulting. You can find an assortment of his 8-, 12- and 24-Hour Comics on his art blog at toysdream.blogspot.com.

### QUICK BACKGROUNDS
I'm a sucker for speed challenges like the annual 24-Hour Comics Day. The original idea of the 24-hour event was to draw 24 complete pages with no prior planning or reference, but just between you and me, I sometimes bend the rules a little. In the case of *Our World*, which I drew for the 2011 event, I was actually working from a script by Julie Davis. Much of the story takes place in a restaurant, and so I took the opportunity to sketch some quick reference at a local Vietnamese noodle house right before the event.

Although I only sketched one interior layout here, and a handful of props and utensils, this was enough for me to depict a plausible-looking noodle house in the 24-Hour Comic itself. As a comic artist, you always have to be conscious of your viewpoint, eye level and relative scale, and I was very taken with the stripes (shown over the page) that ran along the wall of the restaurant, roughly level with the heads of the seated

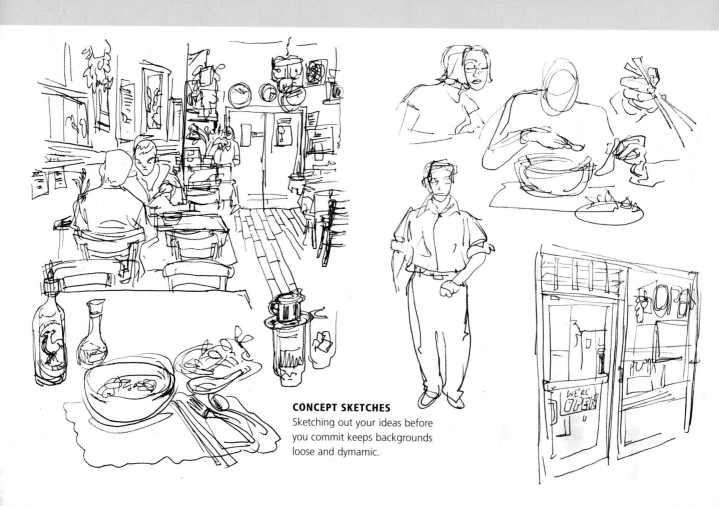

### CONCEPT SKETCHES
Sketching out your ideas before you commit keeps backgrounds loose and dymamic.

diners. Not only was this a useful measuring tool, but it also made for a great design element, and I shamelessly stole it for my story.

I didn't end up showing the front of the restaurant in the story, so I used it as a background element at the bottom of page 8 (see below). The interior location is established on page 9, and then it's largely omitted in favour of close-ups and artsy silhouettes, which are a great time-saving device when you only have an hour to draw each page! Establishing your location properly gives you a lot of leeway to simplify the backgrounds in the rest of the scene. Note the

differing heights of the two bickering game developers relative to the wall stripes on page 9 (see below).

For a 24-Hour Comic, there's not much reason to bother drawing straight lines, but you still need to keep your scale and perspective basics in mind. Every panel should have a clearly defined horizon, parallel lines should at least look as if they're converging on a vanishing point and props and settings can't go changing size willy-nilly from one panel to the next.

**INKED PAGE 8**

This finished inked and lettered page has some background suggested in the first three panels, but in the last panel, a fully rendered background is established to create a convincing setting for the two characters interacting. Notice how the shadows add an ambience to the sequence and provide contrast to emphasise the focal point.

**INKED PAGE 9**

Compare panels four, five and six with the 'not-so-quick' background on the next page. The characters are roughly sketched and the background is a mere suggestion in comparison.

## PHOTO REFERENCE

Photo referencing a restaurant based on the initial concept sketches paints a clearer picture of the background desired for the story.

## NOT-SO-QUICK BACKGROUNDS

Sometimes you'll have more time for your backgrounds. You need to put just as much thought into your backgrounds as you would for a 'real' comics page. To illustrate this, let's revisit those establishing concept sketches and polish them up a bit. First, though, it's time to go back to that Vietnamese noodle house and shoot some photo reference. We're not going to copy these photographs directly. This is just detail reference, and we can reconstruct any part of our imaginary restaurant simply by placing our

## UNDERDRAWING

Flesh out the conceptual sketches using only what is relevant to the scene from the photo reference. Blue pencils are sometimes used as underdrawings in comic page layouts, useful for figuring out the composition, background and figures in the panels.

## PENCIL SKETCH

A graphite pencil is used to tighten up the underdrawings and to establish the line weights for definition and depth between the characters and backgrounds.

horizon and then drawing everything else in proportion. In these three panels, our eye level is lined up with the characters' hips, the tabletop and the taller character's eyes, respectively.

I resized some of these panels in the tight pencils, so I can show a bit more of the environment. This will also give us more elbow room for the word balloons, too.

The final inked version (below), features some spot blacks thrown in to emphasise the foreground action. Aside from a couple of pose adjustments and a more dramatic eye level in the first panel, this is essentially the same thing as the 24 Hour Comic version, just drawn with a bit more detail and finesse.

**INKED PAGE**
The finished page is rendered in ink and reflects the qualities of both the concept sketches and photo reference used to create a convincing scene.

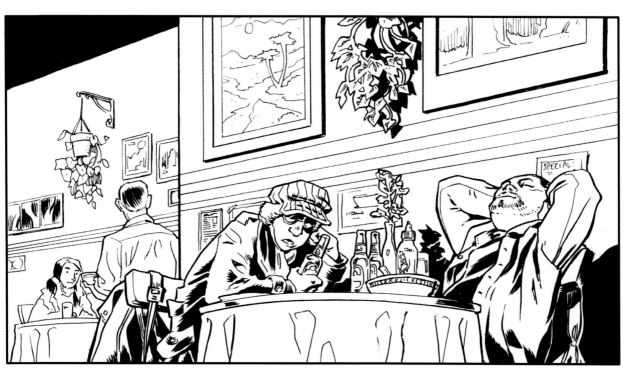

# 6

# FIGURES AND THE PANEL

This chapter teaches you how to draw well-composed panels. We touch on the issues of visual clarity, space and negative space and framing the action. It is important to remember that you are telling a story in a graphic novel; good composition will always be based on and challenged by the narrative needs of the panel.

# BASIC PRINCIPLES OF THE PANEL

The majority of your figure drawing will be placed within a panel on a page layout. The panel is your stage and your characters need to be actors in it. The who, what and where all apply to storytelling; it's the how that will distinguish your execution of figurative storytelling from other artists.

Just like the stage, the panel has its limitations. Your job as the artist is to present a clear, engaging production within a confined space.

### THINK LIKE A DIRECTOR

Practise drawing both inside and outside of the panel. You decide the point of view for the reader. Each panel is a window to a world you're composing. You're not just an artist drawing a comic book, you're a director telling the actor how close or far away they need to be to the camera. You're in charge of lighting, the stage and your characters.

Use contour lines for varying weights of depth, heavy shadows for drama and emphasise the focal point in each panel. Your actors need to be doing something and sometimes that means just standing there, but make it interesting. Give them something to do like scratch their head, roll their eyes, adjust their tie, look at their watch, shrug

their shoulders, etc. Draw what is relevant to the story and nothing more. Keep it simple by drawing it clearly and engaging enough to draw the reader into your story.

### DRAWING THROUGH THE PANEL

The conventional approach is to draw the figure first and then to sketch some sort of background to establish the setting. The next step is to overlay the sketches on the panel outline to determine the best composition. Some artists can lay out a comic book page with panels drawn in and then draw in the figures and the background. Avoid this approach if you're just starting out. Learn to develop a good sense of composition first. In most cases, the panel will distort the proper proportions of the figure and you won't know how to proceed. The chances are you'll be forcing the legs and feet to fit within the panel. The drawing will look unprofessional and static.

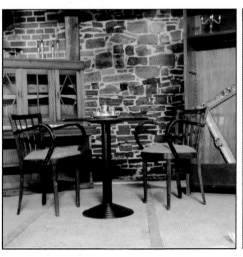

**PHOTO REFERENCE**
Use only what is needed from the photo reference to establish the setting.

**ESTABLISHING THE BACKGROUND**
Just like a stage, the environment you create in each panel is a space for your figures to act, move and express what needs to happen in the story.

**ADDING IN THE FIGURE(S)**
Once you have created a background for your scene, sketch in the character(s) that will be acting the actions and speaking the dialogue necessary to convey your story.

Drawing through the panel is a good solution for working out proportion issues and framing the figure the best way possible. When only a part of your character(s) appear within the panel, it's a good habit to pencil in the figures completely, not just in the panel, but drawing them as if there was no panel to begin with. This enables the figures to remain in proportion.

## 'DRAWING THROUGH' THE PANEL

Depicted here are two characters engaged in casual conversation. Their proportions have already been established in the reader's mind – one is tall while the other is short.

## MAINTAINING PROPORTIONS IN THE PANEL

The examples depicted below illustrate the right approach to maintaining proportions in a panel and what happens when guesswork is applied for incorrect proportions.

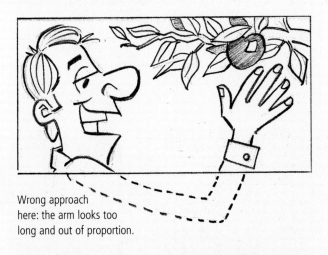

Wrong approach here: the arm looks too long and out of proportion.

Here's a common mistake beginners tend to make – the heads of the two characters have been drawn on the same plane. This gives the reader the feeling that the short guy is standing on an invisible box or some kind of support to make him taller, which is not the intention of the artist.

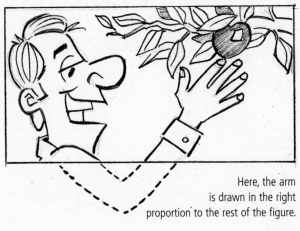

Here, the arm is drawn in the right proportion to the rest of the figure.

In order to avoid this mistake, 'draw through' the panel and pencil the entire figure's body. Juxtaposing this panel with panel one shows a more professional and consistent relationship between the proportions of the figures visible within the panel.

## ENTERING AND LEAVING THE PANEL

Characters are always on the move in panels – the script may call for a character to enter or leave a room. Depicted below are just some of the basic examples of how to draw characters entering and leaving a scene.

**ENTERING**

The figure in the foreground enters from the left in the panel. The figure is larger because he's closer to the reader's POV or the camera.

The figure enters from the left walking into the scene towards the figure on the right. Notice the proportions of the figures are equal to one another, since they are both at the same distance from the camera.

The figure in the background enters from a three-quarter angle while the figure in the foreground looks on. Again, the figure in the foreground is larger because he is closer to the camera, but his eyes are on the same picture plane.

## FIGURES DICTATE THE ACTION IN A PANEL

Here, the panels are all the same, but it is the figures within the panel, and in particular their body language, that conveys the action.

To emphasise just how powerful the figures' body language can be, dialogue and facial expression have been omitted.

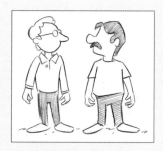
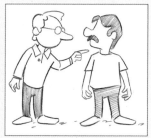

Two figures standing with arms down by their sides tells no story at all. It mirrors the square composition of the panel: static and boring storytelling.

Despite the size and shape of the panel, the artist must create a composition that depicts the action. The figure on the left leans forward pointing at the other, so the reader knows who's doing the talking.

Again, the square panel is presented, but the storytelling within engages the reader. The figures are leaning towards one another, engaged in a heated conversation or argument.

Even though the square panel doesn't change, the action within does; the figure on the left is being aggressive. He leans forward, up close to the figure cowering away.

## LEAVING

The figure in the foreground exits the panel on the left as the figure in the background looks on.

Here, the figure on the right exits as the figure in the room looks on. The character is partially visible as he exits the panel, but drawn in proportion based on the 'drawing through' lesson explained earlier in the chapter. Having the figure leave or enter the panel partially visible is effective to show how objects move through the panel.

The figure in the background leaves through the door drawn at a three-quarter angle as the figure in the foreground looks on.

The figure on the right is not interested in hearing anything the other character has to say. Notice the gesture of the figure on the left trying to talk while the one on the right has his back turned away from the figure, arms crossed and head turned up and away.

The panel is a stage that stays the same while the composition and action of the figures continue to change. The figure on the left gets the attention of the figure on the right through use of a hand gesture.

The figure on the left is talking about another figure off panel, while the figure on the right looks towards the direction of the figure pointing.

Both bodies face one another while their heads are turned away, indicating they might be looking for something or someone off panel.

# FIGURES AND WORD BALLOONS

The figures in each panel must be placed in a position that will permit the proper reading of the balloons. There is no one right way to use word balloons, but using them in a way that reads clear to the reader is your first consideration.

### TROULESHOOTING FOR WORD BALLOONS

Depicted to the right are a series of panels showing how to troubleshoot the interplay between word balloons and figures for the purpose of readability. The panels progress from incorrect ways to an effective way of choreographing word balloons and figures.

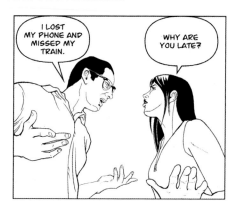

**INCORRECT**
The word balloons and the dialogue are composed incorrectly here: The question is answered before it is asked.

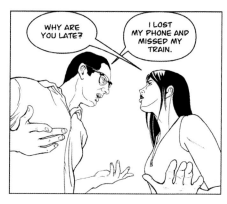

**MUDDLED**
Crossing the word balloon tails, as depicted above, is highly discouraged unless you are rushing to meet a deadline.

### LETTERING AND SOUND EFFECTS

Writer and artist Mark Schultz shares his graphic novel *Xenozoic Tales* for examples of how to word thought balloons, sound effects and captions for effective lettering around figures in panels.

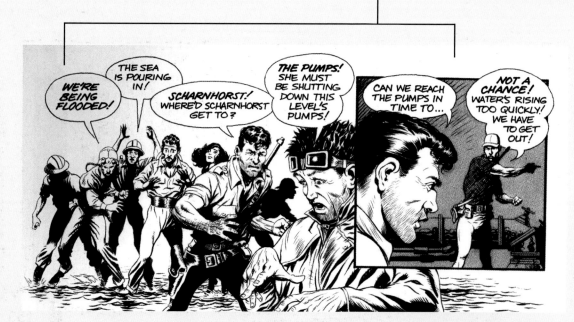

**MULTIPLE BALLOONS**
The reader follows the word balloons from the background to the foreground and from left to right in the panel. The panel is well composed and highly contrasted so the reader knows who is speaking from one person to the next. The inset panel emphasises the focus of two figures talking to one another.

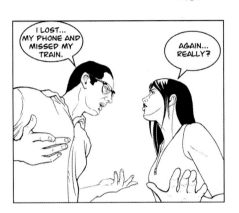

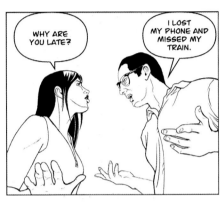

**POORLY COMPOSED**

The panel still reads somewhat clearly, but looks terrible. A poorly composed panel is not a habit to be getting into when lettering comics.

**PROBLEM SOLVED?**

One option is to alter the dialogue. If the figure on the right needs to speak first, you answer the question first, therefore changing the woman's answer on the right.

**CORRECT**

The best solution for reading a panel from left to right is to draw it right in the first place, thus enabling the lettering and word balloons to flow naturally for the reader.

**SETTING THE SCENE**

This scene is introduced in a scroll of paper. Notice how the bridge stretches across the panel, leading the reader's eye to the hunter's word balloon.

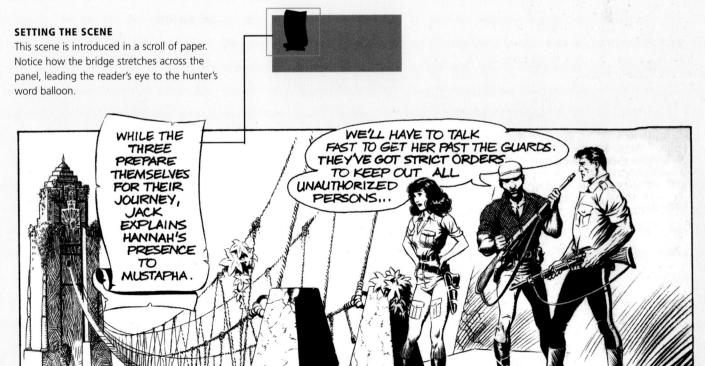

WHILE THE THREE PREPARE THEMSELVES FOR THEIR JOURNEY, JACK EXPLAINS HANNAH'S PRESENCE TO MUSTAPHA.

WE'LL HAVE TO TALK FAST TO GET HER PAST THE GUARDS. THEY'VE GOT STRICT ORDERS TO KEEP OUT ALL UNAUTHORIZED PERSONS...

Figures and word balloons

153

## NARRATIVE CAPTION

The point of view remains the same in this panel. The woman's dialogue segues into a caption narrating a short story regarding her past. Notice how the panel edge changes from the standard straight border lines to a more squiggly design, as if she's recalling a memory.

## SFX

Sound effects, or 'SFX' as the industry term goes, are effective when used properly to compound the action in the panel from someone or something. The figure in the foreground fires his weapon as the two figures in the background react to the creature being shot in the sky.

## ▶ TWO FIGURES IN CONVERSATION

As you read from left to right, the word balloons remain clear as to who is speaking the words. What makes this page so effective are the various camera angles, proximity of the characters to the camera, body language and facial expressions.

I CAN'T BELIEVE IT. I CAN'T BELIEVE YOU'D BE SO STUPID...

AND WHERE HAVE YOU BEEN LATELY?

NONE OF YOUR DAMN BUSINESS. DON'T CHANGE THE SUBJECT.

BALCLUTHA IS A DANGEROUS MAN! YOU MUST KNOW HE ISN'T TAKING YOU ON A MERE HUNTING TRIP!

YOU DISAPPEARED RIGHT AFTER YOUR PARTY. THOUGHT MAYBE YOU'D TURNED INTO A PUMPKIN, OR MAYBE IT WAS BACK HOME WITH HIM...

LORD BALCLUTHA IS MY OFFICIAL CONSORT...

OH...LORD BALCLUTHA. I GUESS THERE'S SOME REAL PRESTIGE IN BEING ATTACHED TO A LORD.

WHATEVER FEELINGS I EVER HAD TOWARD BALCLUTHA DIED LONG AGO... WHEN I LEARNED HOW VICIOUS HE COULD BE.

I KNOW. I'VE SEEN HIS TROPHY ROOM.

MORE THAN THAT, JACK. HE'S GAINED A LOT OF PERSONAL POWER IN RETURN FOR PERFORMING CERTAIN... TASKS FOR THE TRIBAL LEADERS.

HE CAN'T BE TRUSTED... AND HE KNOWS ABOUT US!

7

# COMPOSITION

In comics, composition is applied to emphasise the focal point in a clear and convincing way from panel to panel in order to tell a story.

Composition is a subject folks can argue about with no resolution. There are no set of rules or shortcuts, just the principles of following good decision-making. However, certain things engage the reader more while others may repel the reader's eye from following the narrative flow.

Think when you draw: think of the three planes of depth, line weights, light, shadow, etc.: will this, or just some of these components, help guide or distract the reader's eye from following your story? If a line or object doesn't help direct the reader's eye to the focal point from panel to panel, revise it and try again.

### CENTRALLY PLACED FIGURES CREATE FOCUS

The figures are the focal point of this panel. Notice how the artist decided to keep the background minimal, but to show enough props to create a clear setting. The creation of props also illustrates the scale of the figures in relation to the objects in the foreground and background.

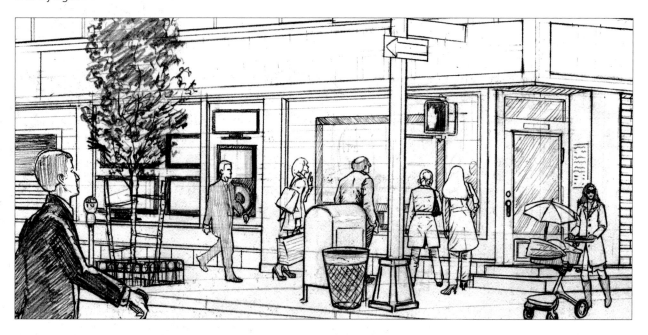

### BODY LANGUAGE CREATES FOCUS

The establishing shot in this panel depicts a busy intersection in Anytown USA. The figure in the foreground entering from the left is shown from the waist up but in proportion to the figures in the background because the camera is positioned at his eye level – the same as everyone else's in the scene. The scene remains interesting because the artist used a two-point perspective, as opposed to a flat scene where the buildings would only show one plane and people would be in profile. The focal point in this panel is directed by the body language of the figures in the background watching the flat-screen television.

Vanishing point

## PERSPECTIVE CREATES FOCUS

The woman on the motorcycle is positioned in the centre and the foreground, making her the clear focal point. She is further emphasised by the one-point perspective vanishing point that converges everything in this scene behind her.

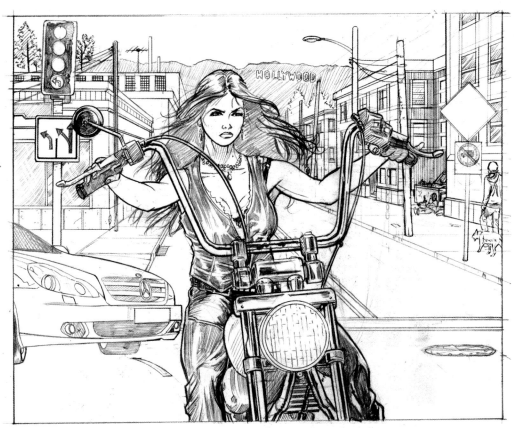

EIGHT O'CLOCK— AND STILL NO CHINO!

R·R·R·R·I·N·G

LEONARD STARR 5-25

EIGHT O'CLOCK— AND STILL NO CHINO!

R·R·R·R·I·N·G

LEONARD STARR 5-25

2    1

## PROPS CREATE FOCUS

The action of the figure here is clear partly due to the contrast of black playing against the white in the panel: a window shade is cleverly placed as a shadow on the wall (2). The man is awoken by his alarm clock as he reaches to shut it off (1), and yet the focus is on the props: the bed, nightstand, lamp and clock, all of which tell a story. Notice the slight downshot two-point perspective angle used to compose this panel.

## MAKE IT INTERESTING

In today's ever-changing and competitive market, an artist won't get very far without discipline and imagination. A panel may be drawn with every component painstakingly correct and still be uninteresting to the reader. If the artwork is uninteresting, the artist is not doing their job.

When composing the panel, don't just pencil the subject. Think about what you can include to make him or her more interesting. Add some action or a different viewpoint. The composition at the bottom of the page, for example, is so much more dynamic than the drawing immediately below, even though the same action is being described.

### FLAT AND UNINTERESTING (1)

Nothing wrong with this, but it's a bit flat and a bit unclear as to what is happening: what are those big black things on the right? Why is the man in the truck looking back? Never assume your reader can interpret what you 'suggest' visually. Give them a panel composed with clarity leaving no doubt as to what the action is in the panel.

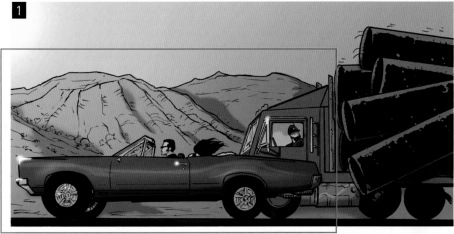

### DYNAMIC AND EXCITING (2)

A three-quarter view reveals what's happening. The car is evading the police as a pipe breaks way from the truck. This increases the danger and compounds the action of the getaway car. Always compose more than one composition per panel from various angles to figure out which one best serves the story.

## 180-DEGREE RULE

The 180-degree rule is a guideline employed in motion pictures. It states that two or more characters or objects should always have the same left-to-right orientation within a scene in order to maintain narrative clarity. Crossing this imaginary line has the potential to create confusion.

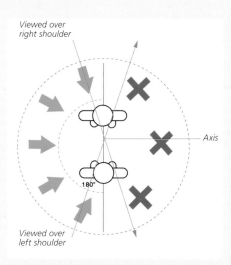

### ▲ AXIS OF ACTION

Think of two characters in a scene. Draw the axis of action (an imaginary line that separates the camera from the action before it). If the 180-degree rule is observed correctly, the camera must not cross over that line, otherwise there is a visual discontinuity.

### ► THE POWER OF THE NEUTRAL SHOT

A neutral shot can be used to change the direction of a moving object, like the car depicted here. Say that in your first panel you draw a car driving from left to right (1). But say that in the second panel, you want to draw the car going from right to left (3). Without a neutral shot (2), the two cars would create the illusion of a collision.

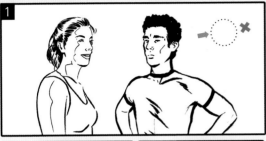

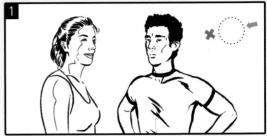

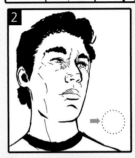 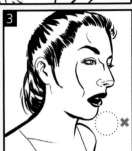

### ◀ THE RULE IN ACTION

Look at the drawing on the left. Panel 1 is an establishing shot of a woman on the left, and a man on the right. In panels 2 and 3, the camera has zoomed in for close-up shots of each character. The imaginary line on one side of the axis has not been broken. In order to change the direction of the action, a neutral shot must be used (see below). In panel 4, the woman and the man are profiled, before crossing the imaginary line of action to the other side of the axis, as we see in panel 5. Without a neutral shot, your story's visual continuity may be disrupted and cause confusion.

### ▶ BREAKING THE RULE

Now look at the drawing on the right. As before, panel 1 is the establishing shot, but in panel 2 the man crosses over the imaginary line. This confuses the reader, creating a pause in the storytelling, and wrongly suggests that the man and woman are talking to someone else in the room that we cannot see. In panel 4, the line is broken again as the camera moves to the other side without the use of a neutral shot. See how confusing this page is compared to the page illustrated the correct way?

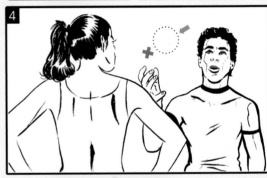

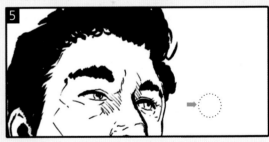

# SPACE AND NEGATIVE SPACE

The relationship between your figures and the space around them is crucial. Space is used to show the distance between figures (or objects) on a flat surface and, more importantly, to create an illusion of distance.

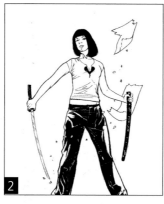

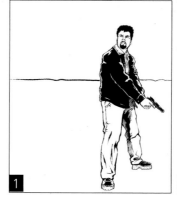

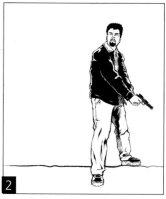

## NEGATIVE SPACE

Negative space is a compositional tool. The simplest way to describe it is as: 'space where other things are not present'. Negative space has no 'negative' connotation. In the examples above, surrounding a figure with a large amount of negative space suggests the figure is in the distance (1); in panel 2, the figure is now closer to the camera.

## HORIZON LINE

A high horizon line can dwarf your figure (1). Lowering the horizon line decreases the ground space and makes the figure appear more important in the scene, at eye level with the reader. With the ground level below the figure, the man has a commanding presence (2).

## TANGENTS

If you allow two figures or lines to touch in a panel – 'tangents' – you create the illusion that the figures are on the same picture plane. This hinders the illusion of depth and can be distracting. Below are two examples, originally depicted in the *Famous Artist Cartoon Course*, of how tangents can be avoided.

## INCORRECT

Here the picture frame appears to rest on the man's head. His nose and finger seem to be attached to the lampshade, and the tangent formed by the lower edge of the newspaper makes it difficult to tell where one form leaves off and the other begins. Further examples of these tangents are indicated by the arrows.

## CORRECT

Compare this picture with the previous one and note how the troublesome contact points have been corrected. Bad contact points should be avoided in the pencil stage (when you're inking it's too late) by overlapping the elements decisively or by keeping them definitely apart. Of course, if two forms are actually intended to touch (as with the man's elbow on the chair arm) there is no problem.

## LEADING THE READER THROUGH SPACE

As a reader moves through the page of a story, they should be able to follow the action clearly. The *Batman* page below, illustrated by Chris Marrinan, is a good example of how the artist leads the reader's eye through the action.

### PANEL 1

An upshot of Batman centred in the panel is the focal point for this sequence. Notice how the radiating lines and Batman's cape suggest the downward direction of the reader's eye – a visual subtext for telling the eye where to move.

### PANEL 2

The bullet lines penetrate the glass doors as Batman bursts out. Again, the lines of the bullets and his cape have the direction moving from left to right, as opposed to down in the previous panel.

### PANEL 3

The reader's eye is drawn to Batman in the foreground. The heavy black inkwork draws your eye in as the police car on the right frames the officers in the background. The radiating police lights help draw attention to them, too.

### PANEL 4

A low angle upshot from the reader's POV hones in on Batman as he leaps on top of the police car, firing off a grappling hook from his wrist into the air. The vanishing point falls behind Batman as the lines of the building converge, drawing the reader's attention to the centre of the panel.

### PANEL 5

A dynamic downshot of Batman as he lunges into the air. The foreshortened leg, which comes towards the reader, is the focal point. Good visual narrative by well-composed panels is compounded by contrast of light and shadow, line weights and body language.

Space and negative space

# FRAMING THE ACTION PANEL BY PANEL

You must interpret the scene based on what the script calls for, but it up to you how you choose to frame the action within the panel. This can be especially difficult when the script calls for no discernible background, as shown here.

Despite the fact that most of the panels are rectangular in both portrait and landscape format in this example, there are many different ways to compose the action in a scene. What is remarkable about this comic is that the panels crop out everything except for the focal point: the characters themselves.

## PAGE ONE

### PANELS 1–3
We begin with a pitch black panel, then move to a hand flicking open a cigarette lighter. What the panels set out to reveal is an ominous, potentially dangerous, character who likes to light up when talking.

### PANEL 4
The camera is pulled back to reveal the suspect being questioned by the interrogator. The interrogator is the hand holding the cigarette, which frames the suspect in the background.

### PANEL 5
The camera angle on the suspect has changed from the reader's POV to an upshot in panel 5.

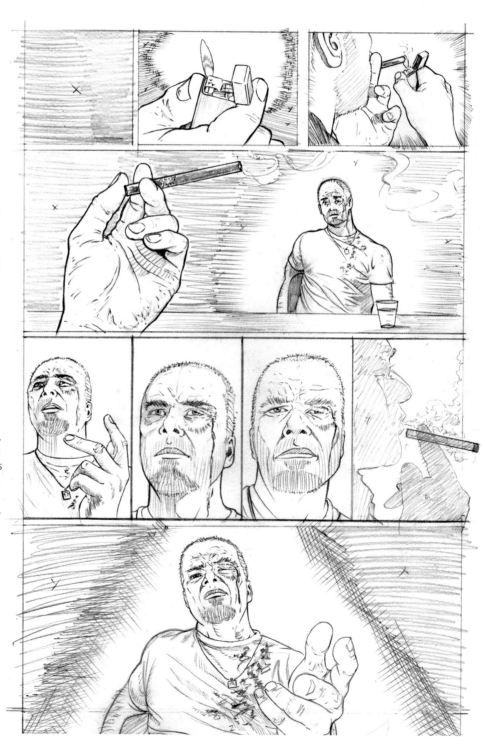

## PAGE TWO

### PANELS 1–3

The interrogator is shown up close, again taking a drag from his cigarette. Panel 3 establishes a perspective at eye level.

### PANEL 4–5

Silhouettes are a useful component in storytelling. The body language suggests the interrogator's intent to learn more from the suspect as he leans back in his chair. In panel 5, the suspect, who, it is revealed, has been beaten, does not look happy.

### PANELS 6–7

Again, the camera is at a low angle shot, just behind the interrogator as the suspect crosses his arms, listening to what he doesn't want to know. In panel 7, the suspect begins to share a story about a little girl that happened some time ago.

### PANELS 8–10

The setting now shifts to the suburbs as a little girl enjoys riding her tricycle. Notice how her expression changes from joy to fear as the bully steps in front of her from out of the bushes. The low camera angle in the last panel suggests the bully is in command here.

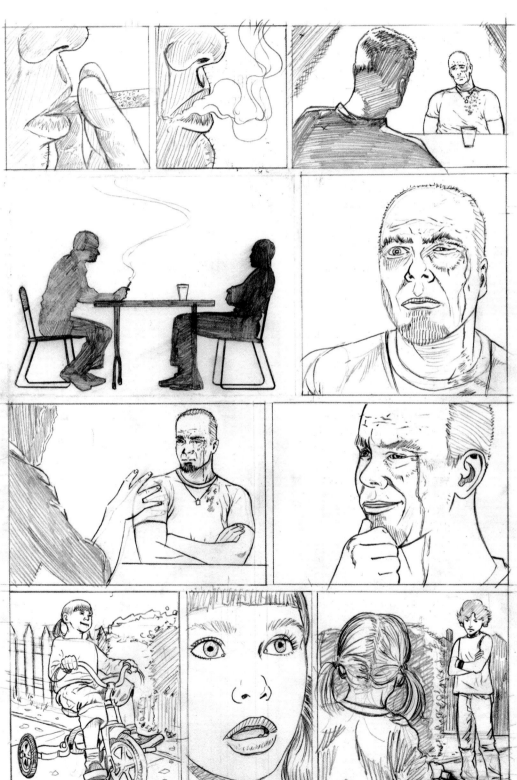

## PAGE THREE
### PANELS 1–3
A downshot angle suggests the girl is smaller than her aggressor as the over-the-shoulder shot of the bully frames the girl in the background. She becomes defiant in panel 2, squeezing the handle bars of her tricycle. In panel 3, the bully seems defensive. The POV in panel three is from the girl's perspective, but it also puts the reader in the seat of the tricycle, so that we might identify with the character.

### PANEL 4–5
Panel 4 communicates the girl's suspicion and, in panel 5, the setting is re-introduced with a bit more detail to remind readers that we are in the suburbs. The bully kneels down to get in closer to speak with the girl.

### PANELS 6–7
The bully reassures her that he means no harm and encourages her to continue on her tricycle down the sidewalk. Notice how she leans towards him a bit, feeling more at ease.

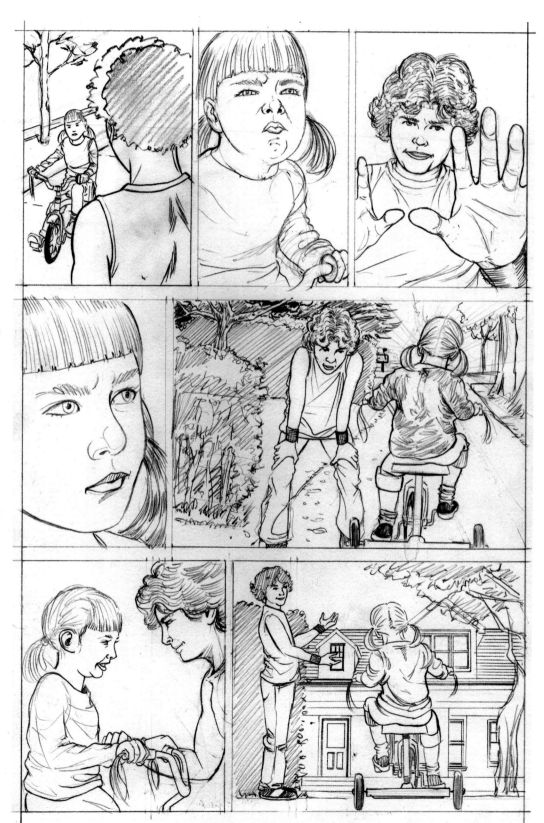

## PAGE FOUR

### PANELS 1–5

The girl smiles slightly suspiciously in panel 1, while, in panel 2, the bully smiles back. The actions of her beginning to pedal again are depicted in panels 3 to 4, suggesting she's ready to move forward, but the bully steps in her way again in panel 5.

### PANELS 6–7

The girl's face now shows concern, perhaps worried by what he might do to her. Notice the difference between her expression in the first panel and her expression now, in panel 6. In panel 7, the bully pushes her off her tricycle into the bushes and obviously enjoys it.

### PANELS 8–10

The girl sits in the bushes humiliated and upset. See how she's holding her knee and cowering in the bushes. The next panel is an over-the-shoulder shot of the girl as she watches the bully ride off with her tricycle. The last panel is the most telling of her emotions, as she cries her eyes out. If illustrated effectively, emotion not only engages the reader, but encourages them to identify with the characters.

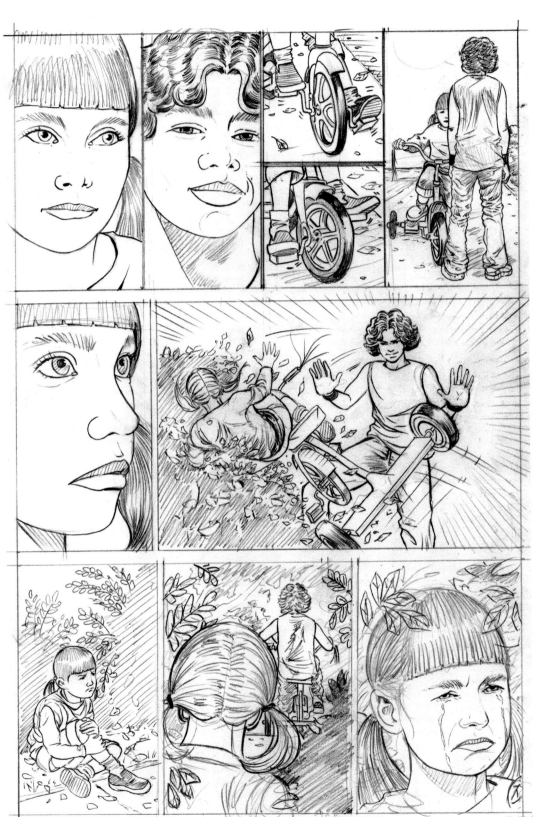

# ARTIST IN RESIDENCE: AMIN AMAT:
## Laying out a comic page

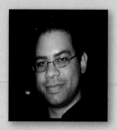

### ABOUT THE ARTIST

Alumni of the School of Visual Arts, NYC. As a comic book artist, he's illustrated for Moonstone Books on two of their best selling properties, *Buckaroo Banzai* and *Kolchak: The Night Stalker*; Scholastic Books, Xbox (Microsoft), IDW Publishing (*Battle of Little Bighorn, Code Word: Geronimo*), Blind Spot Pictures (Iron Sky Movie Prequel Adaptations). Currently he's working on several creator-owned projects as well as a book adaptation. He resides in San Juan, Puerto Rico, with his wife, Maria.

### THUMBNAILS [1]

Before I do any thumbs, I'll read a script from start to finish and then come back and start with thumbnails, usually the first thing that comes to mind. I'll do simple shapes and blacks to get a basic idea of how the panels will be composed and the juxtaposition/relationship of the panels in terms of storytelling. For the most part, the thumbs I'll do right on the script.

### LAYOUT [2]

Once I have a layout that I feel best works for what is needed to tell, I'll do full-size roughs of the thumbnail sketches. At this stage I'll start to see how it all looks and begin to question if the camera angles/shots are the best for that panel in the sequence to be drawn. My choices of

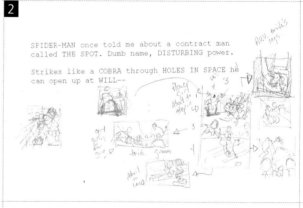

camera angles are based mostly on creating a visual guideline for the eye to follow so that the story can visually flow from one panel to the next. Also, by varying if the shot is close/far, up/down, helps me to simulate movement.

## ROUGHS [3]

Here is where I begin to really flesh out the locale, characters, and overall setting. I'll lay down a grid work for my perspective to make sure everything lines up. I also flesh out clothing and figures to make sure proportions are correct and believable. Even at this stage I'll continue to edit/alter some of the drawing to make it work with the other panels as well as within itself.

## FINAL PENCILS [4]

The final pencilled piece, with most of the grid work erased and a few items cleaned up, now brings to life what I originally created in the thumbnail on the script. Now, although the pencil work is 'completed', if I see that a certain element isn't working or needs an adjustment, I'll erase and make the fix, or in some cases, erase panels and redraw them. The story always comes first. Thus, whatever helps to move the story along will always have precedence.

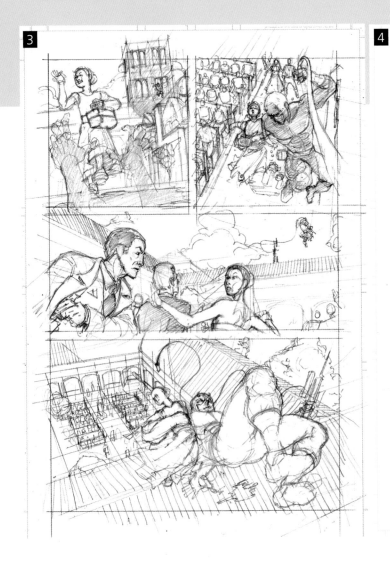

Laying out a comic page

# 7 GRAPHIC NOVEL PREVIEW: THE FINISHED PAGES

In the following pages, you will find the complete original script by Daniel Cooney for *Atomic Yeti #1*, side by side with Jeffrey Hime's finished inked pages, for a unique insight into the creative process. Each page is accompanied with annotations by Daniel Cooney.

Graphic novel preview: The finished pages

## PAGE 1

The opening scene here was worked out many times before deciding on this one. We decided to go with one setting and divide up the action with panel gutters as the skiers run through the snowstorm in the forest. Notice how the folds in the figure's pants change as the figure moves.

**See Law of folds, pages 96–101**

**See Entering and leaving the panel, page 150**

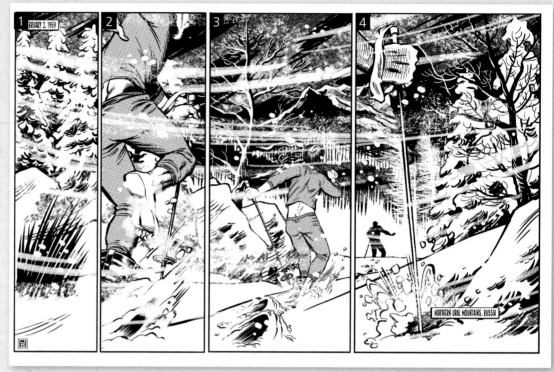

## PAGE 2

Page 2 has the camera moving around from panel to panel. I wanted to establish the desperation of these characters as they run through a wicked blizzard in the middle of the night. What I hoped to accomplish through this scene is chaos, established by the partially dressed figures running for their lives from an unseen threat. Artist Jeff Himes did a wonderful job setting the tone of the story right out of the gate. A good artist can render the body language of a character in action as well as drawing the folds in their clothes for whatever the context of the scene calls for.

**See Lettering and sound effects, pages 152–155**

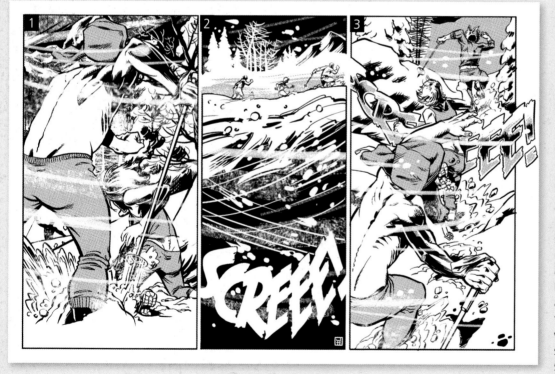

## PAGE 3

Hand gestures help compound the emotion of the character, as you can see here in panels 1 and 3. The terror in the figures' eyes tells the reader that whatever is chasing them has caught up. The closeup and upshot camera angle exaggerate the terror the character is feeling in this scene. Note the man's hand in panel 1 reaching out in a futile attempt to stop the threat about to envelop him. The terror in the man's face is dramatised by the shadows, wide eyes and clenched hand as his body cowers away.

**See Hands in detail, pages 90–92**

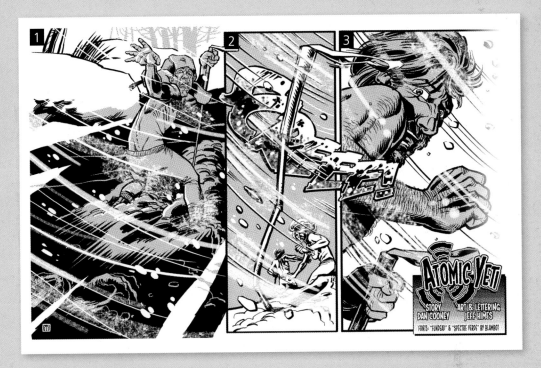

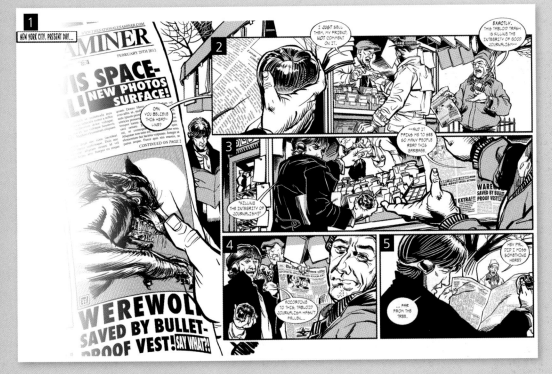

The apple, first introduced in panel 2, is a visual tag that carries through the scene. This storytelling device helps the reader track the main character, as the camera work changes from panel to panel.

## PAGE 4

A new scene is introduced on page 4. The artist suggested we segue the two scenes by having a vignetted newspaper clipping of a werewolf in a similar pose to that of the skier on the previous page. When collaborating with a good artist, great ideas like these often come to fruition and make the story even better visually.

The landscape page layouts are a tip of the hat to the golden age of Sunday newspaper strips with their serialised storytelling. The format also works well on a computer screen or portable reading device and offers up something different for the reader.

**See Props and details, pages 120–121**
**See Framing the action panel by panel, pages 162–165**

## PAGE 5

Every scene should have a clear establishing shot of the setting for the characters to play through, whether they walk through the scene or not. It's camera shots that give the reader a sense of where and when the action is taking place and what is going on in the scene. Note how the figure is drawn in each panel at various camera angles: three-quarter view upshot, low angle straight-on view, an eye-level profile shot of the figure in full and a downshot of multiple figures in the last panel. A visual tag in this scene is the black winter coat. The focus of the visual narrative in each panel is the main character, Lane.

See Camera shots and angles, pages 134–137

See Props and details, pages 120–121

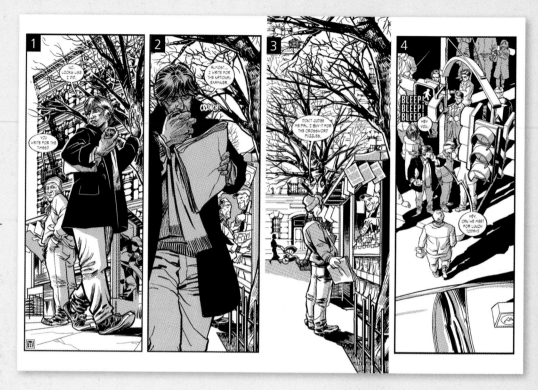

## PAGE 6

Here, we see the main character moving through the first panel clearly. It's a static shot of the same camera angle as Lane walks past the New York Times building, where he worked briefly as a journalist. We see the apple in play through this page before it finally ends up in the rubbish bin. Good reference comes from drawing what you see every day. As a comic book artist seeking to be successful in the craft, you must be able to draw everything well (buildings, jackets, newsstands, rubbish bins, even the spokes on a wheel) to be competitive as a working professional in the field.

See Building a reference library, pages 24–25

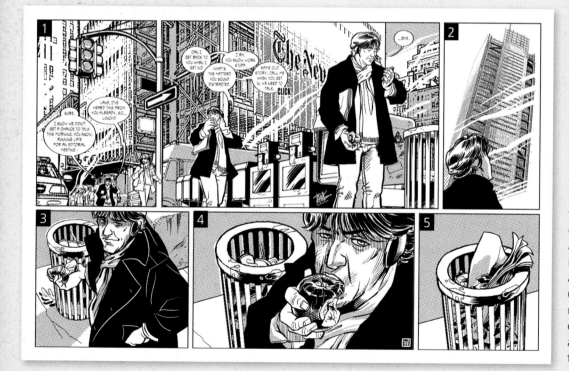

## PAGE 7

Every time a scene shifts, make the new setting clear right away on the page, or you may lose your reader in the process. This page utilises a variety of camera shots and angles for it to work effectively. A close-up of the lift buttons indicates where the character is going. Pull the camera back to reveal the new setting of a lobby in a building as you see the main character (recognisable by his black jacket) taking the lift.

Now you're into a new scene: establish the setting as the character enters and walks through it. As he's given some bad news, he reacts by squeezing his coffee cup too tight, thereby implying, through visual subtext, the anxiety that's been building up with the character about employees being let go – as his facial expression in the last panels reveals.

**See Facial expressions, pages 42–45**
**See Hands in detail, pages 90–92**

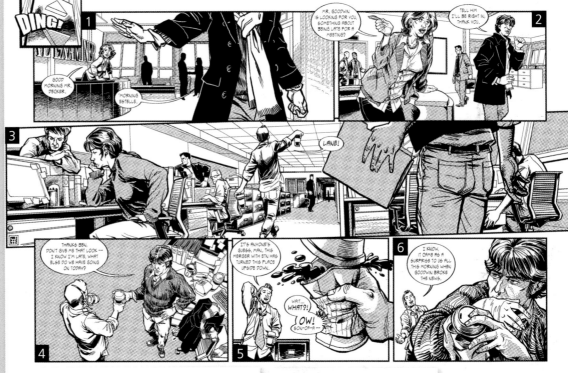

There is a great attention to detail on this page. Note the silhouetted figures shaking hands in the background of panel 1 (enlarged above top), the two figures having a conversation as they wait for the lift in panel 2 (enlarged above centre), and the figure in the far distance of panel 3 (enlarged above bottom). These details not only help to set a scene through the use of perspective, they give the impression that this is an office populated by hard-working and not-so-hard-working staffers.

See how the man at his desk watches the character with the coffee cup in panel 3 (left). It is the little things like body language that make you a good storyteller. You want your reader to buy into the world you create.

Details like the half-open lid of this coffee cup (left) can say so much about your characters.

## PAGE 8

The first three panels depict figures drawn from the waist up at the same camera level. This type of consistency in establishing the characters helps the reader identify with them as they follow the story. The last two panels illustrate an upshot and a downshot of the figures. Again, body language is at work here, as well as hands expressing the emotion of the character and compounding their facial expressions.

**See Camera shots and angles, pages 134–137**
**See Hands in detail, pages 90–92**

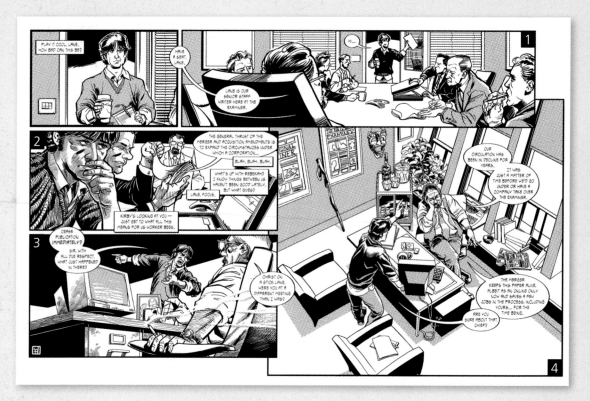

To create the panel on the right, the artist referenced himself in the mirror blowing out smoke. Equally, you could ask a friend to pose for the shot, or use a movie image still. Note the position of the fingers around the cigarette, and the pursed lips.

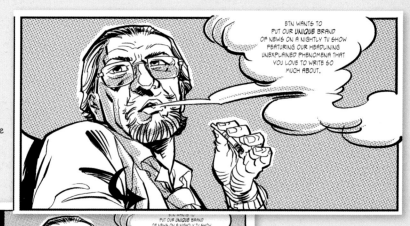

## PAGE 9

The artist has used the cigarette smoke as part of the word balloons for the dialogue, which I thought was a clever idea. If you look closely in panel four, you'll notice that the artist Jeff Himes has used the chair the character is sitting in as a word balloon.

**See Eyes and brows in detail, pages 34–35**
**See Figures and word balloons, pages 152–155**

## PAGE 10

Backgrounds are an essential part of the story in which the characters live and breathe. Sometimes, it's wise to leave a background blank (especially after it's been established in previous panels) to put an emphasis on the character, who may be saying something profound that's pivotal to the story. This also helps the reader's eye focus on the story.

See Composition,
pages 156–159

See Foreshortening the figure,
pages 74–75

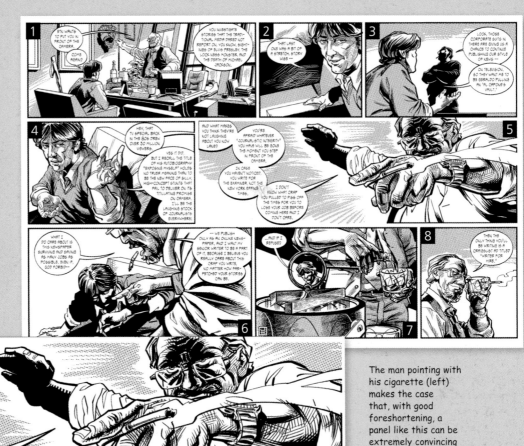

The man pointing with his cigarette (left) makes the case that, with good foreshortening, a panel like this can be extremely convincing and dynamic.

## PAGE 11

A good example of showing how time can pass is using the same composition in two consecutive panels juxtaposed next to one another, as you see here in panels 4 and 5, with the character looking out the window having a drink and then, in the next panel, taking a drag of his cigarette. The character in the background has moved slightly as well.

See Composition,
pages 156–159

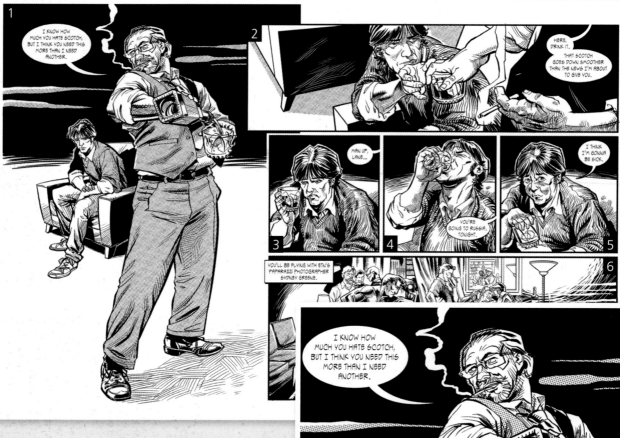

## PAGE 12

Notice the absence of background in panel 1. The scene has not changed from the office on the previous page, so it was a decision by the artist to leave out the backgrounds for the most part (which I agree with) to focus on the two characters as his boss, who is pouring the drinks, gives him instructions on his new assignment.
**See Facial expressions, pages 42–45**

Note the figure sitting down, shoulders slumped forward and the disappointed look on his face. Again, body language and facial expression play a part here. The figure in the foreground arches his back slightly as he pours a drink and smokes a cigarette. Folds play a part, too, in expressing the actions of the character.

## PAGE 13

As stated on the previous page, caption boxes are used in this scene as voiceovers. The scene ends as we return back to the office (notice how we immediately re-establish the office setting) as he hands over the dossier to the main character. The last panel is composed from the reader's point-of-view, to give them a sense of being a part of the story; this way, they may feel more engaged, becoming the character and the story as it progresses.

**See Camera shots and angles, pages 134–137**

Light and shadow play a part in dramatising the action as depicted here in panel 2 (right). Note how her body has to twist and use her left arm to support the weight of her actions.

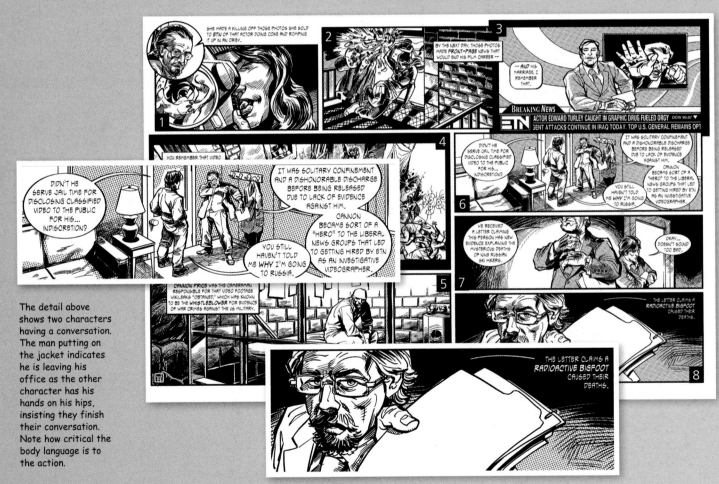

The detail above shows two characters having a conversation. The man putting on the jacket indicates he is leaving his office as the other character has his hands on his hips, insisting they finish their conversation. Note how critical the body language is to the action.

Facial expression and gestures are critical to clear and effective storytelling.

## PAGE 14

The scene changes to the workplace outside Lane's boss's office. Again, we immediately establish the setting as the two walk through it. Several storytelling devices are at play in this scene: the upshot camera angle to give an interesting viewpoint of the action; the two-shot profile of Lane and his boss in panel 3, the close-up shot of the dossier in Lane's hand in the foreground framing his boss in the background, establishing a POV from his co-workers to remind the reader of where the character is in the scene.
**See Camera shots and angles, pages 134–137**

The body language of the man leaning into his employee clearly demonstrates how angry he is with him, as the employee cowers back in defense. The effect carries over to the final panel, depicting the discouraged employee on his mobile phone.

## PAGE 15

The last page ended with Lane on the phone with his fiancée, which is a clear segue into the new scene on this page. A convincing establishing shot is created in the first panel, showing the reader we're no longer in the office building. I felt body language was key between the two characters in this scene, as Lane learns his fiancée is leaving him for a news presenting job in another part of the country.

**See Camera shots and angles, pages 134–137**

Note the contrast in body language between this couple. He takes a more relaxed approach to a serious matter, while she is intent on discussing things further. Note how her arms and legs are crossed, shoulders leaning forward: it reveals much about her character.

The man's body language conveys to the reader that he is not interested in hearing what she has to say. She leans into him, driving home her point. This scene wouldn't be as effective if the two characters were merely just sitting there. Observe how people behave with one another in real life. Take photos, sketch, save images and use them for scenes like this to help you become a better figurative storyteller.

## PAGE 16

Body language plays an important part in describing the relationship between Lane and Rebekah in these panels. In panel 1, they are seen silhouetted in the background as removal men take away an old couch. In panel 2, they're in the same pose as the previous panel. This creates a visual clarity for the reader. Notice how differently Lane and Rebekah respond to the same situation – she is obviously in a hurry to leave while Lane is relaxed. Note how Lane never leaves the steps and Rebekah is more or less in the same position throughout; it is the camera that moves around the characters and it is this that creates movement.
**See Space and negative space, pages 160–161**

Notice the use of the open panel and the negative space that surrounds the characters. It contrasts from the rest of the page, which is extremely detailed, and allows the reader's eye to pause for a moment and consider the unfolding drama.

## PAGE 17

In this page, the body language is replicated across panels. This effectively reinforces what the characters are trying to say to each other. Notice how the artist has played with the proximity of the camera: it moves in closer between panels 1 and 2 and panels 5 and 6. There are many ways of communicating a farewell. Note how Lane's emotions change and develop from panel to panel as Rebekah says goodbye.

**See Facial expressions, pages 142–145**

When it comes to storytelling in comics, sometimes less is more. Try to let some panels speak for themselves; you will soon discover that drawings alone can be just as resonant as fully lettered panels. Silence speaks volumes after all.

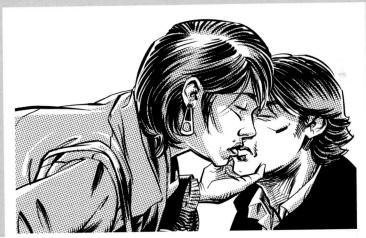

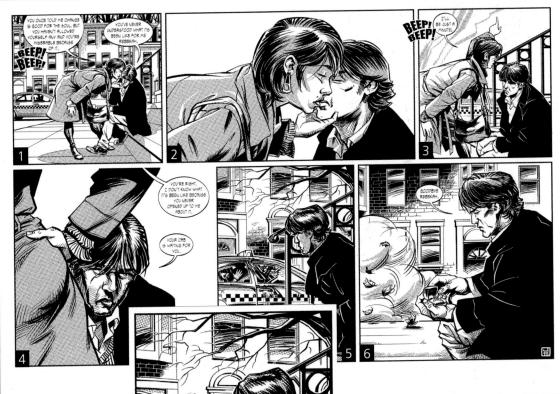

Our character faces a bleak outlook as his fiancée departs in a cab, leaving Lane sitting alone on the steps. This is amplified by the winter scenery. The panel is ambiguous: Rebekah's hand on the cab window might be read as a wave goodbye or as a last attempt to reach out to Lane. These subtle visual clues warn the reader that events shouldn't be taken at face value.

## PAGE 18

Page 18 begins with an establishing shot, which informs the reader that the story has moved to a different location. Whenever a new scene is introduced, remember to establish the new setting and the time of day. Here, time has elapsed since earlier in the story and it is now nighttime. Lane is visiting an old college buddy in hospital. The purpose of this scene is to reveal a bit more about Lane's past. The last panel shows a hand pushing the door open as it frames Lane in the background. This creates suspense and encourages the reader to turn the page as they may be wondering: whose hand is that and why are they eavesdropping?

**See Camera shots and angles, pages 134–137**

Lighting can be a powerful tool when it comes to navigating the reader around a page or panel. Here, we look down at two figures in a room. They are the focal point because they are framed by shadows on the bed, the wall and the floor of the panel. The bird's-eye view looks down on the characters, a perspective that reflects Lane's mood: he himself is feeling down.

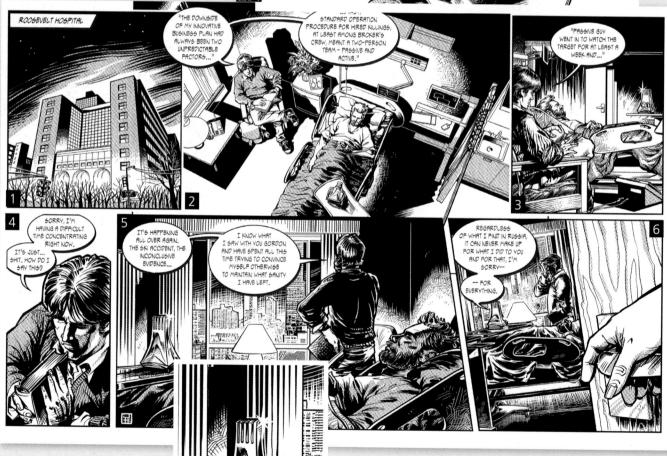

Notice the glass object on the tray by the patient's bedside. The placement is subtle, but the frequency of its appearance throughout the page should tell the reader that it is more than just a background prop.

## PAGE 19

The hand from the previous page is transformed into a partial silhouette in panel 1 as the door is opened. Again, body language plays a part in telling the reader how Lane feels about the patient's mother showing up. Facial expressions say it all in panel 5; the mother looks at Lane with contempt, which explains Lane's rapid departure in the final panel.
**See Facial expressions, pages 142–145**

Framing the focal point using other characters is an effective technique. Here, the mother cares for her comatose son. She is in the foreground, he is in the centre, and the main character reacts to her arrival in the background. This composition establishes depth of field to create an engaging shot.

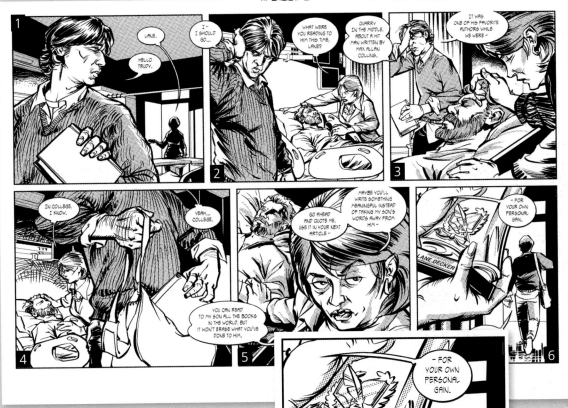

The last panel reveals to the reader what the glass object is: Lane's journalism award. The mother holds the award implying that it should have gone to her son instead. Like the last panel on the previous page, the sequence ends with a close up of the mother's hand, but this time it is Lane who is in the background, walking out of the door.

# GETTING YOUR WORK OUT THERE

Portfolios are what artists thrust under commissioning editors' noses and say 'This is what I do'. A portfolio is a catalogue of a body of work that editors can look at to see what the artist has done, is capable of and how his or her style has changed and matured over the years.

Start your portfolio with your first sale (if you have sold work), including copies of the original artwork and the finished comic book. If you want to keep copies of the books on your vanity shelf too, that's okay, but any copies you carry around are going to get worn. Stuff on the vanity shelf should be pristine – it's for gloating over, not reading.

Include material you haven't sold, too – as long as it's good stuff. Your portfolio is there to create an impression, so make sure it's a good one.

## ORGANISING AND PRESENTING YOUR ARTWORK

A portfolio of your work as it grows and improves is essential. You can organise it by figure or chronologically (to show how you've improved). It's up to you. The main point is that you can show examples of your work in a tidy and professional manner. If you use a ring-binder portfolio, samples can be removed for passing around at meetings.

- Don't use too large a folder. Remember, you have to carry it, and editors don't want something the size of a table dropped on their desks.
- If the originals are large, get good-quality copies made: photocopies or scanned-in prints.
- Use separate, detachable sleeves for each piece of work. These can be handed around easily, while being protected.

## PORTFOLIO CHECKLIST

Your portfolio information should include:

❯ Your contact information: name, email and telephone number.

❯ Short bio that explains why you are passionate about creating figure work and your goals for a career.

❯ Traditional illustration work, including the human form.

❯ Examples of the work you are best at.

❯ List of the software you are proficient in using.

❯ List of any prior work you have created for a client.

- Only show material you're happy with. If you include work that you're not sure about, the editor will pick up on it. You're there to sell yourself.
- Do present each page on a separate board or strong paper that you've mounted on board (but only at the corners).
- Don't leave too much white space at the edges. Excess white will simply be trimmed off during reproduction. Because boards are expensive, not using as much as you can is wasteful.
- Do cover each board or sheet with clear layout or visualising paper. This not only protects both art and paper, but provides space for any special proofing requirements or sizing notes (either yours or your publisher's) to be written.
- Don't use different-sized boards – a carefully packed, uniform-sized package stands the best chance of surviving both the mail and publishers.
- Do write the title of the book and publisher on each board – in case the protection sheet gets lost. Also, add the page number (book page, not manuscript) and your name.

## DO I NEED TO QUALIFY MY ART WITH TEXT?

Include some brief text explanation when necessary, but assume that many people will page quickly through your work if they are looking through several portfolios in one sitting. Once they have decided they like your stuff, they are going to take a more detailed look at your explanations, and so these should enhance their visual experience and give additional details. Short and informative information such as a project title and media/software used is enough.

## PRESENTATION FORMATS

The best way to get your figure work seen and circulated is to present it on a webpage or blog. Your work can be easily viewed and forwarded as a link in an email. Do make your page easy to navigate and use standard file formats. Don't make it restrictive so that a reviewer has to enter passwords or download any uncommon programs to view your work. Your website should contain: a short bio that explains who you are, the type of work your site contains and why you are passionate about creating figures for comic book art.

## MAKE YOURSELF MEMORABLE

There are several ways that artists can present themselves and be remembered by commissioning editors.

❯ Try postcards with an example of your work on one side and your contact details on the other.

❯ Use your own personal logo on letters, business cards, invoices, compliments slips, postcards and fliers.

❯ Produce fliers or one-page ads.

❯ A website or blog can contain a gallery of your work, reproduced perfectly and almost cost-free.

### CONTRACTS AND AGENTS

When negotiating a contract, it pays to be careful. In other areas of art, the creators hire themselves an agent and let him or her do all the work. But in the comics field, this method of working is rare. That's not to say there aren't agents for the field.

The alternative is to source a book that details an artist's rights. *Artist's and Graphic Designer's Market*, for example, includes sections on rights, copyright and intellectual property – as well as lists of publishers and societies throughout the world. Or, if you want more detail, seek out a specialist title, such as *The Rights of Authors, Artists, and Other Creative People* (Norwick and Chasen) or *The Internet and Authors' Rights* (Pollaud-Dalian, ed.).

And, finally, there are artists' collectives, whose aim is to look out for the rights of comic book creators. They can be found on the web.

### COPYRIGHT

Now we're approaching the sticky stuff – copyright. Who owns what, and for how long.

Copyright is something with which you're going to have to get acquainted. All published work is copyrighted – the very act of publishing is recognised as registering copyright for that particular work. The purpose of copyright is to prevent plagiarism – the theft of your work by someone who presents it as his or her own.

Full-time writers and artists don't want to spend months over something just to have it stolen from under their noses. Sadly, all the copyright laws in existence still don't prevent this from happening.

Copyright exists on a work for the duration of the creator's life plus a specified term after death. In the United States and the European Union that presently stands at life plus 70 years. You'll often see the term 'intellectual property' – this is the law covering copyright as well as patents and trademarks. To all intents and purposes intellectual property can be considered your book or script and the Intellectual Property Law stands as Copyright Law.

When you make a sale, the ideal situation is to just sell first US publication rights, or first foreign publication rights. This means that the company buys, from you, the right to publish – just once – your book. Your contract will determine how long the publisher retains the rights to your work (it could be for life, or it could be when the book goes out of print). It also covers whether you will receive a flat fee or advance against future royalties – royalties are an agreed percentage that you will receive from the book's sales, but the book has to earn back your advance first.

However, often you will find that publishers buy all rights. And this is just what it sounds like. Once you've signed on the dotted line, the book belongs to the publisher. The story and all characters contained within are now the intellectual property of the publisher. You get no royalties, and any movie sales go to the publisher. You may get the chance to write further adventures of your hero, except he won't be your hero any longer. Also, the publishers might want to develop him in ways you hate.

*Getting your work out there*

# GLOSSARY

Once you have enough figure drawings to build a portfolio, the chances are you are going to want to present your work to the graphic novel world. In order to do this, you will need to become familiar with some of the industry jargon.

**Action:** Visual movement of the figure within the panel.

**Angle shot:** Composition within the panel from a different point of view, or a different angle of the action from the previous panel.

**Antagonist:** Principal character in opposition to the protagonist or hero of a narrative.

**Background:** General scene or surface against which characters, objects or action are represented in a panel.

**Bird's-eye view**: Point of view elevated above an object, with a perspective as though the reader were a bird looking down at the action of the panel.

**Bleed:** The art is allowed to run to the edge of each page, rather than having a white border around it. Bleeds are sometimes used on internal panels to create the illusion of space or to emphasise action.

**Camera angle**: Angle of the point of view from the reader's perspective to a subject or scene; the camera angle can greatly influence the reader's interpretation of what is happening on the comic book page.

**Captions:** Comic book captions are a narrative device, often used to convey information that cannot be communicated by the art or speech. Captions can be used in place of thought bubbles, can be in the first-, second- or third-person and can either be assigned to an independent narrator or one of the characters.

**Close-up (CU):** Concentrates on a relatively small object, human face or action. It puts an emphasis on emotion to create tension.

**Composition:** The arrangement of the physical elements (or the subject matter) within a comic book panel. A successful composition draws in the reader and directs their eye across the panel so that everything is taken in.

**Dialogue:** Conversation between characters in a narrative.

**Double-page spread:** Two comic book pages designed as one large page layout.

**Dots per inch (dpi):** Measure of printing resolution. The higher dpi you scan your artwork, the larger the file size and sharper the image for printing. The industry standard is 400 dpi.

**Establishing shot:** Sets up the context for a scene by showing the relationship between its important figures and objects.

**Exterior (EXT):** A scene that takes place outside any architectural structure.

**Extreme close-up (ECU):** Subject or action in a panel is so up close that it fills the entire panel.

**Extreme long shot (ELS):** Typically shows the entire human figure in some relation to its surroundings.

**Eye movement:** Arrangement of words and pictures in the panel, directing the narrative eye of the reader throughout the page layout.

**File Transfer Protocol (FTP):** Facility on the Internet that allows you to copy files from one computer to another. The address (or URL) is usually something like ftp://ftp.somewhere.com.

**Flashback:** An interjected scene comprised of panels that take the narrative back in time from the current point in the story. Often used to recount events that happened before the story's primary sequence of events or to fill in crucial backstory. Character-origin flashbacks specifically refers to flashbacks dealing with key events early in a character's development.

**Focal point:** Emphasis of action, subject or any element in a panel on a page.

**Foreground (FG):** Objects, characters or action closest to the reader in a panel.

**Full shot (FS):** Composition that illustrates the entire subject, comprised of one individual, a group or the centre of the action in a single panel or page.

**Graphic novel:** Narrative work in which the story is conveyed to the reader using sequential art in either an experimental design or in a traditional comics format. The term is employed in a broad manner, encompassing non-fiction works and thematically linked short stories as well as fictional stories across a number of genres.

**Grid:** Series of panels organised on a page, often found to be consistent in size and shape for visual storytelling. The artwork is traditionally composed within each panel separated by the equal spacing of gutters.

**Inker:** The inker (also sometimes credited as the finisher or the embellisher) is one of the two line artists in a traditional comic book or graphic novel. After a pencilled drawing is given to the inker, the inker uses black ink (usually India ink) to produce refined outlines over the pencil lines.

**Inset panel:** Panel within a larger panel, often used as a close-up on the action to invoke emotion or to drive the narrative.

**Interior (INT):** Setting that takes place inside a structure such as a house, office building, spaceship or cave.

**Lettering:** The art of lettering is penned from the comic book creator responsible for drawing the comic book's text. The letterer crafts the comic's 'display lettering': the story title lettering and other special captions and credits that usually appear on a story's first page. The letterer also writes the letters in the word balloons and draws in sound effects. The letterer's use of typefaces, calligraphy, letter size and layout all contribute to the impact of the comic.

**Long shot (LS):** Typically shows the entire human figure and is intended to place it in some relation to its surroundings.

**Medium shot (MS):** Subject and background share equal dominance in the panel. A medium shot of a character will take in the body from the knees or waist up, with incidental background decided upon by the discretion of the writer/artist.

**Mini-series:** Tells a story in a planned limited number of comics or graphic novels.

**Montage:** Combination of illustrated images used for flashbacks, accelerated pacing of a story, transition between scenes and as emotional devices to engage the reader.

**Narrator:** The person who tells the story to the audience. When the narrator is also a character within the story, he or she is sometimes known as the viewpoint character.

**Panel:** Individual frame in the multiple-panel sequence of a comic book. Consists of a single drawing depicting a frozen moment.

**Panel transition:** Method a creator takes the reader through using a series of static images. Clearly transitions the contents of the action of one panel to the next panel.

**Penciller:** Artist who works in the creation of comic books and graphic novels. The penciller is the first step in rendering the story in visual form and may require several steps of feedback from the writer. These artists are concerned with layout (positions and vantages on scenes) to showcase steps in the plot.

**Plot:** Literary term for the events a story comprises, particularly as they relate to one another in a pattern, a sequence, through cause and effect or by coincidence.

**Point of view (POV):** Camera angle positioned for a key character, allowing the reader to view the action as a character within the panel can view it.

**Roughs:** Conceptual sketches or thumbnails of layouts that help plan the story visually.

**Scene:** Setting in a narrative sequence throughout several panels that can run for a page or more in a story involving key characters.

**Script:** Document describing the narrative and dialogue of a comic book. In comics, a script may be preceded by a plot outline, and is almost always followed by page sketches, drawn by an artist and inked, succeeded by the colouring and lettering stages.

**Setting:** Time, location and everything in which a story takes place, and initiates the main backdrop and mood for a story.

**Sound effects (SFX):** Lettering style designed to visually duplicate the sound of a character within a panel or page.

**Speed lines:** Often in action sequences, the background will possess an overlay of neatly ruled lines to portray direction of movements. Speed lines can also be applied to characters as a way to emphasise the motion of their bodies.

**Splash page:** Full-page drawing in a comic book, often used as the first page of a story. Includes the title and credits. Sometimes referred to simply as a 'splash'.

**Spotting blacks:** Process of deciding what areas in a comic panel should be solid black. Gives the illusion of depth, mass, contrast and a focal point on the character or action of the panel.

**Stat panel:** Artwork within the panel copied, and then repeated in subsequent panels from the original.

**Story arc:** Extended or continuing storyline in episodic storytelling media such as television, comic books, comic strips, board games, video games and in some cases, movies.

**Tangent:** When two objects within a panel, or in separate panels close in proximity, confuse the eye and create unusual forms thereby disrupting the visual narrative. Often, it's the panel border, or similar linear composition in a nearby panel, that creates unwanted tangents.

**Thought balloon:** Large, cloud-like bubble containing the text of a thought.

**Tier:** Row of panels horizontally from left to right. Traditionally, comic page layouts were designed with three tiers of panels.

**Tilt:** Cinematic tactic used to portray psychological uneasiness in the subject or compounding action within a panel.

**Whisper balloon:** Word balloon broken up by small dashes throughout its border to indicate a character is whispering.

**Word balloon:** Oval shape with rounded corner used to communicate dialogue or speech.

**Worm's-eye view:** Low-angle shot from the ground looking up at the focus of the composition. Used to make the subject more imposing and larger than it appears to be.

**Zoom:** Proximity of the camera, which moves towards or away from the central character or focal point of a composition in a panel.

# INDEX